INNER VISIONS

INNER VISIONS

GERMAN PRINTS *from the* AGE OF EXPRESSIONISM

Introduction by Ida Katherine Rigby

Catalogue by Mary Priester
with assistance by Lois Allan, Elizabeth Sarah Davis,
and Virginia Wilson Hanson

PORTLAND ART MUSEUM
Portland, Oregon

Portland Art Museum, Portland, Oregon
December 4, 1991 — March 8, 1992

Marion Koogler McNay Art Museum, San Antonio, Texas
June 14 — August 9, 1992

Duke University Museum of Art, Durham, North Carolina
September 11 — October 25, 1992

Kalamazoo Institute of Arts, Kalamazoo, Michigan
March 26 — May 9, 1993

Tacoma Art Museum, Tacoma, Washington
July — August, 1993

This catalogue is supported by a grant from the National Endowment
for the Arts with additional funding from Friends of the Gilkey
Center, the Consulate General of the Federal Republic of Germany,
Seattle, and the Oregon Council for the Humanities.

© Portland Art Museum

Printed in Korea.
Library of Congress Catalogue Card Number 91-068440
ISBN 0-295-97190-8

Design by Corinna Campbell
Photography by Steven Bloch and Guy Orcutt

COVER: detail, Karl Schmidt-Rottluff, *Christus und die Ehebrecherin*
(Christ and the Woman Taken in Adultery), 1918, plate 48

Contents

Board of Trustees 1991-1992

Message from the President

The works of art presented in *Inner Visions: German Prints from the Age of Expressionism* exemplify the ability of exceptional artists to transcend artistic tradition and prevailing social values. Looking at many of these extraordinary works of art, we have no choice but to share in the experience of social turmoil, confusion, suffering, and catastrophic change that marked the period from the turn of the century to the dark days preceding World War II. In many ways, it is hard to imagine a more compelling way to capture the spirit of those times than to study and absorb these superb works of art. At the same time, the aesthetic quality of these works is extraordinary.

We are especially proud to have organized this exhibition and catalogue with the support and encouragement of the Federal Republic of Germany.

Dan L. Monroe
President, Portland Art Museum

Message from the Consul General

I am particularly glad about the realization of this exhibition which will give its visitors all over the United States the opportunity to review the fine graphic work of German Expressionist artists.

Expressionist graphic art takes a special place in modern art. Expressionism stands for the beginning of a new era which broke the constraints of traditional artistic means, conventions, and academic rules. It also reflects the time between the two wars which so deeply marked this century and devastated so many lives. The artists whose works are shown in this exhibition are counted among the most important of my country. Many of their hopes and convictions were destroyed by World War I and many of them were persecuted under the National Socialistic Dictatorship.

It is in this country where they found the possibility to continue in their aspirations. It is also here where experts and admirers gathered outstanding collections. We owe sincere thanks to Gordon Gilkey and Edward Littman who saved so many of these works for us.

The collection preserves all the freshness, directness, and vigor of its creators and thus fulfills the Expressionists' endeavor to be a bridge not only to one's own inner self, but also to one's fellow man. It is in this spirit that I wish this exhibition all the success it so greatly merits.

Dr. Hans-Jürgen Mendel
*Consul General of the Federal Republic of Germany,
Seattle*

Acknowledgements

Most museum exhibitions and publications represent the collaborative enterprise of many participants, and this is especially so in the case of *Inner Visions: German Prints from the Age of Expressionism*. Initial efforts began over eight years ago when Gordon Gilkey and Mary Priester first conceived the idea. The project gained momentum with receipt of a National Endowment for the Arts grant in 1988. We acknowledge with gratitude NEA's timely commitment to the project as well as Ms. Priester's perseverance in its realization.

As the Gilkey Center for Graphic Arts enters construction, *Inner Visions* constitutes a welcome reminder of Gordon and Vivian Gilkey's many contributions to our community. The cache of treasures received from the Gilkeys has been enhanced, as witnessed in this exhibition, by many superb prints given by community members. The catalogue thus offers the opportunity to express our gratitude to the Gilkeys and others who have created what is now one of the Portland Art Museum's areas of excellence.

We are especially indebted to Dr. Ida Katherine Rigby, Professor of Art History, San Diego State University, who has made many contributions to the exhibition and catalogue as project consultant, essayist, and editor. Gordon Gilkey, who knew several of the artists personally, has continued to work tirelessly on all the details of the undertaking.

Creation of this catalogue has brought together the talents of many specialists whom we here recognize. Lois Allan, Elizabeth Davis, and Virginia Hanson assisted Mary Priester in authoring the catalogue entries. Ernestine Blomberg and Elsa and Konrad Reisner translated challenging documents and inscriptions. For help in assembling the glossary and related materials at an especially critical time we are grateful to Deborah Broderson. Lois Allan and Ida Rigby made many additional contributions as they edited this publication with Mary Priester. Dr. Franz Langhammer scrupulously helped proof the manuscript. We also thank John and Thomas Littman for their catalogue statement.

Many staff members advanced the project including Diane Kantor, who oversaw this publication, Laura Gamble, Amy Osaki, David Potter, Judy Schultz, Cheryl Tonkin, Prudence Roberts and John Weber. Peter Decius untangled computers and helped produce a clean manuscript. We also acknowledge Elizabeth Chambers, who renewed the physical vitality of the prints with her conservation efforts.

We are obliged to the Federal Republic of Germany, Dr. Hans-Jürgen Mendel, Consul General, and Gönke Roscher, Consul, for honoring us with support of *Inner Visions*. The Oregon Council for the Humanities, an affiliate of the National Endowment for the Humanities, also provided financial aid. The Metropolitan Arts Commission and the Oregon Arts Commission both underwrote general programming this year, as have members of the Museum. Finally, we thank the Friends of the Gilkey Center for their steadfast support of this and related activities centered on the Museum's collection of works of art on paper.

Gerald D. Bolas
Director, Portland Art Museum

Collectors' Statements

My early enthusiasm for the art of the German Expressionists was stimulated by viewing their work at the Art Institute of Chicago and in the Guggenheim Collection of Non-Objective Paintings in New York in the late 1930s. Later, in 1942-1943, while on Army Air Corps duty at Ellington Field, Texas, I visited the home of Edward Littman where I had the opportunity of holding in my hands fine modern German prints that had been collected by Edward's father, Ismar. In my mind, Expressionism was emerging as a major movement of the twentieth century.

I learned that Ismar Littmann (1879-1934) had been a collector friend of many of the artists represented in the collection and that he made frequent purchasing trips to their studios beginning in 1916 and ending about 1930. With a keen eye, he selected many unique prints and otherwise superlative examples of the artists' work. When his son, Edward, immigrated to the United States in 1935, he brought many of these works with him.

After World War II Edward served in the legal branch of military government and was posted in Wiesbaden, West Germany. My assignment as head of the U.S. War Department Special Staff Art Projects in Europe was nearby at the Headquarters, U.S. Forces European Theater in Frankfurt am Main. We met from time to time as schedules permitted. I returned to Oregon in August, 1947 as a professor and Chairman of the Department of Art, Oregon State University. Edward returned to the United States in 1950.

Shortly thereafter, Edward wrote asking for my help in selling items in the collection. I agreed to purchase some and to act on his behalf in finding suitable homes for others. Over one hundred were added to the Gilkey Collection, about thirty were purchased by the Portland Art Museum, and others were acquired by collectors in the community. Edward died in May, 1970, leaving a wife and two sons.

Before returning to the United States in August, 1947, I revisited my friends Carl Hofer and Max Pechstein in Berlin and gave them my remaining art supplies. I also helped to reinstate them as Director and Professor respectively at the Berlin College of Art. They, in turn, gave me dedicated gifts of prints. In late 1946 I had helped the grand patron and unofficial ambassador of German art, Frau Hanna Bekker vom Rath, with clearance and business papers which enabled her to open her Frankfurter Kunstkabinett. In the years of friendship that followed, from visits and parcel post I secured valued prints from her, from Gerd Rosen in Berlin, and Günther Franke in Munich. Franke had put me in communication with Max Beckmann in Amsterdam where I convinced him that his future was in America. Our friendship continued until his death in December, 1950.

I salute them and many more who encouraged the formation of the German graphics section of the Gilkey Collection. My early estimate of the importance of German Expressionism in the history of twentieth century art has proven to be overwhelmingly true. The oppressive twelve years of the Third Reich and their label, "Degenerate Art," are not forgotten. The Expressionist art that survived the Nazi onslaught shines bright in the ultimate test of time.

Dr. Gordon W. Gilkey
Curator Emeritus of Prints and Drawings
Portland Art Museum

Collectors' Statements

Many of the original prints in this important exhibition came from the extensive art collection acquired by our grandfather, Ismar Littmann, an attorney in Breslau, Germany, from 1907 until his death in 1934. He was a passionate, well informed collector with great enthusiasm for Expressionism. He encouraged many young artists, some not well known, others now famous. His collection was extensive and diverse. He was generous in making loans of his art for exhibitions, including one at the Neisser Haus in Breslau in 1930. The exhibitions were well received by the public and art critics alike.

As a result of the Nazi takeover in Germany in 1933, most of the Littmann collection was confiscated or lost. Ismar's son, our father, Edward H. Littman, brought the remainder of the collection with him when he immigrated to the United States in 1935. Most of these were dispersed over the years, primarily to Gordon Gilkey and the Portland Art Museum.

We are glad that so many of the prints from our grandfather's collection have found a home at the Portland Art Museum where they will be viewed, studied, and preserved for the enlightenment of future generations. We appreciate Mary Priester's and Dr. Gilkey's efforts to organize this exhibition. It is in the spirit of Ismar Littmann who wanted to share his enjoyment of art and to acquaint the public with the artists of that period.

Thomas F Littman
John F Littman
Houston, Texas

Franz Marc called the works of art of his era "spiritual treasures." For Marc and his contemporaries, art embodied the deepest emotional, psychological and spiritual yearnings of the times and pointed prophetically to the future.(1) These artists' interest in the psychological self that Freud was revealing, their schizophrenic response to the metropolis as a place both of stimulation and dehumanization and their apprehensive view of the toll taken on individual freedom by materialism and technological progress often infused their work with anxiety, brooding melancholy or apocalyptic urgency. At the same time, it could be ecstatic, reflecting their resilient spirits, full of utopian optimism.

Viewing the art of this period is at once draining and exhilarating. It is draining because the artists' responses to the forces they feared were eroding spiritual life were extremely powerful. Their work seismographically recorded the stresses born of strained personal and dislocated societal relationships. On the other hand, it is exhilarating in its spiritual ecstasy, profound pantheism and celebration of creative freedom.

The prints in this exhibition bear testimony to intense encounters with what it meant to be alive, acutely alive, in Germany from the turn of the century to the beginnings of the Third Reich. As one of the first art historians to devote a book to modern German prints, Hans Tietze wrote, "The prints of our time will give evidence . . . of the fever that agitates us."(2)

This particular collection has an intimate tie to those times because it was largely assembled by Gordon Gilkey, himself a master printmaker, who lived in Germany immediately after World War II. He knew several of the artists included here as well as most of the major print dealers of the day. Gilkey's personal contacts, especially his association with Edward Littman, and his connoisseurship shaped this portrait of modern German printmaking.

In these prints the sure hand reveals in the slashing of the wood block, a quick movement across the etching plate or a broad stroke on the lithographic stone, the contents of the exuberant or tremulous soul. The abstract forms expressed these artists' efforts to fathom the metaphysical and reveal the eternal, transcendent truths that lay behind the veil of materialism. The critic, editor, publisher and staunch supporter of Expressionism, Paul Westheim, described these distilled essences when he characterized Oskar Kokoschka's prints as always tending towards the absolute in "a symbolic language of suggestive power."(3)

The experience of printmaking is essentially that of the draftsman, as an alert hand fixes images from an invisible, inner world. Ludwig Meidner gave a riveting description of that process:

> Do not fear the empty white of the paper . . . There is . . . the horrible uncertainty — and here is your spirit and your hot will . . . We draftsmen . . . swim in a magic current and with hot fingers and powerfully tense brains bore, scratch and burrow our inner vision in stone, metal, wood and cardboard.(4)

The Expressionist artist Ernst L. Kirchner exulted in the process of revelation inherent in printmaking. He wrote,

> There is no greater joy than seeing the roller move for the first time over the just-completed woodblock, or etching the lithographic slab with nitric acid and gum and watching the effects striven for appear, or examining in the proofs the ripening of the final form of a print.(5)

The finished print can be held in one's hand and closely scrutinized, creating a sense of intimacy with the artist. As Kirchner wrote, "How interesting it is to feel out the prints to the smallest detail, sheet by sheet. . . . Nowhere does one come to know an artist better than in his prints."(6) Gustav Schiefler, an early collector of Expressionist prints, noted the immediacy and acuteness of expression associated with the prints of this period: "One feels the pulse of an artist when one contemplates his graphic work . . . The needle, the crayon, the cutting knife are simpler and therefore more penetrating means of expression than brush and color."(7)

For the Expressionists, the woodcut was a particularly satisfying medium. The Expressionist poet Rudolf Adrian Dietrich captured the spirit of the artists as they reveled in its attributes:

> The simplest means, a woodblock, suffices...It is terribly exciting to paint. But most exciting are the black and white surfaces. There are only contrasts. Perpetual snow and precipice, every slice with the knife is a slice into the innermost self. This wood is truly flesh of thy flesh.(8)

Westheim also conveyed his generation's enchantment with the woodcut, citing its historical antecedents in medieval prints, which he celebrated for sharpening the eye:

> the power, which...can dwell in a line torn in wood by the sharp steel, or ... the ... inimitable structure, which a blackened-over wood surface lays down in the process of printing...something unachievable without the wood.(9)

One of the distinguishing features of Expressionism was this commitment to the collaboration of the medium in the process of creation. Each medium was relished for its expressive potential. Of lithography Kirchner wrote, "The deep blacks and silky grays produced by the stone's grain alternate. The delicate tonality has a coloristic effect ...and lends warmth to the prints."(10) Nolde stated that with etching he could produce "an impression of light, a beauty of tones...full of life, an ecstasy, a dance, a gentle motion and fluctuation in tones."(11) Otto Dix concluded, "When one etches, one becomes a pure alchemist."(12)

Both Kirchner and Max Pechstein insisted that printing by hand carried the artist into the final phase and insured the retention of the much-prized presence of the artist in the finished print. According to Kirchner, "Only the artist who has love and ability for handicraft should make prints, only when the artist truly prints himself does the work earn the designation of original print."(13)

Printmaking has had a long history in Germany, from the work of medieval artisans through that of Albrecht Dürer, to its revival in the early years of the twentieth century. At that time, Käthe Kollwitz, essentially Impressionist painters such as Max Liebermann, Max Slevogt and Lovis Corinth, and the romantic realist Max Beckmann worked seriously as printmakers. Beckmann's experiences during World War I made of him an Expressionist. After the war, Kollwitz incorporated an Expressionist abstraction into her woodcuts. Inspired by Ernst Barlach, she found in the woodcut the emotional power that had eluded her in etching and lithography as she had tried to express her grief over the deaths of her son Peter and a whole generation of European youth. Her first woodcut was the memorial print to Karl Liebknecht (plate 24); the *Seven Woodcuts about War* (plates 28, 29) followed.

The Expressionist sensibility, with its intense engagement with the medium and modernist sense of process, came to the fore in the prints of Die Brücke (The Bridge). The art historian and museum director Gustav Hartlaub credited the group with raising "the art of black and white in Germany to the direct symbolic and gestural language of inner agitation."(14) Emil Nolde was a member, briefly; more long-term members included Kirchner, Max Pechstein, Karl Schmidt-Rottluff, Erich Heckel and Otto Mueller. The group officially disbanded in 1913.

The other prominent and influential prewar group, Der Blaue Reiter (The Blue Rider), was a looser association. Wassily Kandinsky and Marc were its core; they invited others to exhibit with them and published an almanac, *Der Blaue Reiter,* in 1912. The American expatriate Lyonel Feininger and the Swiss artist Paul Klee were among the associates. A few individuals, such as the poet, painter, and printmaker Ludwig Meidner, were part of smaller Expressionist groups, such as Meidner's Die Pathetiker (The Pathetics). Some like Kokoschka were in contact with other Expressionists through Herwarth Walden's Sturm circle.

During the first world war, most of the artists served either as combatants or in humanitarian roles with medical units. They produced very few prints in wartime; the last months of the war and the immediate post-war, post-revolutionary period, however, witnessed an explosion of printmaking. While at the Russian front in 1918, Karl Schmidt-Rottluff, for example, executed a powerful series of prints on the life of Christ. Its ecstatic spirituality and mysticism reflect the intensity of the war experience (plates 48, 49). Dr. Rosa Schapire, an art historian and collector of Expressionist prints, wrote that in these prints,

> in his struggle with the ultimate questions of being, he grasped the meaning that conceals itself behind all eternal occurrences...The most secret mysteries of the soul reveal themselves in black and white...we immerse ourselves in a world that, liberated from reality, born of ecstasy, extends to the stars. It is saturated with mysticism, the fertile soil of all great art.(15)

This heightened spirituality permeated the Expressionist prints of 1918-1919.

Much of the imagery also expressed the increasingly

anti-war sentiments of the period. In his review of an exhibition of woodcuts held in Munich in 1918, Dietrich described this atmosphere, "The experience of unbenumbed men is disgust, broken heartedness, shame before all bloodthirsty sentiments."(16) At the same time, an ebullient euphoria born of the belief that the war had cleared the way for a new age was also in evidence. Prints bearing ragged images of the wounded, shocked and dispirited, as well as of ecstatic resurrection lined exhibition walls, illustrated the periodicals that covered cafe tables and filled collectors' cabinets.

Many of the prints by Kollwitz, George Grosz and Beckmann comment on life in Germany's big cities. Beckmann, for example, chose to live in Frankfurt because in the metropolis he could experience the "grand human orchestra" and "expose the ghastly cry of pain of the poor disillusioned people."(17) Hartlaub wrote of Grosz, "The outer world overpowers his feeling and his mind, and it does this exactly there, where it is the most immediate, the loudest, the most inescapable: in the strident presence of the big cities."(18)

The critic Paul F. Schmidt characterized the role often envisioned for the artist during this period when he wrote, "We shift all the torment and despair of our condition to the conscience of the artist; he carries our burden as the prophet and soothsayer of the times . . . with cruel clarity [he] holds up to us the mirror with the distorted image that makes us recoil in horror . . . suffers more and sees the dark and tragic ground of things out of which all life grows."(19)

Many of the prints in this collection by Otto Dix and Beckmann come from the 1920s. Both artists present a symbolic world in which personal, psychological, and broader Weimar social realities are metaphorically staged in circus or theatrical settings. Hartlaub described Beckmann's pieces as "allegories of the radical-evil in our civilization, but also symbols for our longing for redemption."(20)

Cast in a different mold are the prints of the 1920s by Kandinsky, Feininger and Klee, all colleagues at the Bauhaus. Kandinsky's prints reflect the Constructivist influence of his wartime stay in Russia and his disciplined study of the forces of the picture plane, the results of which he published in *Point and Line to Plane*, 1926. Klee's prints invite the viewer to follow his imagination as he takes a little "trip" with a line.(21) Feininger's prints reflect his assimilation of the cubo-futurist idiom into Expressionism.

The collection presented in this catalogue offers a broad view of the themes, techniques and concerns that preoccupied the German artists who, in the first decades of the twentieth century, explored a seemingly endless array of sensations, emotions and spiritual states. For these artists, printmaking offered direct, immediate techniques for fixing these states and impressions. They savored the processes and were transfixed by the results. For them printmaking had a splended life of its own, well beyond more conventional illustrative purposes. This sense of discovery and total engagement still animates these prints after the lapse of more than half a century.

Ida Katherine Rigby
Professor, San Diego State University

1. Franz Marc, "Spiritual Treasures," *The Blaue Reiter Almanach*, Documentary edition by Klaus Lankheit (London: Thames and Hudson Ltd., 1974), p.55.

2. Hans Tietze, *Deutsche Graphik der Gegenwart* (Leipzig: Verlag von E. A. Seemann, 1922), p.3.

3. Paul Westheim, "Kokoschkas Graphik," *Das graphisches Jahrbuch*, 1919 (Darmstadt: Joel, 1920), p.31.

4. Ludwig Meidner, "Vom Zeichnen," *Das Kunstblatt* no. 4 (April 1917), p.97.

5. L. de Marsalle, "Über Kirchners Graphik," *Genius* 3, no. 2 (1921), p.252.

6. Ibid.

7. Gustav Schiefler, "Erich Heckels graphisches Werk," *Das Kunstblatt* 1, no. 9 (1918), pp.283-4.

8. Rudolf Adrian Dietrich, "Geschichte (zur Ausstellung 'Der expressionistische Holzschnitt' bei Goltz in München)," *Die schöne Rarität* 2 (1918/1919), p.16.

9. Paul Westheim, "Holzschnitt und Monumentalkunst," *Das Kunstblatt* 2 (February 1918), pp.42-4.

10. L. de Marsalle, p.257.

11. Nolde to Hans Fehr, 1905, in Hans Fehr, "Aus Leben und Werkstatt Emil Noldes," *Das Kunstblatt* 3, no. 7 (1919), p.208.

12. Florian Karsch, ed., *Otto Dix: Das Graphische Werk* (Hannover: Fachelträger Verlag Schmidt-Küster, 1970), p.15.

13. L. de Marsalle, p. 262.

14. Gustav Hartlaub, *Die neue deutsche Graphik* (Berlin: Erich Reiss Verlag, 1920), p. 49.

15. Rosa Schapire, "Schmidt-Rottluffs religiöse Holzschnitte," *Die Rote Erde*, 1: 6 (November 1919), pp.186-7.

16. Dietrich, p.16.

17. Max Beckmann, "Schöpferishe Konfessionen," in Kasimir Edschmid, ed., *Schöpferische Konfessionen*, Tribüne der Kunst und Zeit no.13 (Berlin: Erich Reiss Verlag, 1920), p.64.

18. Hartlaub, p. 92.

19. P. F. Schmidt, "Max Beckmanns Holle," *Der Cicerone* 12:23 (1920), p.841.

20. Hartlaub, pp.91-92.

21. Paul Klee, "Creative Credo," 1920, in Herschel B. Chipp, *Theories of Modern Art* (Berkeley and Los Angeles: University of California Press, 1968), p.183.

CATALOGUE

Measurements are listed in centimeters, height before width, and represent the greatest dimension of the stone, block or plate. In the absence of any plate marks, the image size is given.

Dates of the prints are those given in the catalogue raisonnés. It is not uncommon for some artists, Max Pechstein, for example, to go back to a plate or block at a later date to print it again; thus the date signed on the print may be later than the date cited for the print.

Papers are listed generically as wove or laid and by weight if notable. The German catalogue raisonnés usually distinguish between Bütten, defined as a hand-made laid paper, and Japan, a thin wove paper. References to the edition derived from the catalogue raisonnés may include descriptions of paper different from those listed in the initial descriptions of the work; in some cases, this may suggest that the Museum's impression lies outside the known edition. Most of the papers range in color from off-white to beige; color is mentioned only if it departs from the normal range.

Provenance is listed when available. To the best of our knowledge all of the work from the Littmann collection was originally purchased directly from the artists themselves.

Some terms that frequently appear on the prints are:

Eigendruck (Own print) A print personally pulled by or for the artist.

Handdruck (Hand-pulled print) A print pulled by the artist, usually by hand without a press, or with an artist-owned press.

Probedruck (Trial proof) A proof impression pulled by the artist before the completion of the print, or outside the numbered edition of the print.

Bibliographic references have been deliberately kept to a minimum. The source of quotations by the artists are not cited but can be found in the standard references listed in the artist's bibliography. When another author needs to be cited, the citation is abbreviated; fuller information on the source can be found in the artist's bibliography.

Contributors to the catalogue:

LA Lois Allan
ESD Elizabeth Sarah Davis
VWH Virginia Wilson Hanson
MP Mary Priester

LOVIS CORINTH 1858-1925

Born into a wealthy family in Taipau, East Prussia, Lovis Corinth began his art education at the Königsberg Academy. He continued his training in Munich and later in Paris at the Academy Julien with Adolphe Bouguereau and Tony Robert-Fleury. Corinth returned to Germany in 1887, first to Berlin and then back to Königsberg to be with his dying father. In 1891 he moved to Munich where he was for a time a member of the Munich Secession. After several years of travel in Italy, he settled permanently in Berlin in 1900. He joined the Berlin Secessionists, an impressionist-oriented artists' group, becoming a chairman, then president in 1915.

Adamantly opposed to the Expressionists' dependence on foreign influence and their use of primitive art, Corinth advocated a German art that combined the northern realist tradition with an artist's own innermost feelings. The powerful vitality and earthy sensuality of his drawings and paintings reflect his grounding in the style of artists such as Peter Paul Rubens, Rembrandt van Rijn, Frans Hals, and Gustav Courbet.

In 1911 a stroke left Corinth partially paralyzed. As a result, his technique became broader and began to reflect some of the characteristics of Expressionism, despite his earlier opposition to the movement. Because of this late work, with its great emotional depth and expressive freedom, Corinth has come to be viewed as an important transition figure linking the 19th century with the modern era.

Corinth made a total of 918 prints, mostly drypoints, and later, lithographs. At first he made only a few prints each year, but from 1908 production steadily increased until by the early 1920s he was making more than 100 prints per year.

ESD/MP

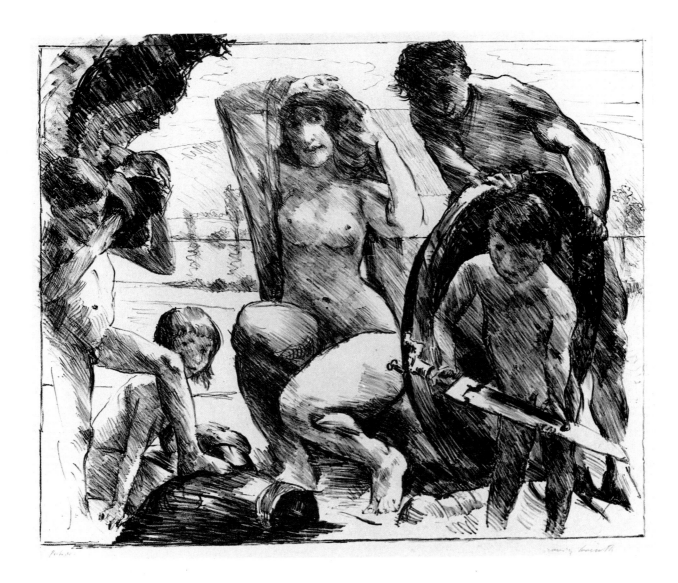

1. *Die Waffen des Mars* (The Weapons of Mars), 1914

Lithograph on heavy wove paper
44.4 x 51.8cm
Signed, l.r., Lovis Corinth; annotated, l.l., Probedruck
Edition: 25
Schwarz L169, III/III
Provenance: Littmann Collection
Vivian and Gordon Gilkey Graphic Arts Collection 82.80.250

The Weapons of Mars is characterized by Corinth's masterful rendering of the effects of light and the momentary quality of the scene. Although its mythological subject was not one favored by the French Impressionists, it is, nevertheless, typical of his "impressionist" style. Like the Impressionists, Corinth relied on observation instead of idealization, thus transforming a scene from mythology into a contemporary image.

Corinth's fascination with this particular theme, in which young boys play with the weapons and armor of Mars while Venus examines her reflection in the polished shield, led him to create two identical versions, one in lithography and one in drypoint. His interest in Venus, whom he depicted in a number of images including the *Toilet of Venus*, the *Birth of Venus*, and *Venus with the Mirror*, lay, at least partially, in the opportunity to depict the female nude. A joy in the physical world permeates his work in much the same way it does that of Peter Paul Rubens, whom he much admired.

MP

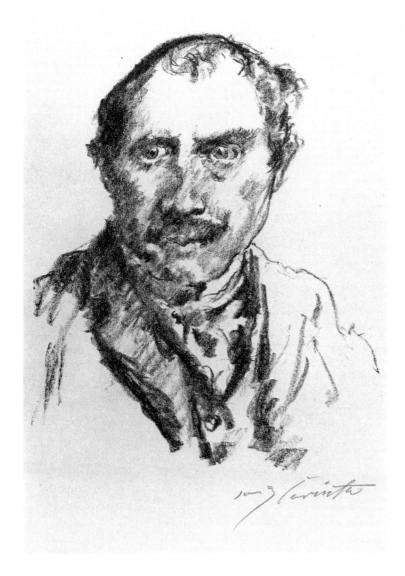

**2. *Selbstbildnis des Künstlers in Frontalansicht ohne Arme*
(Self-Portrait in Front View without Arms), 1920**

Lithograph on laid paper
32 x 24.2cm
Signed in pencil, l.r., Lovis Corinth
Edition: 100
Schwarz 407
Provenance: Littmann Collection
Vivian and Gordon Gilkey Graphic Arts Collection 80.122.523

Like many artists of the time, Corinth produced a large number of self-portraits throughout his career, including approximately 60 in the print media. *Self-Portrait in Front View without Arms* is one of the 17 self-portraits he made between 1918-1920. In its honesty and depth of feeling it recalls the profound humanity of Rembrandt's late self-portraits.

Although he continued to picture himself in historical and allegorical series, such as the 1922 *Dance of Death* (plate 5), this lithograph from March 19, 1920 is one of Corinth's last direct self-portraits. Drawn with a broad parallel stroke, the image seems on the verge of dissolution, held together purely by the artist's own passion and force of will.

ESD/MP

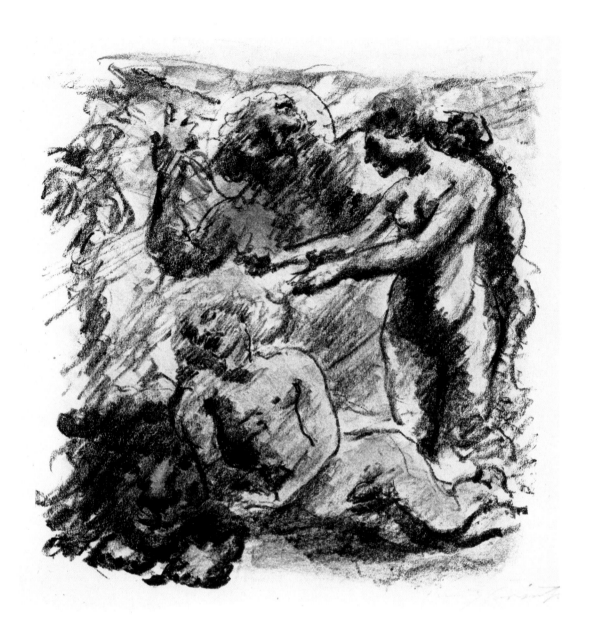

From *Im Paradies* (In Paradise), a portfolio of six color lithographs
(Leipzig: E.A. Seeman, c. 1921)
Edition: 14/60
Provenance: Littmann Collection

3. *Die Erschaffung Evas* (The Creation of Eve), 1921, plate 2

Color lithograph on heavy wove paper
34.7 x 31.5cm
Signed in pencil, l.r., Lovis Corinth
Müller 541
Vivian and Gordon Gilkey Graphic Arts Collection 86.13.136

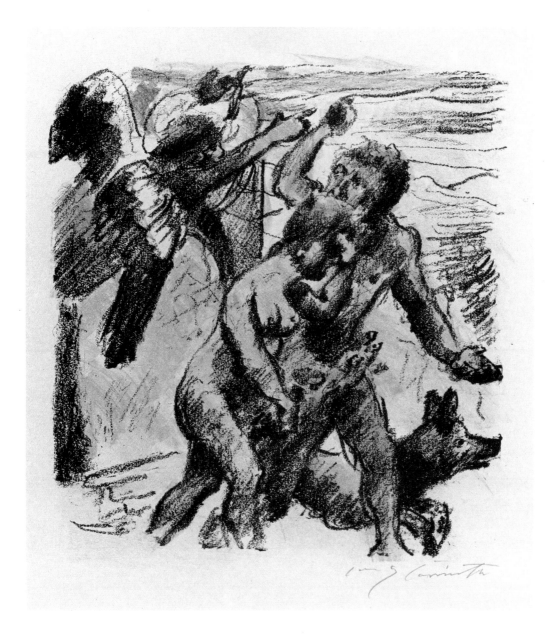

4. *Die Vertreibung aus dem Paradies* (The Expulsion from Paradise), 1920-21, plate 6

Color lithograph on heavy wove paper
35.3 x 31.7cm
Signed in pencil, l.r., Lovis Corinth
Müller 545
Vivian and Gordon Gilkey Graphic Arts Collection 85.14.447

Throughout his prolific career, Corinth was well-known for his use of Biblical and mythological imagery. *In Paradise*, produced late in the artist's life, exemplifies his thorough grounding in traditional Judeo-Christian iconography. As in the fresco cycles of the Italian Renaissance, he portrays the full sequence of events from the creation of Adam and Eve through the Temptation, the Fall, and the Expulsion from Paradise. The robust naturalism of the figures, however, reflects his distinctly northern aesthetic. The bright pastel colors of *In Paradise* are indicative of Corinth's late work which won him praise as a brilliant colorist.

ESD/MP

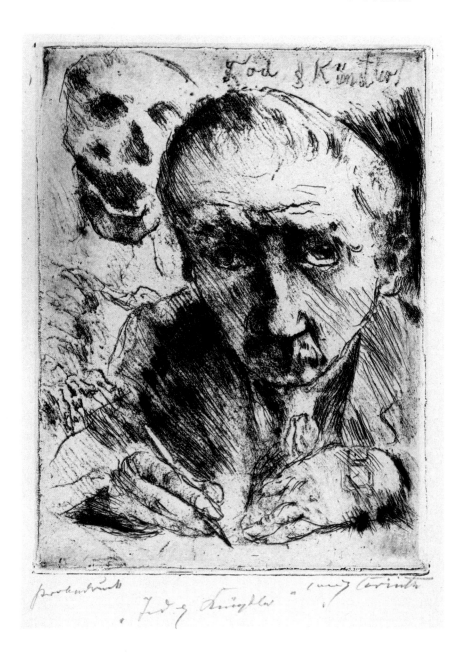

From *Totentanz* (Dance of Death), a portfolio of five etchings (Berlin:
Euphorian Verlag, 1922)
Edition: 25 on Japan, 95 on buff Van Gelden
Provenance: Littmann Collection

5. *Tod und Künstler* (Death and the Artist), 1922 , plate 1

Etching and softground on wove paper
24.2 x 17.9cm
Signed in pencil, l.r., Lovis Corinth; titled, l.c., "Tod und Künstler";
annotated, l.l., probedruck; titled in plate, u.r., Tod & Künstler
Müller 546, trial proof
Helen Thurston Ayer Fund 51.260

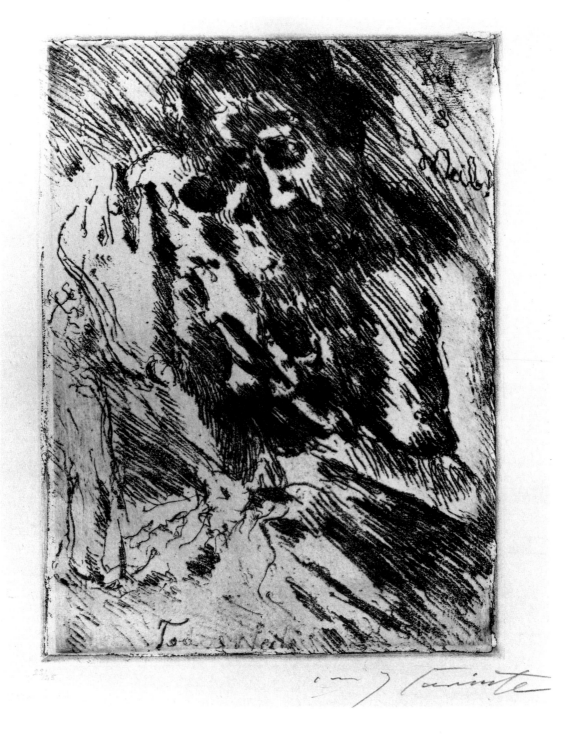

6. *Tod und Weib* **(Death and the Woman), 1922 , plate 2**

Softground etching on wove paper
23.6 x 17.4cm
Signed in pencil, l.r., Lovis Corinth; numbered, l.r., 22/25; titled in
plate, l.c., Tod & Weib; u.r., Tod & Weib
Müller 549
Vivian and Gordon Gilkey Graphic Arts Collection G5681

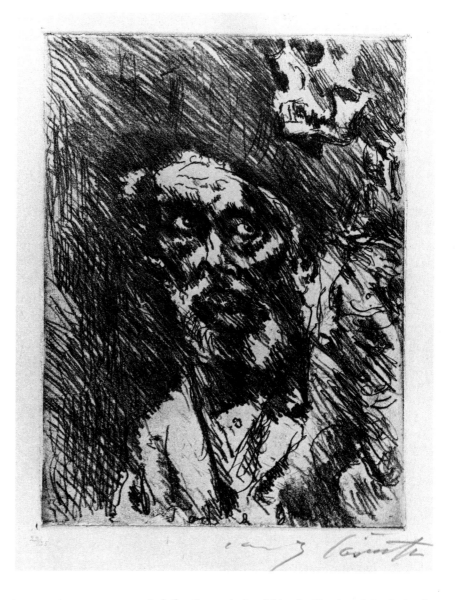

7. *Tod und Greis* (Death and the Old Man), 1922, plate 4

Softground etching on wove paper
23.8 x 17.5cm
Signed in pencil, l.r., Lovis Corinth; numbered, l.l., 22/25
Müller 548
Vivian and Gordon Gilkey Graphic Arts Collection G5683

In spite of two severe strokes in December 1911, Corinth's graphic output increased dramatically. Images of death, with a penetrating, psychological orientation, began to appear more frequently. *Dance of Death,* one of Corinth's best known print cycles, is an example from this period.

Highly atmospheric and expressive, each of the five prints in this series pairs Death with a specific phase or aspect of life. Although not specifically intended to be portraits, each stage is represented by a member of the artist's family or circle of friends. *Death and the Artist,* for example, depicts Corinth, transcribing his image from a mirror, with Death looming over his shoulder. The woman in *Death and the Woman,* said to be the artist's wife Charlotte Berend, gazes into Death's eyes and gently embraces him. The figure in *Death and the Old Man* is generally believed to be the artist's beloved father who died in 1889. The other two images in the series are *Death and the Young Man,* featuring his son Thomas, and *Death and the Couple,* with his friends Hermann Stuck and his wife. Stuck, a well-respected etcher, probably introduced Corinth to the soft-ground technique which he used to such powerful effect in this series.

ESD

KÄTHE KOLLWITZ 1867-1945

Käthe Kollwitz occupies a singular place in the history of modern German prints. Her style was conservative, relying on direct observation rather than stylistic experimentation or symbolism. Moral and ethical issues, which are at the core of her work, came from a profound, lifelong compassion for the poor and powerless. She did not align herself with radical political groups but was deeply committed to the causes of peace and social change.

Although she was also an accomplished sculptor, Kollwitz was primarily a printmaker. She began art school intending to study painting, but after seeing *Ein Leben* (A Life), a series of prints by Max Klinger, and reading his *Malerei und Zeichnung* (Painting and Drawing), she decided that her real talent was in drawing and that she would devote herself to the graphic media. The aesthetics and technical processes of printmaking held particular appeal for her and, in addition, its potential for wide distribution suited her social purposes. Her graphic oeuvre consists of 100 etchings, 125 lithographs and 42 woodcuts, many issued in cycles and some published as posters.

She was born Käthe Schmidt in Königsberg, East Prussia, in 1867, the fifth child in a family dedicated to socialistic principles. With the encouragement of her father, she began training in art in Königsberg at age thirteen. In 1885 she went to Berlin to study with Karl Stauffer-Bern, then to Munich in 1888, where she spent two years at the Women's Art School.

After her marriage in 1891 to Dr. Karl Kollwitz, the couple established residence in a working-class section of Berlin in an apartment which remained their home throughout their married life. Both were dedicated to humanitarian service, he as a physician to the poor, she as a socially-conscious artist. Two sons were born, and her maternal experience intensified the moral values from which she worked. She was appointed in 1919 to the Berlin Academy of Art, the first woman to be so honored, and was director of graphic arts from 1928 until 1933 when pressure from the Nazi government forced her to resign. Dr. Kollwitz died in 1940, and soon after, bombing attacks on Berlin forced Käthe Kollwitz to evacuate. She died in April, 1945, just a few days before the war ended, in Moritzburg where she was given refuge by Prince Ernst Heinrich of Saxony.

LA

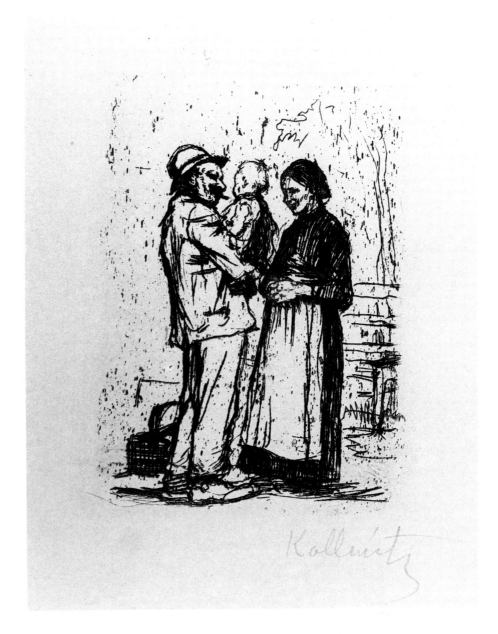

8. *Begrüssung* (Greeting), 1892

Etching on heavy wove paper
11.8 x 8.3cm
Signed, l.r., Kollwitz
Klipstein 10, II(c)/II
Edition: unknown
Provenance: Gerd Rosen, Berlin
Vivian and Gordon Gilkey Graphic Arts Collection 80.122.427

One of the earliest known of Kollwitz's prints, *Greeting* was done only two years after her introduction to etching. Although her technique was not yet fully developed, her accomplished draftsmanship is evident in the naturalistic poses and expressions of the figures. The theme of family closeness, particularly that of mother and child, remained an important one throughout the artist's career.

In its intimacy and charm, this small composition suggests the domesticity of her own life at the time. Her marriage had occurred the previous year and her older son, Hans, was just recently born.

LA

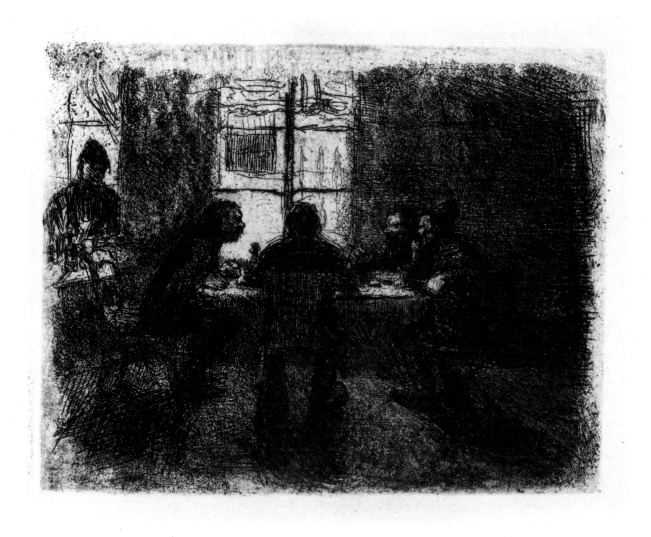

9. *Vier Männer in der Kneipe* (Four Men in a Pub), 1892/93

Etching on wove paper
12.9 x 15.8cm
Unsigned
Edition: 50, partly numbered
Klipstein 12, I(a)/III
Provenance: Gerd Rosen, Berlin
Vivian and Gordon Gilkey Graphic Arts Collection 82.80.120

Four Men in a Pub captures a moment of relaxation in the everyday life of workmen. Sitting together in the darkened pub, they lean toward each other in seemingly animated conversation. The woman, who stands in the light from the window, appears to be an interested observer as well as a waitress — a worker herself. The dark atmosphere and psychological overtones can be attributed to the influence of Edvard Munch whose work Kollwitz had seen about this time in a Berlin exhibition.

LA

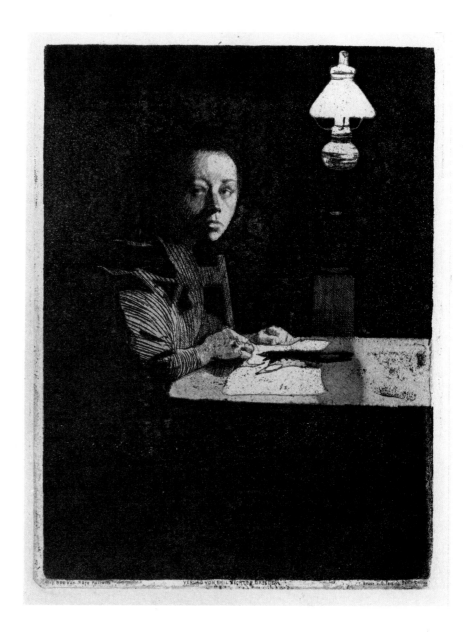

10. *Selbstbildnis am Tisch* (Self-Portrait at Table), c.1893

Etching and aquatint on heavy wove paper
17.6 x 12.8cm
Unsigned; annotated in plate, l.l., Orig Rad von Käte Kollwitz; l.c.,
VERLAG VON EMIL RICHTER DRESDEN; l.r., Druck v. O. Felsing
Berlin-Chlttbg
Edition: unknown
Klipstein 14, state IV/V
Provenance: Littmann Collection
Helen Thurston Ayer Fund 52.156

In this rare print, a valuable example of her early technique and drawing style, Kollwitz depicts herself at age 26 sitting at her table. Her features, hands, and paper are lifted out of darkness by the light of the bright lamp. Although she was a young married woman with an infant, she represents herself as a solitary figure, drawing alone in the quiet of the night.

During her career Kollwitz made more than 80 images of herself, more than 30 of them in the print media. Unlike later self-portraits, in which she isolates her features against a blank background, Kollwitz here provides a setting for herself, however minimal.

LA

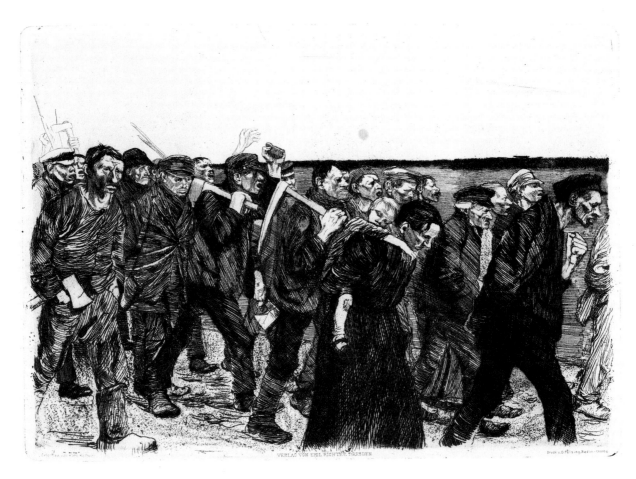

From *Ein Weberaufstand* (Revolt of the Weavers), a series of three
etchings and three lithographs (Dresden: Verlag von Emil Richter,
1897-98)
Edition: unknown

11. *Weberzug (The Weavers' March)*, 1897, plate 4

Etching on heavy wove paper
21.4 x 29.5cm
Unsigned, annotated in plate, l.l., Orig rad von Käte Kollwitz, l.c.,
VERLAG VON EMIL RICHTER DRESDEN, l.r., Druck v.o. Felsing Berlin-
Chlttbg
Klipstein 32, II/IV
Provenance: Littmann Collection
Vivian and Gordon Gilkey Graphic Arts Collection 81.81.218

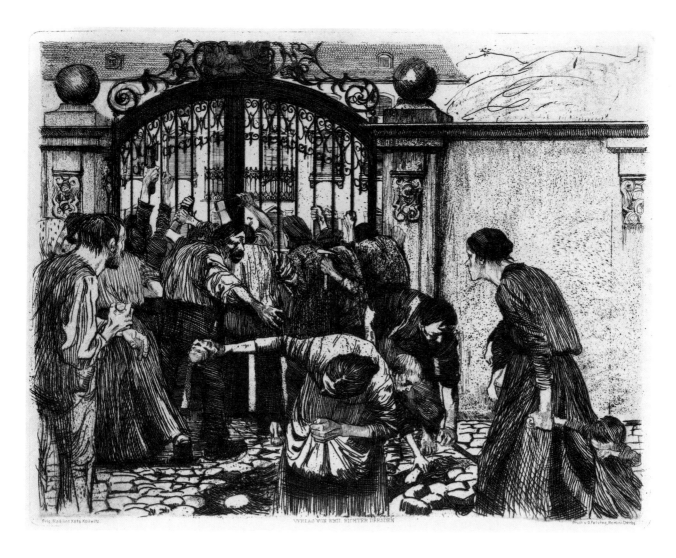

12. *Sturm* (Riot), 1897, plate 5

Etching on heavy wove paper
23.3 x 29.5cm
Unsigned, annotated in plate, l.l., Orig rad von Käte Kollwitz, l.c.,
VERLAG VON EMIL RICHTER DRESDEN, l.r., Druck v.o. Felsing Berlin-
Chlttbg
Klipstein 33, III/V
Provenance: Littmann Collection
Vivian and Gordon Gilkey Graphic Arts Collection 81.81.210

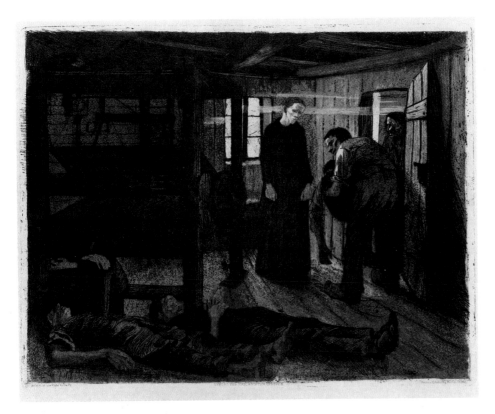

13. *Ende* (End), 1898, plate 6

Etching, aquatint on heavy wove paper
24.2 x 30.5 cm
Unsigned, annotated in plate, l.l., Orig rad von Käte Kollwitz, l.c.,
VERLAG VON EMIL RICHTER DRESDEN, l.r., Druck v.o. Felsing Berlin-
Chlttbg
Klipstein 37, III/V
Provenance: Littmann Collection
Vivian and Gordon Gilkey Graphic Arts Collection 80.122.423

In 1893 Kollwitz saw a private performance of Gerhart Hauptmann's play, *Die Weber* (The Weavers). It made a deep impression on her, causing her to abandon a project based on Emile Zola's *Germinal* in order to begin a series based on the plot of the play.

Die Weber was inspired by an actual event that had taken place some fifty years earlier. Silesian weavers, impoverished by their overbearing employers and by the competition of industrialized textile mills, rioted. At the climax of the revolt they looted the home of the wealthy factory owner, and were then crushed by military forces. Nevertheless, they had, in Kollwitz's view, courageously fought for their rights.

The six plates of *Revolt of the Weavers* follow the sequence of the drama from the causes of the riot to the uprising, the fighting, and finally, the tragic end. Her

first major print cycle, the series achieved critical success and established the young artist's reputation. On first showing at the Great Berlin Exhibition of 1898, however, it was denied a medal by the Kaiser on the grounds that it fostered class hatred. Ironically, a year later, when the cycle was exhibited in Dresden, it was bought for the Dresden state art collection, and the monarch awarded the medal.

Revolt of the Weavers exemplifies Kollwitz's early drawing style and reflects the influence of Max Klinger. In addition, Kollwitz had seen the work of Edvard Munch about this time, and absorbed from it a sensibility for emotionally charged subjects. Kollwitz's early training in painting is evident in the painterly qualities of the series, particularly in *The End*.

Women are seen as prominent participants in the drama represented in these three prints. Throughout her oeuvre Kollwitz often used images of women and children to call attention to the important role women play in social conflict. One of the preparatory drawings for *The End* shows the woman with her hands folded, as if in resignation. The artist discarded that pose in favor of placing the woman's arms and hands at her sides in an attitude of dignity and strength.

LA

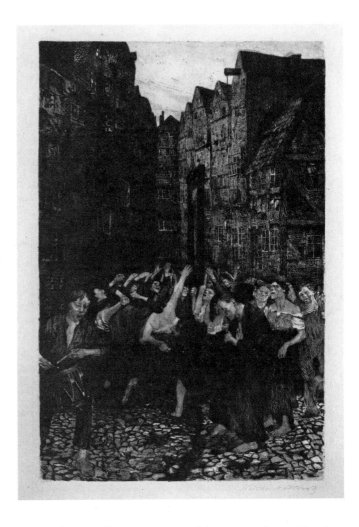

14. *Die Carmagnole* **(The Dance Around the Guillotine), 1901**

Etching and aquatint on heavy wove paper
52.6 x 34.4cm
Signed, l.l., Felsing, l.r., Käthe Kollwitz
Edition: unknown
Klipstein 49, V/VIII
Provenance: Hanna Bekker vom Rath, Frankfurt am Main
Vivian and Gordon Gilkey Graphic Arts Collection 78.52.326

Kollwitz, always interested in women's social roles, found inspiration for *Die Carmagnole* in Charles Dickens' account of the French Revolution in his novel, *A Tale of Two Cities*. Although the title of the print was taken from a French song widely sung during the Reign of Terror, the image is based on Dickens' description of an all-female battalion: ". . . there was no other music than their own singing. They danced to the popular revolution song, keeping a ferocious time that was like a gnashing of teeth in unison."

Preliminary drawings show that detailed attention initially was given to the buildings and cobblestones. The figures were then worked into this setting, and subtle changes were made through most of the eight states in order to bring maximum impact to the mass of arms stretched up to the guillotine. The drummer in the foreground faces outward and provides the visual entry point to the circular group of dancers.

LA

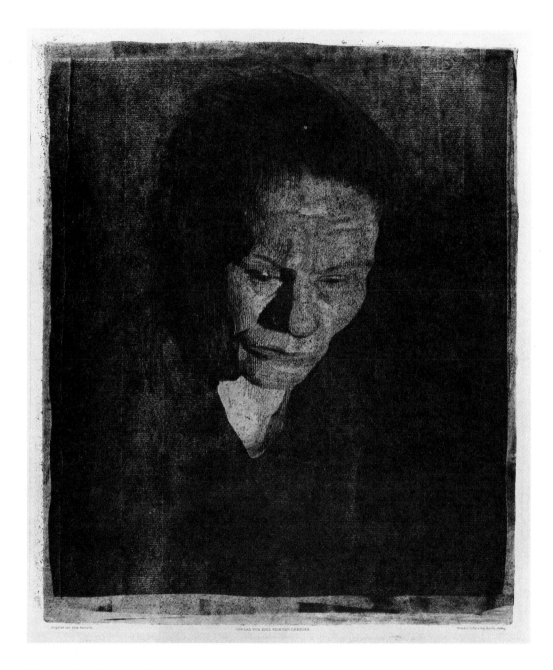

15. Gesenkter Frauenkopf (Woman with Bowed Head), 1905

Softground etching on heavy wove paper
37.8 x 31.4cm
Unsigned; annotated in plate, l.l., Orig. Rad. von Käte Kollwitz; l.c.,
VERLAG VON EMIL RICHTER DRESDEN; l.r., Druck v.o. Felsing,
Berlin-Chlttbg.
Edition: unknown
Klipstein 77, IV/IV
Provenance: Littmann Collection
Helen Thurston Ayer Fund 52.157

Between 1900 and 1910 Kollwitz made many studies of women whose expressions and bearing show the effects of hardship. She felt deep respect and empathy for working people and wrote that she wished to pay tribute to the hard work and sacrifices made by women, particularly mothers.

The artist's concentration on the psychological aspects of her subject is exemplified by the lighting contrasts, the down-turned eyes, and somber mien of this woman.

LA

From *Bauernkrieg* (The Peasants' War), a series of seven etchings
(Berlin: Verbindung für historische Kunst, 1908)
Edition: unknown

16. *Beim Dengeln* (Sharpening the Scythe), 1905, plate 3

Etching and softground on wove paper
29.6 x 29.6cm
Signed, l.r., Kollwitz; dated in the plate, l.r., 1921
Klipstein 90, XII(a)/XII
Provenance: Gerd Rosen, Berlin
Vivian and Gordon Gilkey Graphic Arts Collection 82.80.208

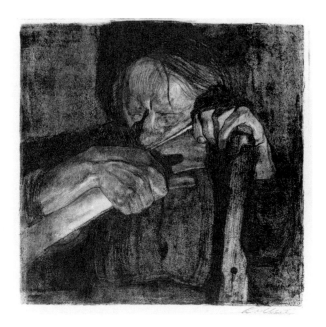

17. *Losbruch* (Outbreak or Uprising), 1903, plate 5

Etching, aquatint, and softground on gray wove paper
48.5 x 58.2cm
Signed and dated in the plate, l.r., Kollwitz 1902
Klipstein 66, VII/XI
Provenance: Gerd Rosen, Berlin
Vivian and Gordon Gilkey Graphic Arts Collection 86.13.11

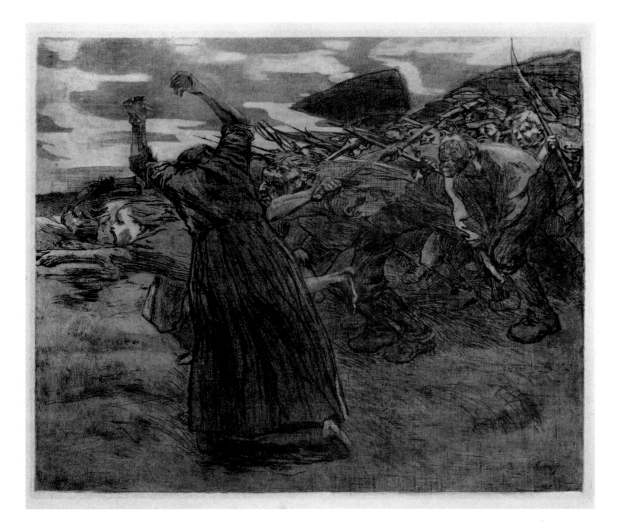

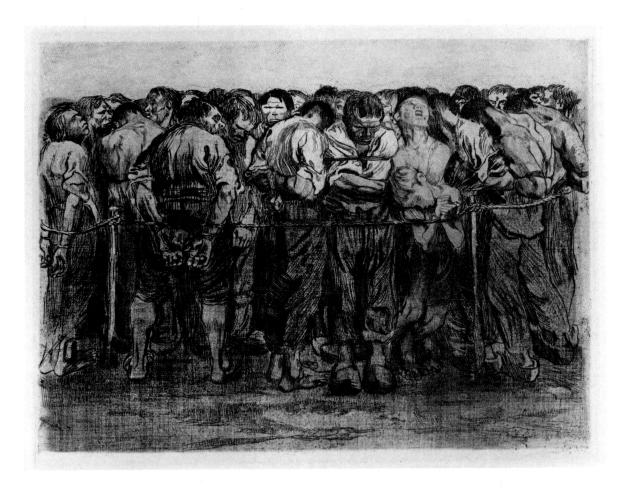

18. *Die Gefangenen* (The Prisoners), 1908, plate 7

Etching on wove paper
32.5 x 42.2cm
Unsigned
Klipstein 98, VIII(b)/VIII
Provenance: Gerd Rosen, Berlin
Vivian and Gordon Gilkey Graphic Arts Collection 86.13.489

The Peasants' War (1522-1525) was the result of terrible living conditions endured by the peasants throughout the preceding century. Kollwitz read extensively before beginning her series on the subject, studying the economic and social conditions of the period as well as the actual events of the rebellion. From historical records, she took the main figure in *Outbreak,* a woman known as "Black Anna" who actively encouraged the fighters. Though defeated, the peasants exemplified the courage of oppressed people which Kollwitz saw as pertinent to conditions in Germany at the time.

The seven plates of the series follow sequentially the causes of the war, preparations, and defeat. The first print completed was *Outbreak,* which Kollwitz submitted to the Verbindung für historische Kunst (Society for Historical Art). On the basis of that print, the organization then commissioned the series and published and distributed it to its members in 1908.

Kollwitz was an excellent draftsman who developed her prints from numerous preparatory drawings. She was also a master printmaker, employing a wide range of innovative techniques for altering tones and textures. *Sharpening the Scythe,* for example, is the result of at least six preparatory drawings and twelve states. The position of the woman's right hand, of critical importance to Kollwitz, was altered both in drawings and in the plate before the final positioning. The dark, shadowed area around the woman's head and arms was steadily darkened until the final state resulted in a successful concentration of face and hands pressed against the scythe as if seen by candlelight.

Preliminary studies for *The Prisoners* show that Kollwitz's younger son, Peter, was the model for the boy slumped against the rope, center right.

LA

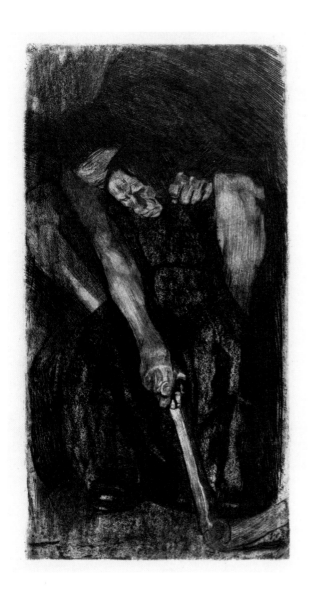

19. *Inspiration*, 1905

Etching and softground on wove paper
56.8 x 29.4cm
Unsigned
Edition: unknown
Klipstein 91, state V/IX
Provenance: Littmann Collection
Vivian and Gordon Gilkey Graphic Arts Collection 86.13.478

Kollwitz worked on the plate for *Inspiration* concurrently with *Sharpening the Scythe* (plate 16). Although both plates were developed from the same preparatory drawings and fall within the same general context, this work was not included in *The Peasant's War* cycle. The figure behind the woman represents the "inspiration" that helps her lift the burden of her life, which is represented by the heavy, axe-like tool.

LA

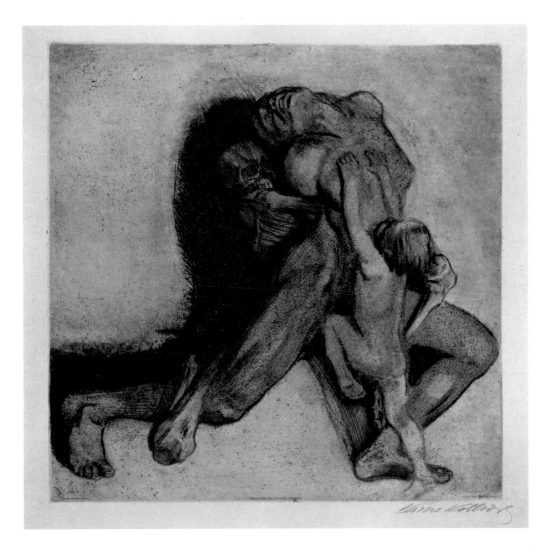

20. *Tod und Frau* (Death and Woman), 1910

Aquatint and softground etching on heavy wove paper
44.2 x 43.6cm
Signed in pencil, l.r., Käthe Kollwitz; annotated in plate, l.l., Orig Rad
von Käte Kollwitz; l.c., VERLAG VON EMIL RICHTER DRESDEN; l.r.,
Druck v.o. Felsing Berlin-Chlttbg
Edition: unknown
Klipstein 103, state VII/VIII, artist's proof
Provenance: Littmann Collection
Vivian and Gordon Gilkey Graphic Arts Collection G6894

Using a medieval iconographic conception, Kollwitz
shows Death as a skeleton wrenching the woman from
her terrified child. The upward thrust of the figures
heightens the drama of the woman's effort to pull herself
away from the grip of Death, who inhabits the dark
shadows. Death as the enemy of young life but the
companion of old age is a central theme in Kollwitz's
oeuvre.

The thick lines and concentrated tonal areas demon-
strate Kollwitz's expertise in etching. The contours have
a softness usually associated with lithography but
achieved here with aquatint and softground.

LA

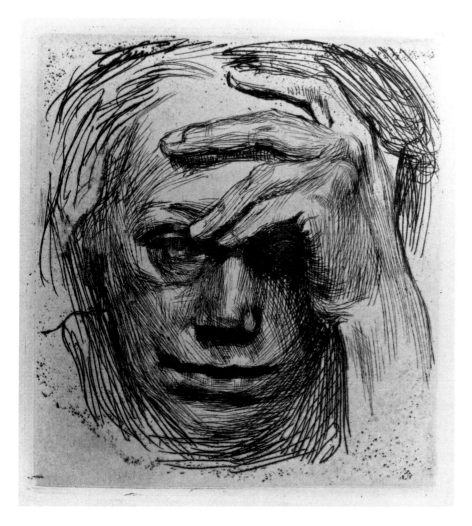

21. *Selbstbildnis mit der Hand an der Stirn* (Self-Portrait with Hand on Forehead), 1910

Etching on heavy wove paper
15 x 13.4cm
Unsigned; annotated in plate, l.c., Selbstbildnis, Radiert von Käthe Kollwitz/Unvollendete Platte
Klipstein 106, IIb/IV
Edition: unknown
Provenance: Gerd Rosen, Berlin
Vivian and Gordon Gilkey Graphic Arts Collection 80.122.426

Printed from an unfinished plate, this self-portrait at age 43 was published in *Zeitschrift für bildende Kunst* (Magazine for the Arts). The drawing style is more spontaneous and linear than that usually seen in Kollwitz's work. Already recognized as an artist of the first rank, she portrays herself as serious and confident. The position of the hand on her forehead suggests the important relationship between the artist's mind and hand.

LA

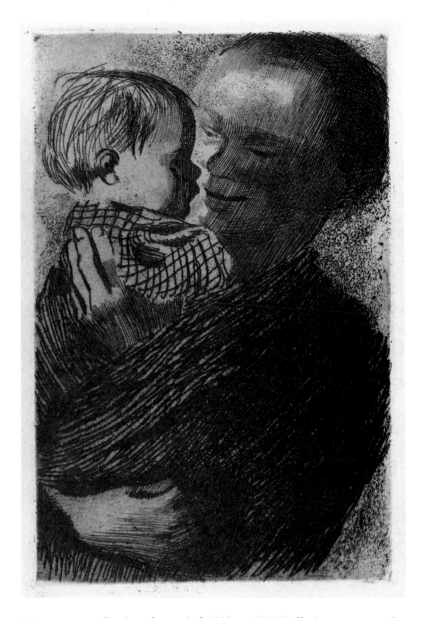

22. *Mutter mit Kind auf dem Arm* (Mother with Child in her Arms), 1910

Etching on wove paper
19.4 x 12.5cm
Unsigned
Edition: unknown
Klipstein 110, III/IV
Provenance: Hanna Bekker vom Rath, Frankfurt am Main
Vivian and Gordon Gilkey Graphic Arts Collection 80.122.421

During the period 1908 to 1911 Kollwitz was a regular contributor to the weekly newspaper *Simplicissimus*. Her drawings from this time show an increasing focus on social problems and the primacy of family life. Although most of her subjects concern adversity and suffering, some are studies of familial happiness. Here, the mother's love and pleasure in her child are conveyed by the enveloping arms and hands, her smile, and the close proximity of the heads.

LA

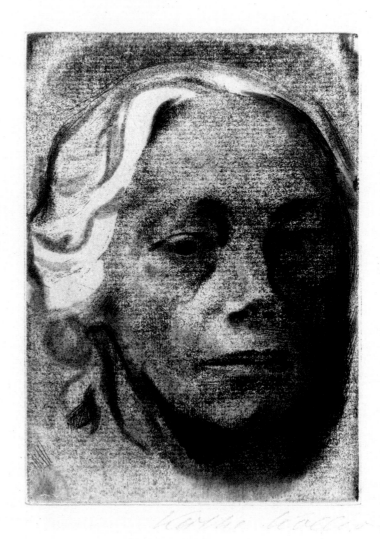

23. *Selbstbildnis* **(Self-Portrait), 1912**

Etching and softground on heavy wove paper
14 x 9.9cm
Signed in pencil, l.r., Käthe Kollwitz
Klipstein 122, VII(b)/VII
Edition: unknown
Provenance: Hanna Bekker vom Rath, Frankfurt am Main
Vivian and Gordon Gilkey Graphic Arts Collection 86.13.474

At age 47 Kollwitz appears as a maturing woman, unidealized but confident and serene. This softly shadowed, textured self-portrait was published as the frontispiece for *Die Radierungen und Steindrucke von Käthe Kollwitz* (The Etchings and Lithographs of Käthe Kollwitz) by Johannes Sievers, 1913, a catalogue of her work to that date.

LA

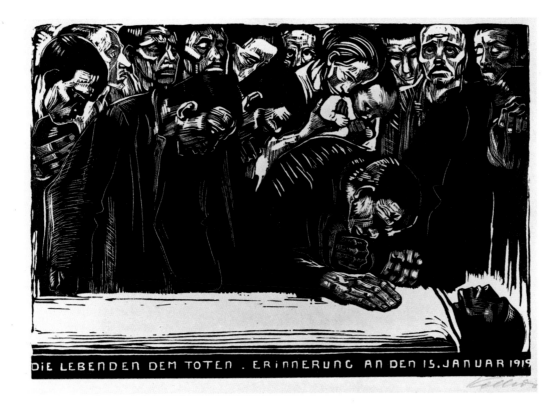

24. *Gedenkblatt für Karl Liebknecht* (Memorial for Karl Liebknecht), 1919/20

Woodcut on wove paper
35.7 x 50.2cm
Signed in pencil, l.r., Kollwitz
Edition: 100
Klipstein 139, IV(a)/IV
Provenance: Gerd Rosen, Berlin
Vivian and Gordon Gilkey Graphic Arts Collection 86.13.488

Karl Liebknecht was a leader of the radical political group, the Spartacists. Along with another leader, Rosa Luxemberg, he was assassinated on January 15, 1919. Liebknecht's family asked Kollwitz to do a portrait of him, a commission she was at first reluctant to accept because she did not share the radicalism of the Spartacists. After visiting the morgue where Liebknecht's body lay and observing the profound grief of the throngs of workers who were in attendance, however, she was persuaded to accede to the family's request. She later wrote in her journal:

> I have as an artist the right to extract from everything its content of feeling, to let it take effect on me and to express this outwardly. Thus, I also have the right to portray the workers taking their farewell of Liebknecht and even to dedicate it to them without thereby being a follower of Liebknecht in a political sense. Or not?

This was a period of artistic uncertainty for Kollwitz. She made many preliminary drawings for the portrait but was unable to produce an etching or lithograph that satisfied her. After seeing an exhibition that included woodcuts by Ernst Barlach, she was inspired by their distilled power to try that medium, and soon completed the woodcut that became the memorial. It was published initially in a numbered edition of 100, and, in 1920, in an unlimited edition at a very low price.

The caption, "Die Lebenden dem Toten" (The Living to the Dead), is an inversion of the title of a famous poem, "The Dead to the Living," by Ferdinand Freiligrath. The notation, "Erinnerung an den 15 Januar 1919" (Remembrance of 15 January 1919), and the caption are carved into the block in the manner of medieval casket decoration. Although the composition is comparable to a lamentation of Christ, it also calls to mind Jacques-Louis David's *Marat* in which another popular hero is shown assassinated. These historical references combined with Kollwitz's strong personal response to the event make this a particularly powerful graphic statement.

LA

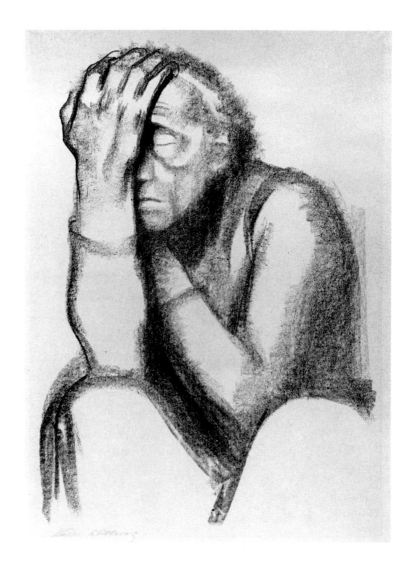

25. *Nachdenkende Frau* (Thinking Woman), 1920

Lithograph on gray wove paper
53.8 x 37cm
Signed in pencil, l.l., Käthe Kollwitz
Edition: unknown
Klipstein 147, II(a)/II
Provenance: Hanna Bekker vom Rath, Frankfurt am Main
Vivian and Gordon Gilkey Graphic Arts Collection G6900

Another example of Kollwitz's long involvement with the subject of burdened, working women, *Thinking Woman* is rendered simply and compactly with emphasis on volume and monumentality. The soft gray tonal areas were achieved by drawing with the side of the litho crayon rather than the tip.

Thinking Woman is related to studies for a sculpture used as the gravestone for the artist's parents.

LA

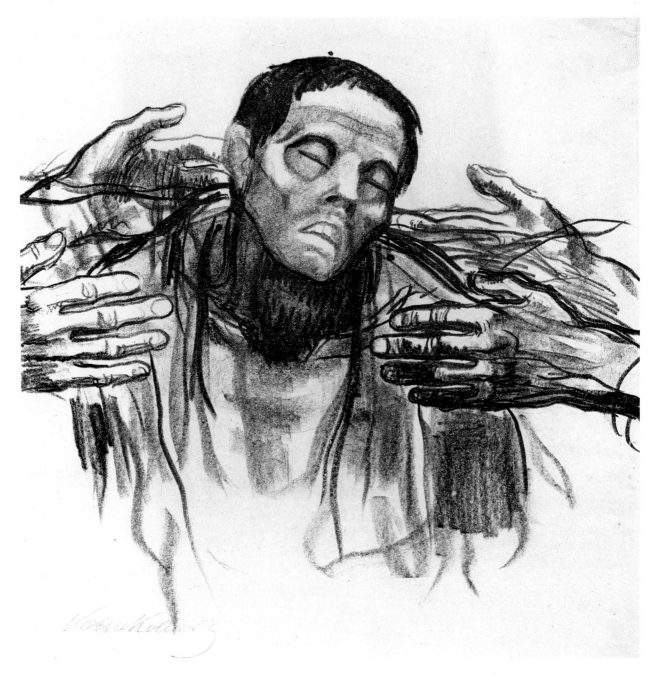

26. *Helft Russland* (Help Russia), 1921

Lithograph on thin wove paper
42 x 47cm
Signed in pencil, l.l., Käthe Kollwitz
Edition: unknown
Klipstein 154, II/III
Provenance: Littmann Collection
Helen Thurston Ayer fund 52.158

Kollwitz was outspoken in her support of the rights of people of all nations to peaceful self-betterment. This figure of the emaciated young man with helping hands reaching toward him was designed for a poster appealing for aid to famine relief efforts in the struggling new nation, the Soviet Union. The first state included the text "Helft Russland" above the figure and below him, "Komite [sic] für Arbeiterhilfe: Berlin Rosenthalerstr. 38." The text was subsequently removed.

LA

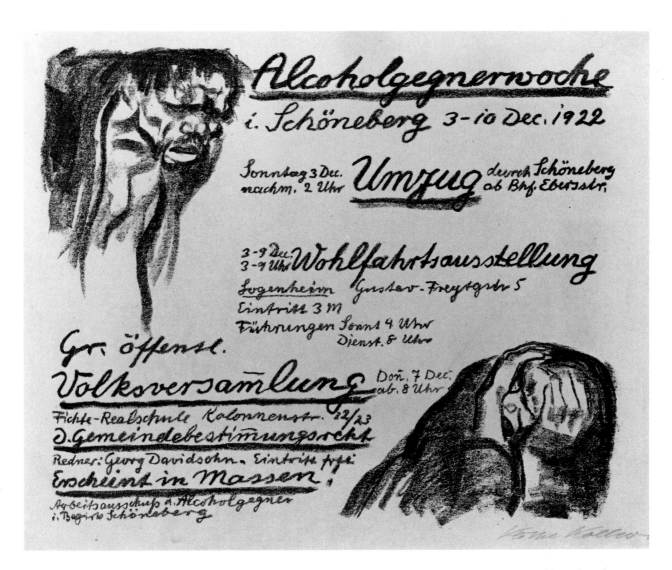

27. *Alcoholgegnerwoche (Anti-Alcohol Week),* 1923

Lithograph on laid paper
34 x 40.5cm
Signed in pencil, l.r., Käthe Kollwitz
Edition: unknown
Klipstein 165, I(a)/I
Provenance: Littmann Collection
Vivian and Gordon Gilkey Graphic Arts Collection G6899

Although she did not consider herself a political activist, Kollwitz supported causes that aided the poor, often by donating posters. She created *Anti-Alcohol Week* in response to a request by the German Good Templar's Order to participate in their public awareness campaign. The text calls on workers to support the procession, welfare exhibition, and other programs associated with the anti-alcohol week. This signed print was made before the edition on poster paper.

The positions and wretched appearance of the faces, ravaged by the effects of liquor, both frame and reinforce the message of the text.

LA

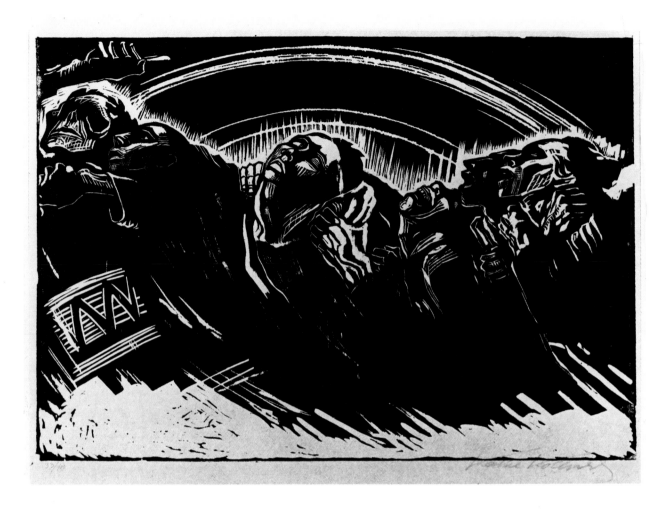

From *Sieben Holzschnitte zum Krieg* (Seven Woodcuts about War), a
portfolio of seven woodcuts (Dresden: Emil Richter, 1924)
Edition: 100

28. *Die Freiwilligen* (The Volunteers), 1922-23, plate 2

Woodcut on heavy wove paper
35 x 49.3cm
Signed in pencil, l.r., Käthe Kollwitz; numbered, l.l., 33/100
Klipstein 178, IV/IV
Provenance: unknown
Gift of Mr. Frederic Rothchild 76.38.3

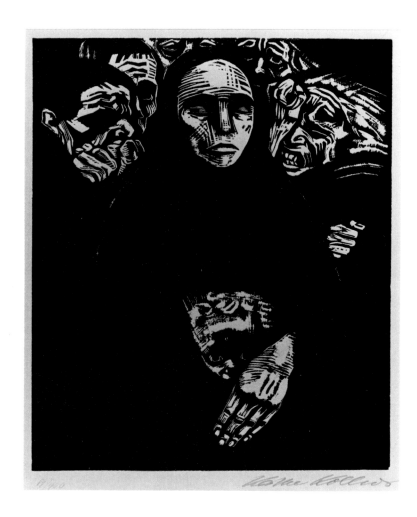

29. *Das Volk* (The People), 1922-23, plate 7

Woodcut on wove paper
35.8 x 30cm
Signed in pencil, l.r., Käthe Kollwitz; numbered, l.l., 89/100
Klipstein 183, V/V
Provenance: Jack Rutberg Gallery, Los Angeles
Gift of Harold and Judy Hummelt 81.117

With the death of her son Peter in October 1914, Kollwitz began to contemplate images that would adequately express the depth of her grief. As the war ground on she struggled to find a theme that would encompass the fuller tragedy of the times. The subject that she finally chose, the effects of war on its innocent victims, as well as the resilience and solidarity of the German common people, synthesized her lifelong humanitarian concerns into the seven compelling woodcut images comprising *Seven Woodcuts about War.*

After experimenting in etching and lithography, Kollwitz turned again to woodcut, the medium in which she recently had found a new boldness of expression. She used its stark contrasts of black and white to condense and dramatize to the fullest the anguish of war. The sharp, minimal cuts that release the image from the heavy black area, the reduced composition, expressive faces and prominent hands all contribute to the prints' focused, powerful impact. *War* was a fervently felt anti-war expression, one of the strongest of its epoch.

In *The Volunteers* Kollwitz pictures the drummer, Death, gathering up the stunned and wounded patriots who are volunteers for Death's army. The central figure in *The People* shields a small child with her hand. It is mothers, Kollwitz seems to say, who must guard the future against the horrors of war.

LA

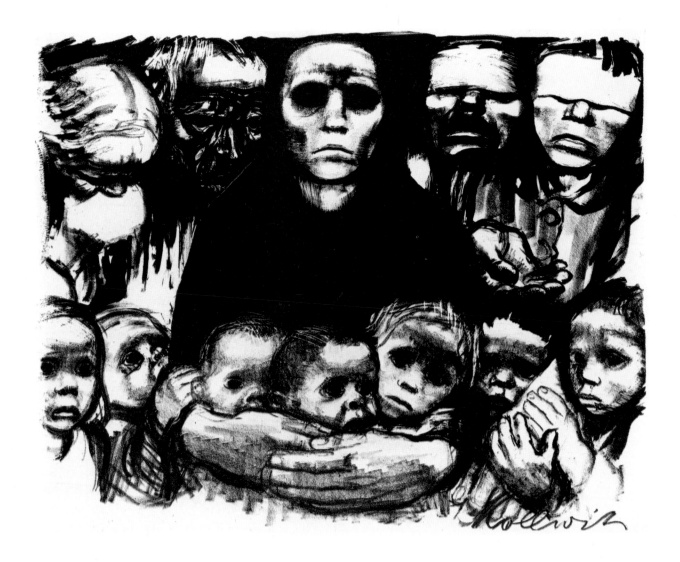

30. *Die Überlebenden* (The Survivors), 1923

Lithograph on thin wove paper
58.5 x 69.5cm
Signed in the stone, l.r., Kollwitz
Edition: unknown
Klipstein 184, I/III, trial proof
Provenance: Hanna Bekker vom Rath, Frankfurt am Main
Vivian and Gordon Gilkey Graphic Arts Collection G7536

The International Association of Labor Unions in
Amsterdam commissioned Kollwitz to create a poster
for its anti-war day, 21 September 1924. A committed
pacifist, she complied by offering this print, to which
text was added. The poster reads: "Die Überlebenden—
Krieg dem Kriege!" (Survivors — Make War on War!).
The Museum's trial proof is one of the very few prints
pulled before the poster edition.

LA

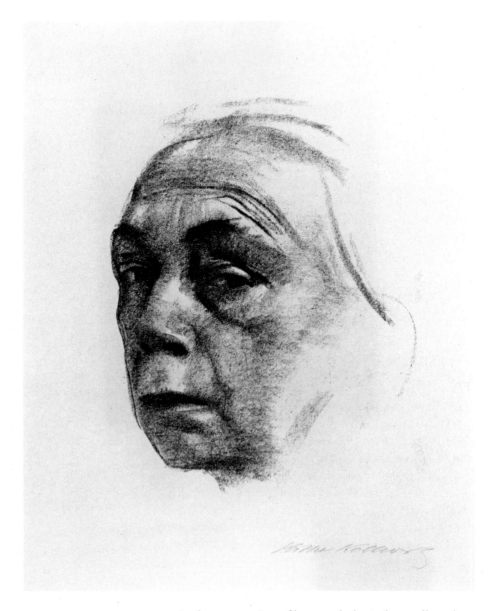

31. *Selbstbildnis* (Self-Portrait), 1924

Transfer lithograph on thin wove paper
29.8 x 22.5cm
Signed in pencil, l.r., Käthe Kollwitz
Edition: 100
Klipstein 198, I(b)/I
Provenance: Gerd Rosen, Berlin
Vivian and Gordon Gilkey Graphic Arts Collection 80.122.526

As documentation of her psychological as well as physical passage from youth to old age, Kollwitz's 84 self-portraits (in drawings, prints, and sculpture) consistently reveal her as a thoughtful, intelligent, and serious-minded woman. Pictured here at age 57, her features affected by age and sorrow, she has a vitality and presence that is haunting in its palpability. Through the elimination of all background and most details including hair, the drawing becomes a distillation of the artist's character into a simple, yet powerful statement.

Generally recognized as one of the finest of the later self-portraits, the original transfer drawing for the plate is in the National Gallery, Washington, D.C.

LA

ERNST BARLACH 1870-1938

Ernst Barlach was born in 1870 in the small north German town, Wedel, in Holstein. Although he studied art in Dresden and Paris, traveled to Florence, and lived in Berlin, he was a reclusive man and lived most of his life in the obscure provincial towns of his homeland.

Primarily known as a sculptor, Barlach also excelled as a draftsman, printmaker, and playwright. His creativity, inspired by the work of Gothic woodcarvers and a seminal trip to Russia in 1906, was fueled by a desire to understand "the problems of the meaning of life." Whichever the medium, his work is characterized by a combination of religious mysticism and worldly sorrow.

Because of his emphasis on the inner, metaphysical world of the imagination, Barlach is often linked with the Expressionists. However, his adherence to classic rules of composition and restrained eloquence connect him to his own, earlier generation.

Barlach's graphic oeuvre of almost 300 woodcuts and lithographs was produced primarily between 1910 and 1930. Paul Cassirer, a leading dealer in Berlin and Barlach's patron, is credited with having first encouraged him to make prints in connection with the publication of his first play, *Dead Day,* in 1912. Over half of Barlach's subsequent printed work consists of illustrations pertaining to his own plays or to poetic works by Goethe and Schiller.

Barlach enjoyed a brief period of success before he was targeted by the Nazis. He died in 1938, the year after a total ban was declared on his work.

MP

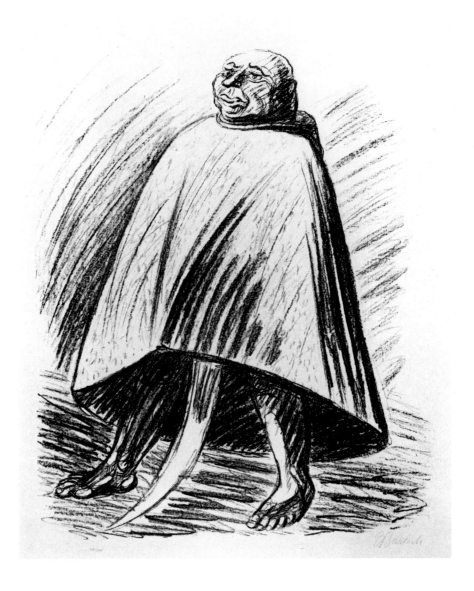

32. *Der Henker* (The Executioner), 1922

From *Die Ausgestossenen* (The Outcasts), a series of eight lithographs
(Berlin: Paul Cassirer, 1922)
Transfer lithograph on laid paper
52.2 x 42cm
Signed in pencil, l.l., E Barlach; numbered, l.r., 38/104
Edition: 104 on Bütten
Schult 197
Provenance: Gerd Rosen, Berlin
Vivian and Gordon Gilkey Graphic Arts Collection 80.122.524

The Executioner is part of a loosely organized series of eight prints by Barlach published under the title of *The Outcasts*. Like his sculptural work which consists primarily of human archetypes *(The Wanderer, The Dancer, The Dreamer, The Doubter),* this series features figure types ranging from the handicapped and the hungry to raging prophets and pregnant girls. Barlach's goal was to give tangible form to the human soul; his focus on human suffering reflects his awareness of man's spiritual struggles.

As in Gothic sculpture, Barlach's figures typically are concealed under loose clothing and expressions are conveyed primarily by the face and hands. In the case of *The Executioner,* the figure's broad stance suggests a stoical attitude that contradicts his anxious expression. The executioner, trapped within the solid sheath of his cape, is, like most of Barlach's characters, a prisoner of his own fate.

MP

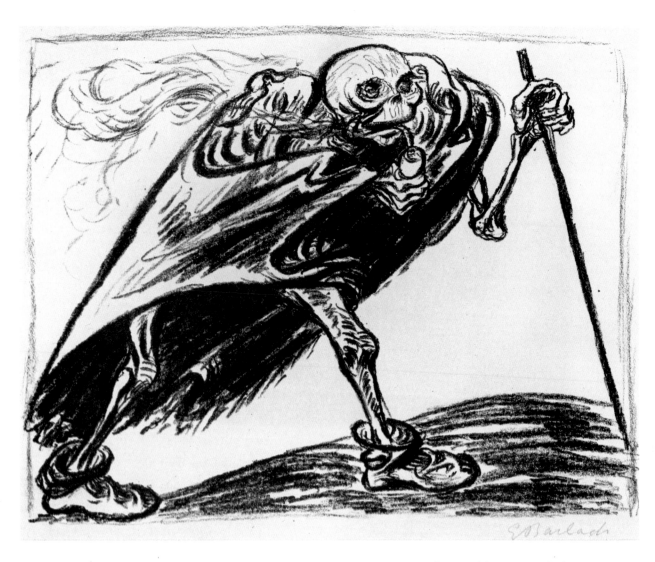

33. *Wandernder Tod* (Wandering Death), 1923

From *Arno Holz zum sechzigsten Geburtstage gewidmet von deutschen Künstlern* (Dedicated to Arno Holz on his Sixtieth Birthday by German Artists), a portfolio of 30 original prints by various artists (Berlin: Fritz Gurlitt, 1923)
Transfer lithograph on wove paper
27.4 x 34.5cm
Signed in pencil, l.r., E Barlach
Edition: 100 numbered portfolios, 30 others
Schult 225
Provenance: Hanna Bekker vom Rath, Frankfurt am Main
Vivian and Gordon Gilkey Graphic Arts Collection 82.80.216

For many years after World War I, Barlach attempted to come to terms with the violence and suffering of the war and post-war years. A number of his images form a part of a tradition that was revitalized by the war and that had its origin with the Black Plague of the late Middle Ages. The medieval "Dance of Death," featuring skeletons posturing as living beings, served to remind humanity of its mortality and to encourage it to lead a better life. Barlach's image, however, does not exhort, but rather criticizes indirectly the policies that led to war and unleashed Death to stalk the land. In another image titled *The Victor*, he makes it clear that in war, Death is the only victor.

MP

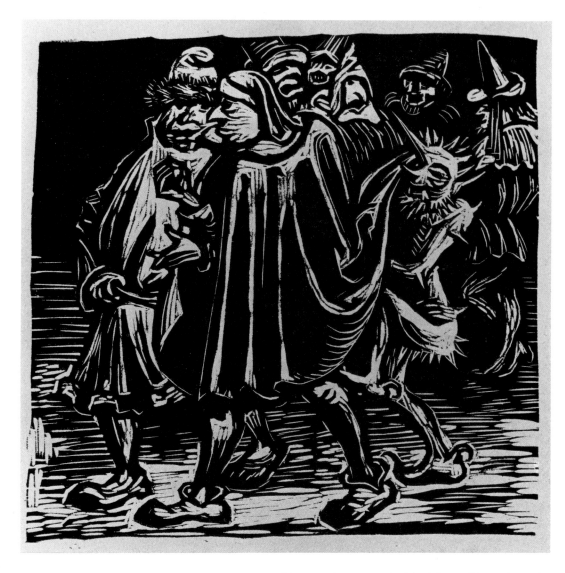

34. *Der Proktophantasmist und Anderes Gelichter* **(The Proctophantasmiac and Other Riffraff), 1923**

From *Walpurgisnacht*, a book with 20 woodcut
illustrations to poetry by Goethe (Berlin: Paul Cassirer, 1923)
Woodcut on wove paper
12.8 x 13cm
Unsigned
Edition: 120 signed and numbered on Bütten, deluxe portfolio edition
on Japan, unknown edition on Bütten printed from zinc plates
Schult 221
Provenance: unknown
Gift of John Mincks 83.4.1

Attracted by its authority and directness, Barlach gave himself wholly to the woodcut medium after the war. Unlike his lithographs, which were for the most part drawn on transfer paper and then transferred either to a stone or a zinc plate by a professional printer, Barlach carved his woodcuts into the block himself. Applying his expertise as a woodcarver, he took up this traditional form and adapted it to serve his own modern sensibility.

The Proctophantasmiac and Other Riffraff illustrates a scene from the first part of Faust in which Mephistopheles transports Faust to a witches' Sabbath (Walpurgisnacht). Goethe's Proctophantasmiac is modeled after one of his critics who had leeches applied to his posterior to rid himself of ghosts. Barlach's own affinity with the Gothic sensibility finds a suitable vehicle in the fantastic subject and earthy humor of Goethe's poem. His woodcut illustrations for *Walpurgisnacht* and other classics of German literature have been described as "among the works of genius in Expressionist book art" (Reed, p.121).

MP

KARL HOFER 1878-1955

Karl Johannes Christian Hofer was born in Karlsruhe in 1878. His father, an oboist with a military band, died shortly after his birth and he was sent to live with two elderly great-aunts. Hofer lived with them for nearly eleven years until they retired to an old age home. He was sent to an orphanage and later apprenticed to a publishing house. After developing an interest in drawing, Hofer enrolled at the Karlsruhe Academy in 1892.

Hofer spent a year in Paris in 1900, then resumed his studies in Karlsruhe, and later, in Stuttgart. Under the sponsorship of the Swiss patron, Dr. Theodor Reinhart, he traveled to Rome where, from 1903 to 1908, he absorbed the lessons of classicism. For the next five years Hofer lived in Paris where he was influenced by Cézanne and by Picasso's early Cubist paintings. He returned to Germany in 1913 but was caught by the outbreak of war while visiting in France. He spent most of World War I in an internment camp until released as an exchange prisoner in 1917. After the war he was appointed to the Berlin Academy and to the faculty of the Berlin College of Fine Arts.

An early, outspoken opponent of National Socialism, Hofer became a target of the Nazis. He was dismissed from his teaching positions and included in the infamous "Degenerate Art" exhibition. Hofer's home and studio, including most of his life's work, were destroyed in air raids during World War II.

After the Second World War, Hofer was an active participant in Berlin's cultural regeneration. The artist turned again to favored themes, resumed his teaching responsibilities, organized exhibitions and helped found art journals. Hofer produced over 250 prints during his lifetime: 17 woodcuts, 69 etchings and 190 lithographs.

ESD

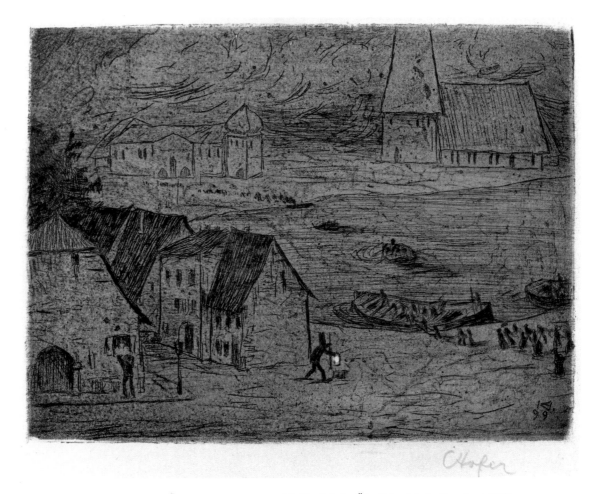

35. *Nächtliche Überfahrt* (Night Crossing), 1899

Etching and drypoint on wove paper
13.2 x 17.2cm
Signed in pencil, l.r., Hofer; signed and dated in the plate, l.r., KH/99
Edition: unknown
Hofer R3, II/II
Provenance: Joseph Anthony Horne Collection
Vivian and Gordon Gilkey Graphic Arts Collection 82.80.122

Hofer's early work, such as *Night Crossing,* shows the influence of Edvard Munch, Hieronymus Bosch, and Francesco Goya in its preoccupation with nocturnal images of isolation and despair. Recalling childhood memories of village landscapes, Hofer created a damp and foggy atmosphere with the use of foul biting and heavy plate tone. The nightwatchman's lantern, burnished and wiped clean, relieves an otherwise bleak image and brings a focus to the composition. As in other images from this period, Hofer concentrates on the melancholy and detachment of the figures, mirroring his own isolation.

ESD

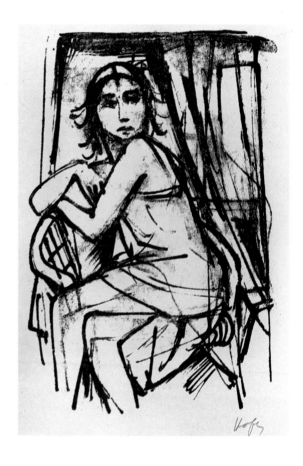

36. *Liebesgedichte* **(Love Poems), 1922**

Book of 12 lithographs
Poetry by Adolf von Hatzfeld
(Frankfurt am Main: Galerie Alfred Flechtheim, 1922)
Edition: 53/125
Provenance: Littmann Collection
Helen Thurston Ayer Fund 59.11

Untitled #9, 1922
Lithograph on wove paper
22 x 14.5cm
Signed in pencil, l.r., Hofer
Hofer L152

Untitled #11, 1922
Lithograph on wove paper
20.5 x 15.7cm
Signed in pencil, l.r., Hofer
Hofer L154

Shortly after his appointment to the Berlin Academy and the Berlin College of Fine Arts in 1919 and 1920 respectively, Hofer entered a period of great productivity. The prints from *Love Poems*, originally printed in the popular artist's journal, *Der Querschnitt* (The Cross-Section), are a product of this fruitful time.

Although the untitled images of seated women reflect to some degree the influence of Picasso and De Chirico, the prevailing impression is of the romantic classicism for which Hofer is best known. Inhabiting a strictly defined picture plane, these self-contained, emotionally aloof women recall figures carved on classical marble grave stele.

The prevalence of single figures in Hofer's imagery and his cool, classicizing style reflect an emotional detachment that can be traced to his youth. As an adult, Hofer deliberately withdrew from the avant-garde mainstream and led a carefully guarded private life.

ESD

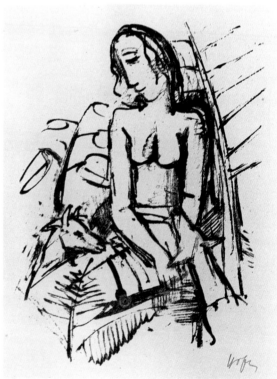

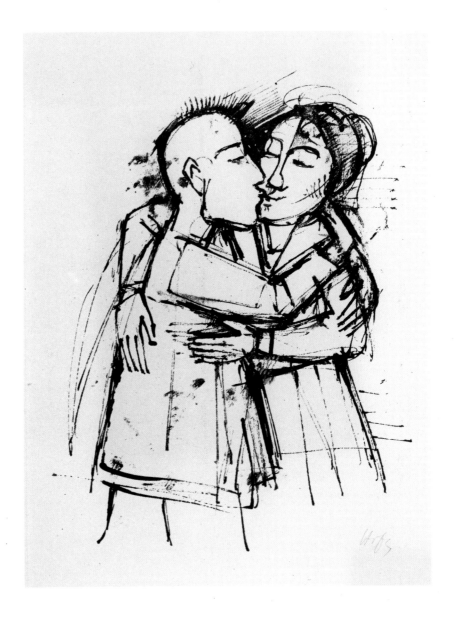

37. *Liebespaar I* **(The Lovers I), c. 1923**

Lithograph on laid paper
30.5 x 23cm
Signed in pencil, l.r., Hofer; numbered, l.l., 15/100
Edition: 100
Hofer L23
Provenance: The artist
Vivian and Gordon Gilkey Graphic Arts Collection 80.122.435

The image of *The Lovers* is one of a number of embracing couples in Hofer's oeuvre. It was printed around 1923 and represents the height of his involvement with Cubist-derived structures. Set in an undefined space, the figures' underlying geometric forms are emphasized with bold, crudely drawn lines.

Hofer once expressed the desire to depict the "essential humanity" of his subjects. In his view this essence included the inability to fully give and receive. Perhaps for this reason the embrace of Hofer's couple seems related more to ritual than to passion, calling to mind the work of 15th century masters such as Giotto and Masaccio.

ESD

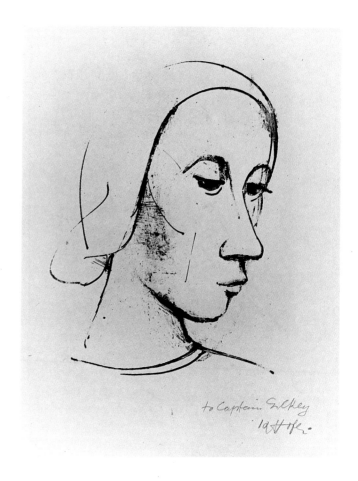

38. *Mädchen Bildnis* (Head of a Girl), 1946

Lithograph on heavy wove paper
23 x 16.5cm
Dedicated and signed in pencil, l.r., to Captain Gilkey/ K Hofer
Verso: *Young Girls*, c.1947, lithograph, crossed out with blue pencil
Edition: unknown
Hofer- not listed
Provenance: The artist
Vivian and Gordon Gilkey Graphic Arts Collection 83.57.85

Head of a Girl is representative of Hofer's post-World War II compositions. Inspired by modernist abstraction and classical ideals, it is typically spare and tersely drawn. Hofer's strong outline of the face and bare delineation of the head create the suggestion of a mask. A metaphor for man's inability to confront himself, the mask is a recurring motif in Hofer's work.

Hofer's creation of this print coincided with the restoration of his reputation after the Nazi's defeat and his reappointment as the Director of the Berlin College of Fine Arts. The Municipal Council of Berlin sponsored a major exhibition of his work in October 1946.

ESD

Oskar Kokoschka, like Ernst Barlach and Wassily Kandinsky, was a significant writer and playwright in addition to being a painter and graphic artist. Born to Czech and Austrian parents in a small Austrian town, he moved with his family to Vienna in 1887. He received a scholarship to attend the School of Applied Arts in 1907, and while still a student, became a member of the Wiener Werkstätte, the modernist design workshops run by the architect, Josef Hoffmann. His earliest work was influenced by Jugendstil artist Gustav Klimt, but his style began to shift soon after he graduated in 1909. Impressed by an exhibition of paintings by Van Gogh, Kokoschka began to develop a more emotionally expressive style particularly evident in his soul-baring portraits. In 1910 he moved to Berlin where his reputation became established through reproductions in *Der Sturm* (The Storm) and exhibitions at Paul Cassirer's and elsewhere.

At the outbreak of World War I, Kokoschka volunteered for military service and was seriously wounded in 1915. He moved to Dresden in 1917, and for many years struggled with the physical and psychological effects of his injuries. After the war he continued to receive recognition; in 1919 he was appointed professor at the Academy of Fine Arts and was the subject of a comprehensive monograph by Paul Westheim. In 1924 he left Dresden and began nearly ten years of travels through Europe and North Africa, supported by an annual salary from Paul Cassirer. Political developments in Germany prompted him to move to Prague in 1934 where he met his future wife, Olda. When Nazi troops occupied Czechoslovakia in 1938, they fled to London. During the war years Kokoschka was active in émigré organizations, becoming president of the Freie Deutsche Kulturbund (Free German Cultural League) in 1943.

Approximately one-third of Kokoschka's oeuvre of 567 prints were made between 1906 and 1923. Most of the others were made after World War II, primarily in Switzerland where he lived from 1953 until his death in 1980. Although he was a great draftsman, Kokoschka was not an innovative printmaker; nearly all of his prints are transfer lithographs.

ESD/MP

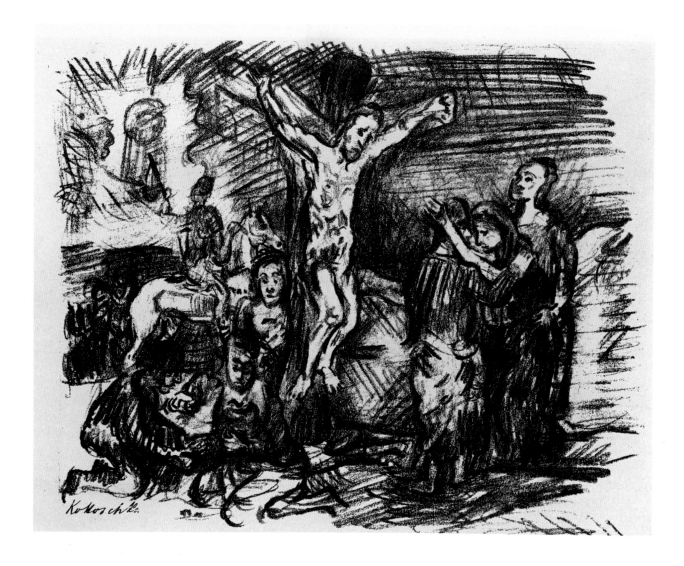

39. *Christus am Kreuz* (The Crucifixion), 1916

From *Der Bildermann* (The Pictureman) 1, no. 12 (Berlin: Paul Cassirer, 1916)
Transfer lithograph on grey heavy wove paper
26.3 x 30.5cm
Signed in the stone, l.l., Kokoschka
Edition: 50 signed, unknown number unsigned and published in book form
Wingler 80
Provenance: Gerd Rosen, Berlin
Vivian and Gordon Gilkey Graphic Arts Collection 81.81.440

Following his discharge from the army in 1916, where he served first in the cavalry and then on the Isonzo Front in Italy as a war artist, Kokoschka began a series of six lithographs of the Passion for Paul Cassirer's war-time journal and yearbook, *Der Bildermann* (The Pictureman).

Like other artists of the day, Kokoschka's exploration of Biblical themes was an attempt to make sense of the horror of the First World War. Using the cruelty and suffering of the Passion as a metaphor for the inhumanity of war, he underscores the tragedy by setting the event during a total eclipse of the sun (upper left). Kokoschka's Old and New Testament scenes, such as the Passion and the Job series from the same year, share not only the motif of human suffering, but also an implicit affirmation of faith.

ESD

12·8·18

40. *Gustav Kokoschka, Der Vater des Künstlers* (Gustav Kokoschka, the Father of the Artist), 1918

Transfer lithograph on wove paper
55.3 x 47.2cm
Signed in pencil, l.r., O Kokoschka; dated in the stone, u.r., 12-8-18
Edition: 25 Japan paper, 50 Bütten
Wingler 128
Provenance: Günther Franke, Munich
Vivian and Gordon Gilkey Graphic Arts Collection G6605

After graduating from the School of Applied Arts in 1909, Kokoschka supported himself as a portrait painter, depicting many of the leading Viennese intellectuals of the day. Influenced by the work of Van Gogh, which he saw exhibited that summer, his portraits were usually half or three-quarter length figures, seated against stark backgrounds and depicted full face or three-quarter view. Later called "*the* great painter of rootless 'modern man'"

(Tate Gallery, p.7), Kokoschka found a precedent for his psychologically rich portraits in the nervous intensity and deep humanity of Van Gogh's work.

With few exceptions, Kokoschka did not make portrait prints until he moved to Dresden in 1917. Supported by a lucrative contract with the art dealer Paul Cassirer, he created nearly fifty lithographic portraits in the next seven years. These were not commissions but were personal portraits of people with whom he had a private or artistic relationship, many of whom he had met as a convalescent in the sanatorium or in the theater and art circles. He drew the portrait of Gustav Kokoschka during a visit to Dresden by his father and sister, Berta, in July 1918.

ESD/MP

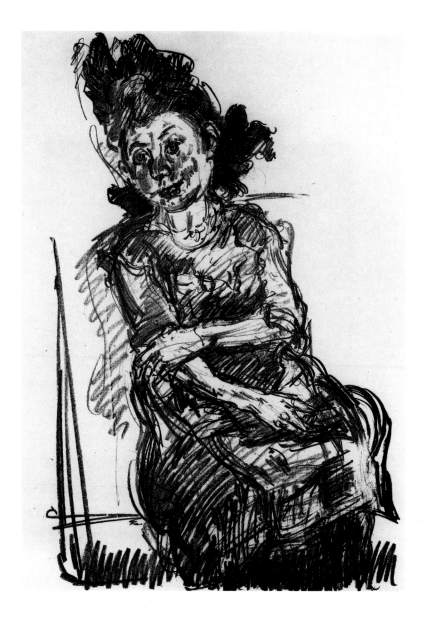

41. *Sitzendes Mädchen* (Sitting Girl), 1919

Tranfer lithograph on thin laid paper
71 x 45cm
Signed in pencil, l.r., Oskar Kokoschka
Edition: 25 on Japan, 50 on Bütten
Wingler 137
Provenance: Charles Heaney Collection
Gift of Mony Dimitre to the Vivian and Gordon Gilkey Graphic Arts
Collection 85.87.88

Sitting Girl is one of a group of portraits Kokoschka created during his Dresden years (1917–1923). Unusual in its nearly full-length format, it is typical in that the sitter appears unconscious of the artist's presence, gazing off distractedly, lost in her own thoughts. This attitude of self-absorption reaches a climax in the series *The Concert* of the following year that features a young woman in various half-length poses listening to music. While Kokoschka usually relies on slight inflections of the face or hands to convey the psychology of the sitter, he uses a broader body language — the tilt of her head and shy grasping of the arm — to convey the self-conscious timidity of the seated girl.

ESD/MP

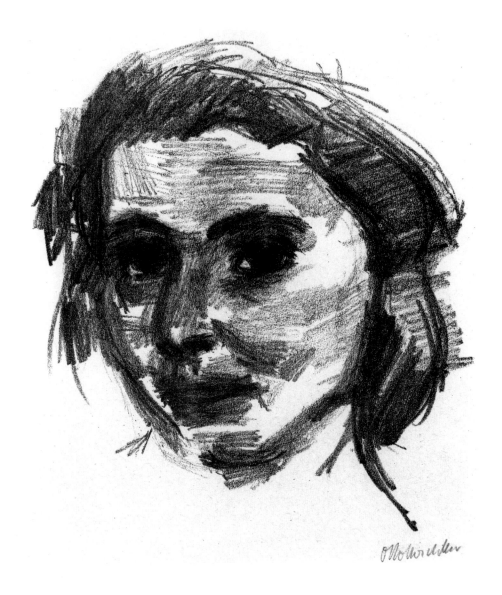

42. Mädchenkopf (Head of a Girl), 1922

From *Neue europäische Graphik-Fünfte Mappe: Deutscher Künstler*
(Fifth Portfolio of New European Graphics: German Artists) (Potsdam:
Müller & Co., 1923), plate 7
Transfer lithograph on wove paper
30.3 x 27 cm
Signed in pencil, l.r., O Kokoschka; printers dry stamp, l.l.
Edition: 10 on Japan, 99 on Bütten; XX on Japan, other unnumbered,
unsigned copies
Wingler 152
Provenance: Wehye Gallery, New York
Gift of Mrs. Paul Feldenheimer 40.21

Head of a Girl is part of a Bauhaus portfolio featuring
German artists. Planned for the fall of 1921, publication
was delayed until 1923. Kokoschka's inclusion in the
portfolio was one of many honors he received in these

years, including his own exhibition room at the Venice
Biennale in 1922.

One of the seven portraits of young women
Kokoschka made in 1922, *Head of a Girl* features a dark-
eyed, full-lipped girl, who, unlike most of his sitters,
looks directly at the viewer. Strikingly compact, her head
fills the full frame with its vital presence. With works
such as this, the development of Kokoschka's graphic
work had reached a peak. In the following year, 1923, he
asked for an unpaid leave from his teaching at the Dres-
den Academy in order to travel and seek new experi-
ences. When he left Dresden, the series of great portrait
lithographs ended and his graphic work underwent a
long hiatus.

ESD/MP

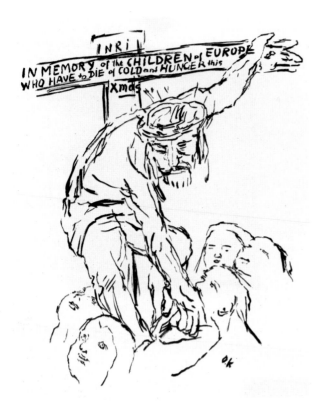

43. *Christus hilft den hungernden Kindern* (Christ Helps the Hungry Children), 1945

Lithograph on thin wove paper (possibly photolithograph)
61 x 48.2cm
Signed in the stone, l.r., O.K.; printed, l.r., The Baynard Press,
London .S.W.9.
Edition: unknown, 500 posters
Wingler 180
Provenance: The artist
Gift of the artist 46.17

Concerned about the impending crisis of World War II and branded a "degenerate artist" by the Nazis, Kokoschka left Europe and settled in London in 1938. Firmly committed to anti-Fascist and anti-war activities, Kokoschka utilized his printmaking abilities and limited financial resources to support his political and social causes. In December 1945 he produced and published *Christ Helps the Hungry Children*. Based on a Baroque statue from London's Charles Bridge by Matthias Braun, the scene represents Christ reaching down from his cross to help the masses. In contrast to the long, fluid crayon lines of his earlier work, Kokoschka here uses pen and liquid tusche to create a brittle, scratchy line more in keeping with the painful subject matter.

Imprinted with the words, "INRI in memory of the children of Europe who have to die of cold and hunger this Xmas," 5,000 reproductions of this print were hung in London underground stations. At least one copy bore a note by Kokoschka stating that no national, political or charity organization was behind the effort. A Spanish edition of this poster was published in 1946.

ESD

Born near Chemnitz, Erich Heckel began studying architecture in Dresden in 1904. He was a founding member of, and the driving organizational force behind, the Brücke group. He acted as both treasurer and secretary and was primarily responsible for the group's public exhibitions and the production of the annual print portfolio.

Heckel was intrigued with the technical possibilities of the graphic media. He is best known for his woodcuts, but he had considerable interest in lithography and drypoint as well. Heckel was the first Brücke artist to abandon the decorative qualities of Jugendstil in favor of the splintery, angular appearance that became the hallmark of the group's woodcuts. Focusing on themes of melancholy, fear, and spiritual isolation, his pre-war work is characterized by sharp angles, compressed spaces, and psychological tension.

Like the other Brücke artists, Heckel left Dresden for Berlin, arriving there in 1911. The following year he and Kirchner decorated the walls and ceiling of the chapel in the Cologne Sonderbund exhibition. In 1915, he volunteered for service as a Red Cross orderly in Belgium under Dr. Walter Kasbach. An art advocate from Berlin, Kasbach encouraged Heckel and the other artists in his unit to continue with their art.

Seeking to rediscover the communal atmosphere he experienced with the Brücke, Heckel affiliated himself with two artists' groups after the war, the Arbeitsrat für Kunst (Worker's Council for Art) and the Novembergruppe (November Group). Both groups strove to overcome elitism and to make art and architecture accessible to the working class.

Heckel lost interest in graphic art in the early twenties. While nearly three-quarters of his approximately 200 etchings, 460 woodcuts, and 400 lithographs were made between 1903 and 1923, he made only a few prints from the late 20s to the early 30s. His art became increasingly decorative, losing the psychological edge of his pre-war work. Like many of his contemporaries, Heckel was denounced by the Nazi government and was forbidden to create, exhibit, or sell his work under that regime. In 1944 his Berlin studio containing all his blocks and plates was destroyed. From 1949 until he retired in 1955 he taught at the Karlsruhe Academy of Fine Arts, where he created his final group of prints.

VWH

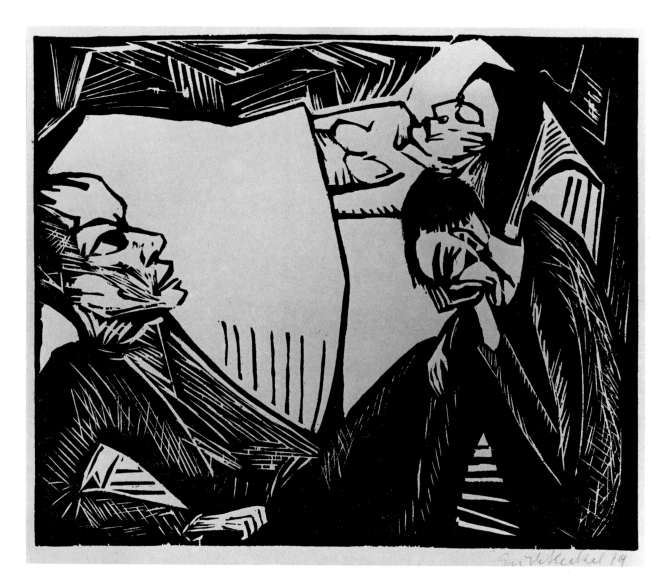

44. *Die Tote* (The Dead Woman), 1912

From *Die Schaffenden* (The Creators) II, no. 2 (Weimar: Paul Westheim, 1919)
Woodcut on wove paper
25 x 29.7cm
Signed and dated in pencil, l.r., Erich Heckel 19; publisher's blind stamp, l.l.
Edition: 100 on Bütten, 25 on Japan
Dube 247, II/II
Provenance: Littmann Collection
Vivian and Gordon Gilkey Graphic Arts Collection 80.122.450

During the first 20 years of his career, Heckel created illustrations for several literary works, beginning in 1907 with prints for Oscar Wilde's *The Ballad of Reading Gaol*. *The Dead Woman* is one of two prints he made illustrating Fyodor Dostoyevsky's *The Idiot*, a novel about madness

and murder. Although both prints portray the moment of the killer's confession of his crime of passion, *The Dead Woman* dramatically juxtaposes the stoicism of the killer with the grief of his sobbing companion. By distorting and condensing the space and exaggerating the head of the killer who directs his malevolent gaze at his victim, the composition itself expresses the unstable world of the madman. Heckel repeated these formal techniques in several other works illustrating the theme of insanity.

The Dead Woman and *Szene zu "Die Brüder Karamasow"* (Scene from "The Brothers Karamazov"), also by Heckel, were included in a special Dostoyevsky portfolio of ten prints published for *Die Schaffenden*.
VWH

45. *Junges Mädchen* (Young Girl), 1913

From *Genius*, no. 1, 1920
Woodcut on wove paper
25.8 x 17.2cm
Printed verso, l.l., Erich Heckel/Mädchenkopf. Original Holzschnitt
Edition: unknown
Dube 264, III/III
Provenance: Joseph Anthony Horne Collection
Vivian and Gordon Gilkey Graphic Arts Collection G8548

In 1912, Heckel's future wife and most frequent model, Siddi Riha, suffered a lengthy and serious illness. In response, the artist made several images of reclining women and girls the following year. This print of Siddi is typical of those images, conveying both physical and psychological trauma.

Although first printed in 1913, this version of *Young Girl* was reprinted and published in 1920. The post-war market for Expressionist graphics in Europe had exploded and, as a result, many pre-war prints were reworked by the artists in preparation for mass publication. Earlier states of this particular print emphasized the wood grain, and the arms and face were flecked with ink, giving the figure of Siddi a more ragged appearance. In the final state, pictured here, the artist has smoothed the surface of the block, resulting in a crisper, cleaner print indicative of post-war aesthetics.

VWH

46. *Antwerpen* (Antwerp), 1914

Etching on wove paper
31.7 x 19.7cm
Signed and dated in pencil, l.r., Erich Heckel 14; titled, l.c.,
Antwerpen
Edition: 65
Dube 123
Provenance: Littmann Collection
Vivian and Gordon Gilkey Graphic Arts Collection 84.25.79

In the last two decades of the 19th century, massive industrialization led to the rapid and often haphazard growth of Europe's urban centers. The results were cities of contrast, with stately villas and magnificent civic and religious architecture rising next to the grimmest hovels of the working poor. The Brücke artists were keenly sensitive to the cities' flaws and took a sharply critical approach when depicting urban landscapes. Heckel's image of Antwerp, while acknowledging the grandeur of its architectural monuments, stresses the human isolation and anonymity of urban life.

As he did with most of his intaglio prints, Heckel used plate tone to define the area of his image. Foul biting and scratches on the surface of the print suggest that the scene of Antwerp was drawn on the back of a previously-used plate. These types of marks appear on a number of drypoints and etchings created by the Brücke artists, attesting to an economy of materials and an appreciation for the inherent qualities of worn metal plates.

VWH

47. *Frauenkopf* (Woman's Head), 1922

From *Arno Holz zum sechzigsten Geburtstage gewidmet von deutschen Künstlern* (Dedicated to Arno Holz on his Sixtieth Birthday by German Artists), a portfolio of 30 original prints by various artists (Berlin: Fritz Gurlitt, 1923)
Lithograph on wove paper
26.9 x 21.5cm
Signed and dated in pencil, l. r., Erich Heckel 22
Edition: 100 numbered portfolios, 30 other
Dube 269
Provenance: Hanna Bekker vom Rath, Frankfurt am Main
Vivian and Gordon Gilkey Graphic Arts Collection 81.81.222

As German society became more urbanized at the turn of the century, a group of young intellectuals, the Jugendbewegung (Youth Movement), strongly advocated the need for periodic excursions to the countryside in order to rediscover their affinity to nature. A popular outgrowth of this idea was "Nacktkultur" (nudism), which symbolized both a release from the constraints of modern German culture and a more complete bonding with nature. The Brücke artists were attuned to this philoso-

phy and the subject of nudes in nature became a favorite. While summering in the northern lake country, they sought out secluded spots where they could freely sketch and paint such scenes, transferring this imagery to the graphic media during the Dresden winters.

Heckel's lithograph, although made long after the dissolution of the Brücke, looks back nostalgically to these summers together. His nudes possess the relaxed, immodest attitude characteristic of Brücke figures. The carefree nature of the earlier works is tempered here, however, by the appearance of a clothed, melancholy woman (likely, his wife, Siddi) in the foreground. Heckel printed a similar composition years earlier in which a reclining Siddi, wrapped in a blanket, is oblivious to the frolicking figures behind her. Both of these prints are evidence of Heckel's preoccupation with isolation and emotional suffering.

VWH

KARL SCHMIDT-ROTTLUFF 1884-1976

Born in 1884 in Rottluff, Karl Schmidt began studying in nearby Chemnitz in 1897. There he met Erich Heckel, with whom he studied architecture in Dresden. Although a co-founder of the Brücke, Schmidt-Rottluff stood slightly apart from the other members of the group in his approach to his work. Unlike his peers, whose graphic work focused on scenes of nudes in nature and other figure studies, Schmidt-Rottluff's pre-war wood-cuts and lithographs are primarily images of unpeopled rural landscapes, which he viewed as a haven from the difficulties of city life. He also preferred the harmony of smooth, curving lines to the angular presentation of other Brücke artists. Finally, Schmidt-Rottluff insisted upon a uniform printing within an edition of prints, favoring consistency over technical experimentation. After about 1913, he relied exclusively on professional printers who pulled relatively large editions of about 25-35 prints.

In 1911 Schmidt-Rottluff joined the other Brücke artists in Berlin. He enlisted in the army in 1915 and spent three years in Russia and Lithuania. He was beset with nervous problems throughout his tour and required a lengthy convalescence at war's end. Like many of his contemporaries who spent time at the front, he began to focus on religious subjects in his post-war work.

Most of Schmidt-Rottluff's 663 prints, including 446 woodcuts, 121 lithographs and 96 intaglio prints, were made between 1905 and 1925. He made very few prints after 1925, preferring instead to concentrate on his paintings. In 1931 he began teaching at the College of Fine Arts in Berlin. Expelled by the Nazis, he was labeled "degenerate" in 1941 and forbidden to work. In 1947 he resumed his former teaching position and in 1967 he established the Brücke-Museum in Berlin.

VWH

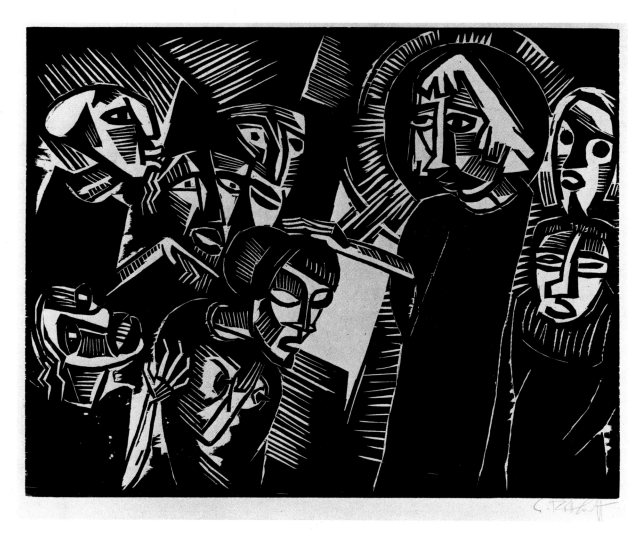

From *Schmidt-Rottluff, 9 Holzschnitte* (9 woodcuts), a portfolio of nine woodcuts (Leipzig: Kurt Wolff Verlag, 1918)
Edition: 75

48. *Christus und die Ehebrecherin* (Christ and the Woman Taken in Adultery), 1918

Woodcut on laid paper
39.5 x 50cm
Signed in pencil, l.r., S. Rottluff
Schapire 215
Provenance: Günther Franke, Munich
Vivian and Gordon Gilkey Graphic Arts Collection 83.57.163

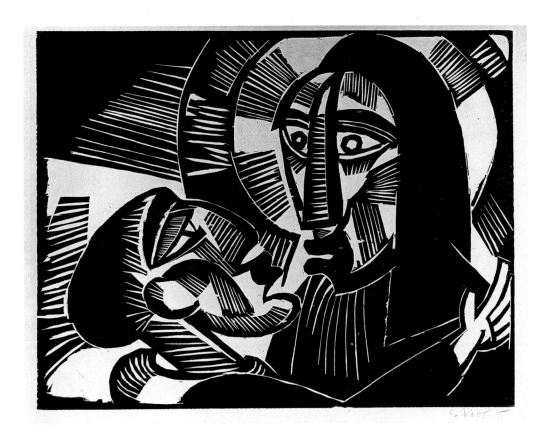

49. *Christus und Judas* (Christ and Judas), 1918

Woodcut on laid paper
39.5 x 50cm
Signed in pencil, l.r., S. Rottluff
Schapire 218
Provenance: Günther Franke, Munich
Vivian and Gordon Gilkey Graphic Arts Collection 81.81.262

One of several portfolios Schmidt-Rottluff created in the years immediately after World War I, *Schmidt-Rottluff, 9 Woodcuts* is unique in that it is the only one he devoted exclusively to religious imagery. Focusing on the life of Christ, this series explores the concepts of sin and forgiveness. Though not an overt reference to recent events, the artist's choice of theme may have been intended to offer spiritual guidance to Germans in the construction of a post-war society. Critics at the time noted the timeliness of the images and responded immediately and frequently to the portfolio.

Each print in this portfolio presents one story of the life of Christ in a single image. In some cases, as in *Christ and the Woman Taken in Adultery*, Schmidt-Rottluff reconfigures the events of the narrative to effect a heightening of the drama. Whereas in the Bible, Christ's forgiveness of the woman is a private act, Schmidt-Rottluff empha-sizes the courage of Christ's forgiveness by placing the action before the hostile mob.

The artist's portrayal of Christ and Judas is equally powerful. Judas' adoration of Christ is demonstrated by the tenderness of his gaze and the touch of his hand on Christ's shoulder. Christ, at once disbelieving and resigned to the act of betrayal, purses his lips in anticipation of the kiss. Schmidt-Rottluff underlines the significance of the kiss by situating the gesture in the center of the composition.

Schmidt-Rottluff's style is clearly indebted to African and Oceanic art, as it had been since shortly before the war. The stylized features and parallel hatching, in particular, recall carved wooden tribal masks. By juxtaposing the elemental power of "primitive" art with these medieval-inspired woodcuts, Schmidt-Rottluff endows this work with a profound mysticism.

VWH

50. *Russischer Wald* (Russian Forest), 1918

From *Die Schaffenden* (The Creators), II, no. 3 (Weimar: Paul Westheim), 1918
Woodcut on wove paper
20 x 25.8cm
Signed in pencil, l.r., S. Rottluff; publisher's dry stamp, l.l.
Edition: unknown
Schapire 229
Provenance: Littmann Collection
Vivian and Gordon Gilkey Graphic Arts Collection 83.57.134

Although he was unable to paint during his tour of duty, Schmidt-Rottluff could continue making woodcuts and small sculptures because of the portability of woodworking materials. This view of the Russian countryside was probably created while he was stationed at the front. It was one of the few landscapes the artist made during the war as journeys into the countryside for purposes other than military were difficult and rare. In contrast to the curving lines of his earlier landscapes, the piercing angularity of this image conveys a harshness heretofore uncommon in his graphics. Whereas the countryside once offered a serene escape from contemporary society, it now bears the scars of battle. The earth, reshaped by artillery, bulges unnaturally and the once lush pines are stripped of much of their growth. Schmidt-Rottluff's forest stands as a memorial to the far-reaching destruction of the war.

VWH

51. *Arbeiterkopf* **(Head of a Worker), 1922**

From *Arno Holz zum sechzigsten Geburtstage gewidmet von deutschen Künstlern* (Dedicated to Arno Holz on his Sixtieth Birthday by German Artists), a portfolio of 30 original prints by various artists
(Berlin: Fritz Gurlitt, 1923)
Woodcut on wove paper
27.9 x 20cm
Signed in pencil, l.r., S.Rottluff
Edition: 100 numbered portfolios, 30 others
Schapire 277
Provenance: Hanna Bekker vom Rath, Frankfurt am Main
Vivian and Gordon Gilkey Graphic Arts Collection 82.80.269

Schmidt-Rottluff began creating monumental portraits of the working class after World War I. His deep empathy was shared by most of his colleagues, who saw the worker as an archetype of the unspoiled human being exempt from the corruption of contemporary bourgeois society.

Head of a Worker typifies Schmidt-Rottluff's portraits done after 1920. Where large, unbroken masses of black and white and simplified features dominated earlier works, the addition of splintery lines and less stylized features softened the later woodcuts. The result is an increased naturalism more suggestive of individuality. Characteristically, the subject has an unmatched pair of eyes: one is detailed with concentric arcs, the other is represented by a black hole.

VWH

ERNST LUDWIG KIRCHNER 1880-1938

Ernst Ludwig Kirchner was reared in the working class town of Chemnitz. He studied painting in Munich and architecture in Dresden where, in 1904, he formed the Brücke group with fellow architectural students, Fritz Bleyl, Erich Heckel, and Karl Schmidt-Rottluff.

From the group's beginnings, Kirchner was its leader, both spiritually and stylistically. Under his direction their studio became a symbol of the Brücke's bohemian lifestyle. Kirchner and Heckel carved furniture, painted wall murals and draped windows in exotic fabrics to create an enveloping environment which offered a haven from the difficulties of contemporary urban life. Kirchner's role as stylistic leader of the Brücke was due in part to his studies in anatomy and figure drawing which he shared with his colleagues. In his written recollections of the Brücke's history, Kirchner also took credit for introducing them to primitivism, as manifested in the art of the South Pacific.

Kirchner was one of the most prolific printmakers of the period, making over 2,000 prints during his lifetime. Roughly half were woodcuts and most of these were hand-printed by Kirchner in editions of less than ten, making them rare in today's market.

Following the dissolution of the Brücke in 1913, Kirchner continued to make and exhibit his work. His early service in the war led to nervous fatigue and he was discharged in 1915 under the condition that he enter a sanitarium. Over the next few years he was in and out of several institutions both in Germany and Switzerland. He eventually settled in Frauenkirch, Switzerland, where, during the twenties, many young artists traveled to study with him. In 1926 he joined with several of them to form the Red-Blue Group.

Kirchner's chronic insomnia led to a dependence on drugs and alcohol which intensified his severe emotional and physiological problems. In 1938, distraught over the Nazi denunciation of his work, Kirchner committed suicide at his mountain home.

VWH

52. *Tänzerin mit gehobenem Rock* (Dancer with Raised Skirt), 1909

From *Die Brücke V,* 1910, a portfolio of two woodcuts and one
drypoint by Kirchner, plate 2
Woodcut on heavy wove paper
25 x 33.8cm
Signed in pencil, l.l., E.L. Kirchner
Edition: approximately 70
Dube-Heynig 141, II/II
Provenance: Buchholz Gallery, New York
Helen Thurston Ayer Fund 46.49

The theme of the cabaret dancer figures prominently in
the work of the Brücke artists and particularly in that of
Kirchner. Although the theme held a lasting fascination
for him, it was of central importance in his work of
1909-1911. In the earlier works, such as *Dancer with Raised*

Skirt, his interest was primarily in the depiction of move-
ment. Typically, details are subordinated to a bold,
dynamic composition. The strong diagonal of the dancer
and her widely flared skirt dominate the print and evoke a
sense of wild abandon. Several abbreviated dancing fig-
ures in the background provide a compositional balance
and also suggest a theatrical context for the main dancer.

By 1911 and through the pre-war years, Kirchner's
interest shifted from the dance as expression of move-
ment to dance as expression of ethnic culture. These
prints illustrate dancers from such exotic locales as Hun-
gary, Russia, and Central America and incorporate native
costumes and other identifying details.

VWH

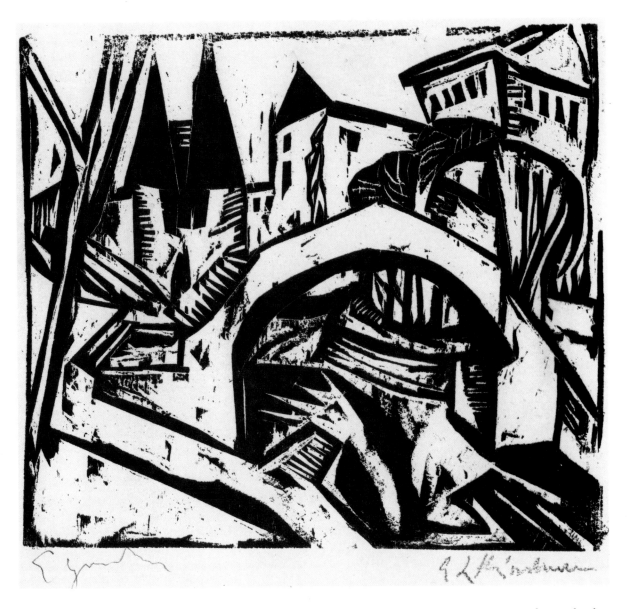

53. *Elisabeth Ufer* (Elisabeth Riverbank), 1912

Woodcut on heavy wove paper
21 x 23.2cm
Signed in pencil, l.r., E.L. Kirchner; annotated, l.l., Eigendruck
Edition: probably less than 10
Dube-Heynig 197
Provenance: Bucholz Gallery, New York
Helen Thurston Ayer Fund 46.48

Kirchner's *Elisabeth Riverbank* was one of several urban images he created after moving from Dresden to Berlin in 1911. In addition to the woodcut, the artist also created a painting and an etching that feature this view. Both prints are uncharacteristically void of human subjects and rely instead upon the buildings and their surroundings to express Berlin's individuality. While the etching is composed in a traditional manner, with straight lines and a logical sense of space, the woodcut shows a strong Cubist influence. The planes of the picture are no longer static and their sense of movement expresses Berlin's vitality. A jagged flash of light on the river's surface emphasizes the active, even menacing quality of the city.

VWH

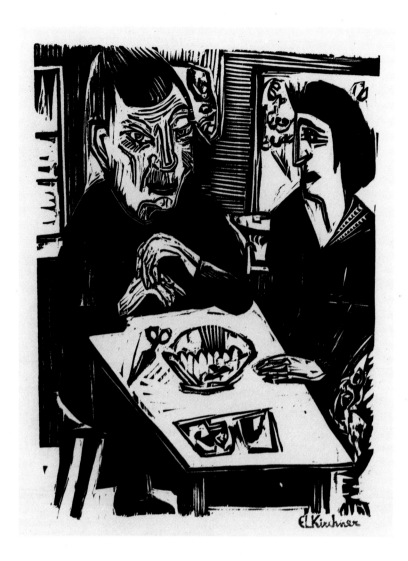

54. *Alte und junge Frau* **(Old and Young Woman), 1921**

From *Arno Holz zum sechzigsten Geburtstage gewidmet von deutschen Künstler* (Dedicated to Arno Holz on his Sixtieth Birthday by German Artists), a portfolio of 30 original prints by various artists (Berlin: Fritz Gurlitt, 1923)
Woodcut on wove paper
33.3 x 24.4cm
Stamped, l.r., E.L. Kirchner
Edition: 100 numbered portfolios, 30 other
Dube-Heynig 463
Provenance: Hanna Bekker vom Rath, Frankfurt am Main
Vivian and Gordon Gilkey Graphic Arts Collection 82.80.268

Kirchner's transition from urban Germany to rural Switzerland had a great impact on his art, both in content and style. Just as he and his Brücke colleagues had admired the purity of the fishermen's lives in northern Germany, Kirchner became fascinated with the peasant culture of Switzerland. This segment of society, at work and at rest, soon became his primary subject for prints.

The techniques evident in this print of two peasant women are typical of Kirchner's woodcut style of 1919 and 1920. The ragged lines used to model the face of the old woman and the parallel hatchings throughout the print allow for greater individuality of subjects and setting. Unlike *Dancer with Raised Skirt* (plate 52), in which the boldness of the composition creates drama, *Old and Young Woman* depends upon detail for its sensitive portrayal of womanhood.

VWH

EMIL NOLDE 1867-1956

Emil Nolde was born Emil Hansen in the north coast town of Nolde, where his family farmed. His artistic leanings were evident at a young age and after an apprenticeship as a woodcarver in a furniture factory, he began studying fine art at various academies both in Germany and France. His earliest work shows the influence of Impressionism, particularly Renoir, and of Art Nouveau.

To a greater extent than most of his colleagues, Nolde used the print medium to explore new directions in his art. The imaginative imagery of his first important group of etchings, a series of grotesques completed in 1904, for example, did not appear in his paintings for approximately four more years. In 1905 Nolde developed an etching technique that enabled him to greatly vary tone, and his prints took on a distinctive individuality. In the next seven years he made nearly three-fourths of his total 231 etchings. Nolde also made 197 woodcuts and 83 lithographs in sporadic bursts between 1906 — 1917 and again in 1926.

Drawn by the expressive use of color in his paintings, the Brücke artists invited Nolde to join their group in 1907. His affiliation was shortlived, however, as he found their practice of communal criticism and their similarities in style oppressive. His brief membership in the group was, nevertheless, mutually beneficial. Nolde introduced the art of etching to the Brücke (though not all the intricacies of his personal style), and they, in turn, instructed him in making woodcuts.

Nolde returned to an insular lifestyle following his break with the Brücke. In 1913-14 he and his wife accompanied an expedition to the South Seas. On his return, he continued his pattern of spending the winters in Berlin and the rest of the year in the flat country bordering on Denmark, first at Alsen, then Utenwarf and finally Seebüll. From 1926 until his death, Nolde lived with his wife as a virtual recluse in Seebüll. Although his strong nationalism led him to support the Nazi party in its early years, he was, in the 1930s, denounced as a "degenerate artist."

VWH

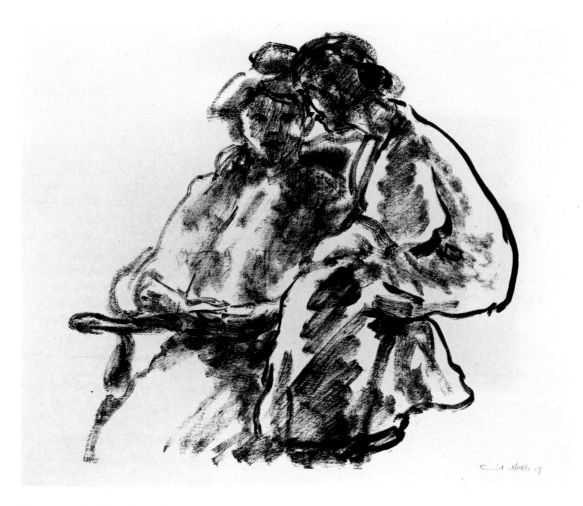

55. *Wie Vögel* (Like Birds), 1907

Lithograph on wove paper
34.5 x 35.5cm
Signed and dated in pencil, l.r., Emil Nolde 07
Edition: 100 (1-20 numbered)
Schiefler 14
Provenance: Littmann Collection
Vivian and Gordon Gilkey Graphic Arts Collection 81.81.457

Nolde's earliest prints, like those of the other Brücke artists, were modelled in part on the art of the French Impressionists. This sensitive depiction of Nolde's wife, Ada, and her sister recalls the intimate figure studies of Auguste Renoir. Like Renoir, Nolde's goal was not a detailed study of individual personalities, but rather a depiction of pure femininity. An air of intimacy is conveyed through the poses and a soft, broadly brushed chiaroscuro that tempers the bold outlines. As in almost all of Nolde's lithographs, there are no background details to detract from the impact of the central image.

VWH

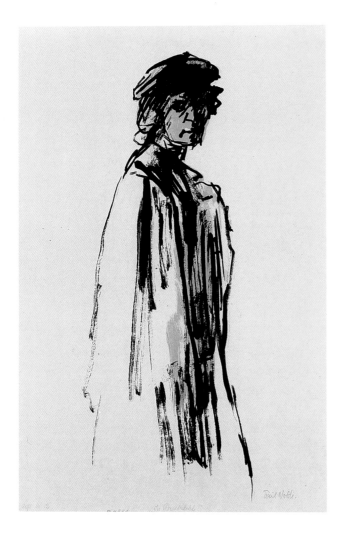

56. *In Reisetracht* (In Traveling Clothes), 1907 (printed in 1915)

Lithograph on wove paper
43.2 x 16cm
Signed in pencil, l.r., Emil Nolde; inscribed, l.l., Aufl. No. 12; titled, l.c., In Reisetracht
Edition: 23
Schiefler 8, II/II
Provenance: Littmann Collection
Gift of Mr. Frederic Rothchild 76.38.4

Nolde's earliest efforts in lithography were done in the transfer method, which involved drawing an image on a special, coated paper and then transferring it under pressure to a lithographic stone. In 1907 he ceased working in this manner, preferring to concentrate on intaglio printmaking where he worked directly on the surface of the plate. His interest in lithography revived in 1911, however, when he learned to make drawings directly on the stone. Now able to consider the characteristics of the stone during the initial creative process, Nolde approached the technique with increased enthusiasm. In 1913 he participated in a lithography workshop in Flensburg where he was introduced to color lithography. Excited by the possibility of adding the rich color of his paintings to his graphics, Nolde not only made many new color prints but also retrieved earlier black and white lithographs and reprinted them with color.

In Reisetracht is one such example. Originally printed in 1907, Nolde added ochre and a bit of blue to the print in 1915. The color gives depth and substance to the figure who, with her heavily shaded face and concealing garments, exudes an air of mystery. Like his Impressionist forebears, Nolde imparted a fleeting quality to the image with the turn of the head and the vitality of line.

VWH

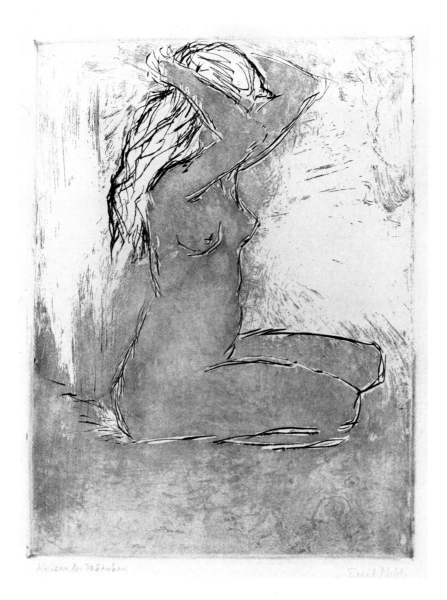

57. *Kniendes Mädchen* (Kneeling Girl), 1907

Drypoint and spitbiting on heavy wove paper
30.4 x 22.7cm
Signed in pencil, l.r., Emil Nolde; titled, l.l., Kniendes Mädchen
Edition: small
Schiefler 76, V/V
Provenance: Littmann Collection
Vivian and Gordon Gilkey Graphic Arts Collection G3298

More than any other Brücke artist, Nolde was fascinated with the technical possibilities of every medium in which he worked. Rarely satisfied with the first version of a print, he consistently reworked his plates and produced several states of each image. Seen together, the different states provide rare insight into the artist's manner of working. An early example of his method, *Kneeling Girl* went through a total of five states before Nolde arrived at his final solution. He began by drawing the figure of the girl into the plate with a drypoint needle. The next two states have minor additions of line which do little to alter the composition. In the fourth state, however, Nolde has applied an acid wash, probably with a brush. The tone is significantly darker on the figure than in the background, causing the figure to stand out against the white of the paper. The fifth and final state, pictured here, shows a lightening of tone in the figure, which better integrates the model with her environment. Within this state are subtle variations of the gray tone which bring life and warmth to the image.

VWH

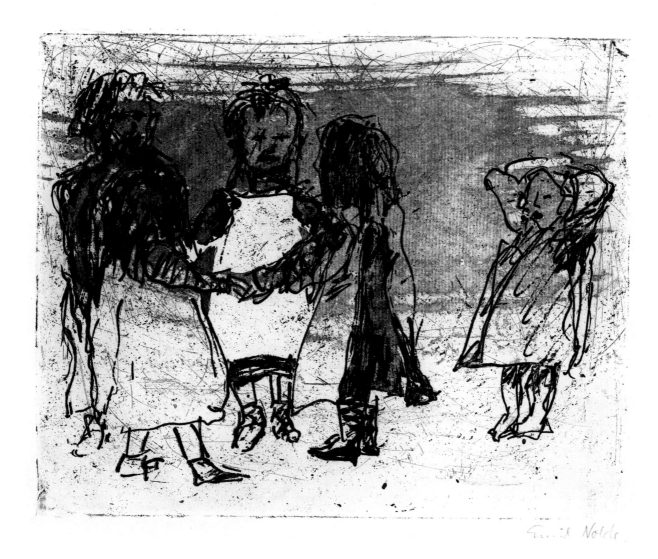

58. *Ringelreihen* (Round Dance), 1908

Etching with spitbiting on laid paper
21 x 25.8cm
Signed in pencil, l.r., Emil Nolde
Edition: about 10
Schiefler 104, II/III
Provenance: Bucholz Gallery, New York
Helen Thurston Ayer Fund 46.50

The innocence of children, as seen in *Round Dance*, appealed to Nolde and other Expressionists in much the same way as did the "primitive" cultures of the South Pacific. In both, the artists saw humankind as being in its most elemental state, free from the constrictions of contemporary society. To underscore the symbolic aspect of his dancing children, Nolde has blurred their faces and erased any traces of individuality.

Round Dance bears the deeply bitten lines characteristic of Nolde's etchings. His facility with acid was remarkable—he knew the exact moment to retrieve the plate, making the difference between the lush, velvety lines of *Round Dance* and a ruined plate. Deliberate needling and accidental foul biting on this plate emphasize the nature of the medium and further enliven the surface of the print.

VWH

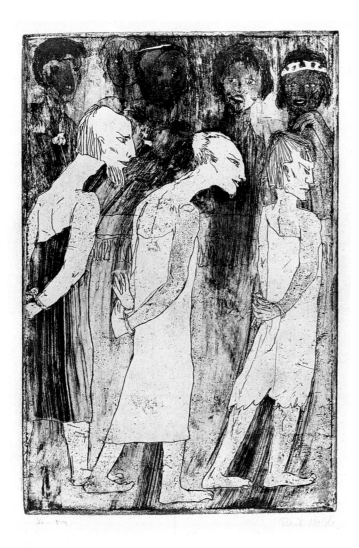

59. *Sklaven* (Slaves), 1918

Etching and spitbiting on heavy wove paper
31.4 x 20.6cm
Signed in pencil, l.r., Emil Nolde; titled, l.l., Sclaven
Edition: 12
Schiefler 198
Provenance: Littmann Collection
Vivian and Gordon Gilkey Graphic Arts Collection 83.57.172

Like the other Brücke artists, Nolde strongly agreed with Nietzsche's philosophy that Western society, particularly urban Germany, was corrupt and depraved. Those peoples distant from the influences of contemporary culture — the rural fishermen of northern Germany, the "primitive" tribes of the South Pacific — were seen as purer and nearer to man's ideal state. Images of these natural human beings are abundant in Brücke oeuvre.

Following Nolde's expedition to the South Seas, during which he documented various racial types, references to non-European cultures began to appear in his work. *Slaves* juxtaposes figures of Oceanic or African origin with those of European heritage. Reflecting Nietzsche's influence, however, Nolde reverses their historic roles; here the slave-holders are the "primitive" people and the slaves are the "civilized" Europeans.

Nolde highlights the distinction between the two groups in several ways. The slaves are presented in profile and their stooped figures convey subordination in contrast to the tall, front-facing slave-holders. Nolde blocked out the faces and two of the three garments of the slaves, leaving them largely untouched by acid. The pure white of the paper stands out boldly against the textures of the acid wash and foul biting. Formed largely by the painterly application of an acid wash, the slave-holders have a dark mystery that stands in marked contrast to the clear linearity of the slaves. VWH

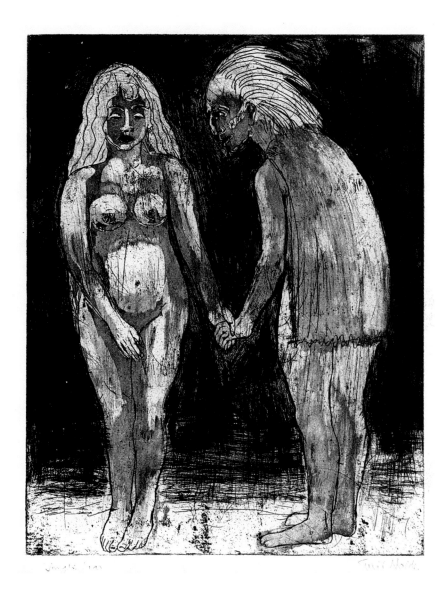

60. *Junges Paar* (Young Couple), 1922

Drypoint, aquatint and spitbiting on heavy wove paper
32.5 x 24.8cm
Signed in pencil, l.r., Emil Nolde; titled, l.l., Junges Paar
Edition: about 9
Schiefler 215, II/II
Provenance: Littmann Collection
Vivian and Gordon Gilkey Graphic Arts Collection 81.81.260

This image of a young couple, one of Nolde's last etchings, embodies many of the qualities for which his prints are known. The theme of the duality of man and woman was a recurring one throughout his career and the treatment of the figures in *Young Couple* shows the artist at his finest.

After his marriage to Ada in 1901, Nolde became fascinated with the complex relationship between man and woman. In an attempt to convey the essence of that relationship, he usually presented the subjects nude or semi-nude in non-specific settings. Through pose and expression, they illustrate what was for him the basic foundation of the relationship — man's inescapable attraction to woman.

Young Couple also exemplifies the richness of Nolde's etching technique. The basic forms of the figures are first drawn with the etching needle and then given substance through the application of acid wash. By blocking out the areas on the woman's stomach and breasts, Nolde emphasizes her sexuality without exaggerating it. The accidental scratches and foul biting deliberately left on the plate lend an earthy materiality to the figures, which stand out boldly against the enveloping darkness. VWH

Max Pechstein was born in Zwickau, the son of a textile worker. After a four-year apprenticeship as a house painter he left for Dresden in 1900 to attend the Dresden School of Arts and Crafts. In 1902 he entered the Academy of Fine Arts in Dresden, graduating in 1905 with a scholarship prize. Although Pechstein had already executed a number of decorative commissions, contact with the art of Van Gogh led him in a new, bolder direction. In 1906 he attracted the attention of Heckel when a ceiling commission he undertook for the Dresden Arts and Crafts Exhibition proved too daring for the architects, and was invited to join the Brücke. He spent the summer with Kirchner in Goppeln and in the fall used his prize money to travel to Ravenna, Florence, Rome, and Paris. In the summer he returned not to Dresden but to Berlin where he continued his association with the Brücke until 1912 when he was expelled for breaking the group's policy of exhibiting together exclusively.

Pechstein traveled to the South Seas in the spring of 1914 to witness firsthand the art and life of the native people. His journey was interrupted, however, by the outbreak of World War I and the occupation of the islands by Japan. When Pechstein finally arrived back in Germany, he was drafted into the infantry where he served until suffering a nervous collapse in early 1917. At war's end he became highly politicized, joining both the Novembergruppe and the Arbeitsrat für Kunst.

Of all the Brücke artists, Pechstein's work showed the most influence of French art, particularly of Cézanne and Matisse. As a result, his was the most popularly "acceptable" and, though actually the least Expressionist of the group, he became recognized as a leader of the movement. Three monographs were written about him before 1921, and in 1923 he became both a member of the Prussian Academy of Art and a professor at the College of Fine Arts, Berlin. In 1927 he was invited to participate in the Carnegie International Exhibition in the United States.

When the Nazis came to power in 1933, Pechstein was dismissed from his teaching post. In 1936 he was forbidden to paint, and in 1937 was prohibited from exhibiting, expelled from the Prussian Academy, and had a total of 326 works confiscated from German museums. Pechstein spent the war years in rural Pomerania, returning to Berlin in 1945 where he resumed teaching at the College of Fine Arts. He died in West Berlin in 1955.

Although Pechstein made prints throughout most of his career, well over one-third of the total were made while he was a member of the Brücke. Of the approximately 900 prints he created, 421 are lithographs, 315, woodcuts, and 165, etchings.

MP

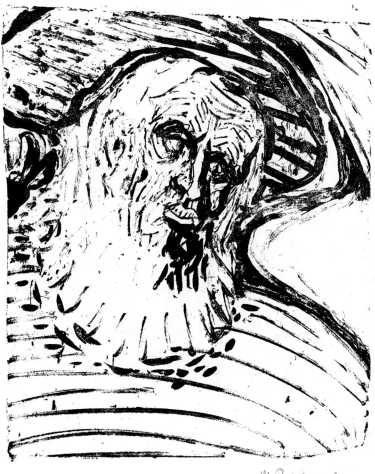

M. Pechstein 08.

61. *Hirte* (Shepherd), 1908

Lithograph on heavy wove paper
41.2 x 33cm
Signed in pencil, l.r., M. Pechstein 08
Edition: unknown
Krüger L20 (not illustrated)
Provenance: Littmann Collection
Vivian and Gordon Gilkey Graphic Arts Collection 81.81.433

During his trip to Italy in 1907, Pechstein found himself drawn to early Italian art, especially the work of Giotto and Etruscan sculpture. Executed the year after his return, *Shepherd* reflects some of these influences on the artist. With its fierce introspection and monumentality, it calls to mind the saints and shepherds of Giotto and other Italian "primitives."

Although he had made a few lithographs and a number of woodcuts earlier, Pechstein's interest in printmaking accelerated in 1908. He learned how to make etchings while in Paris and continued to make both etchings and lithographs after his move to Berlin. The spontaneous use of the litho tusche in *Shepherd* is typical of his earliest lithographs. The rawness of the technique exemplifies the Brücke aesthetic in which the unique quality of the print and the creative process of the artist are boldly proclaimed.

MP

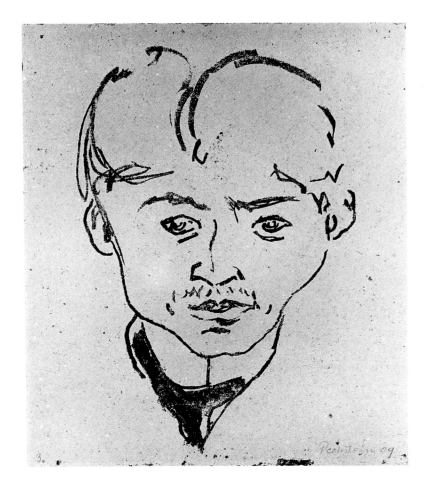

62. *Blonder Jüngling* (Blond Young Man), 1909

Lithograph on oatmeal paper
38.5 x 35cm
Signed and dated in pencil, l.r., Pechstein 09; annotated, l.r., 3.
Edition: probably 5
Kruger L61
Provenance: Littmann Collection
Helen Thurston Ayer Fund 52.163

During his extended visit to Paris in 1907-08, Pechstein met several of the Fauves — Henri Manguin, Andre Derain, and Kees van Dongen—and carried their influence back to Germany. In response to his enthusiasm, the Brücke artists included 60 works by Fauvist painters in their fall exhibition in Dresden. Kees van Dongen became a member of the Brücke in 1908 and while Matisse was also invited, he declined.

Matisse's influence on Pechstein was strongest after a major exhibition of the French artist's work at the Paul Cassirer Gallery in January 1909. Pechstein's overall economy and his use of the single contour line to define the face of the *Blond Young Man* are unmistakably Matisse-like. MP

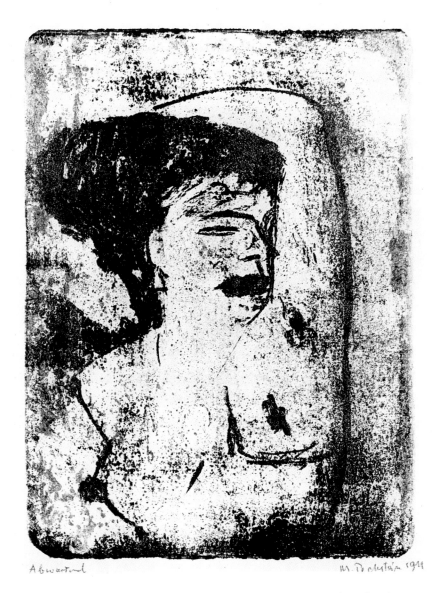

Abwartend M. Pechstein 1911

63. *Weiblicher Halbackt* (Female Half-Nude) or *Abwartend* (Waiting), 1910

Color lithograph on proof paper
38 x 28cm
Signed and dated in pencil, l.r., M. Pechstein 1911; titled, l.l.,
Abwartend
Edition: very few with yellow overprinting
Krüger L112
Provenance: Littmann Collection
Vivian and Gordon Gilkey Graphic Arts Collection 81.81.458

From 1909 on, Kirchner, Heckel, and Pechstein were regular visitors to the variety shows and cabarets in Dresden and Berlin. The shows were usually bawdy, and in the poorer venues it was common for dancers and waitresses to double as prostitutes. Influenced in part by Kees Van Dongen, who frequently portrayed prostitutes in his work, Pechstein depicted the prostitute as integral to his view of urban life. Exuding a raw sexuality, the image of the waiting prostitute in *Female Half-Nude* combines the Brücke's fascination with primitivism with the theme of modernity. The dissolute character of the image is enhanced by the use of turpentine or alcohol mixed with water to create a grainy, uneven texture on the surface.

MP

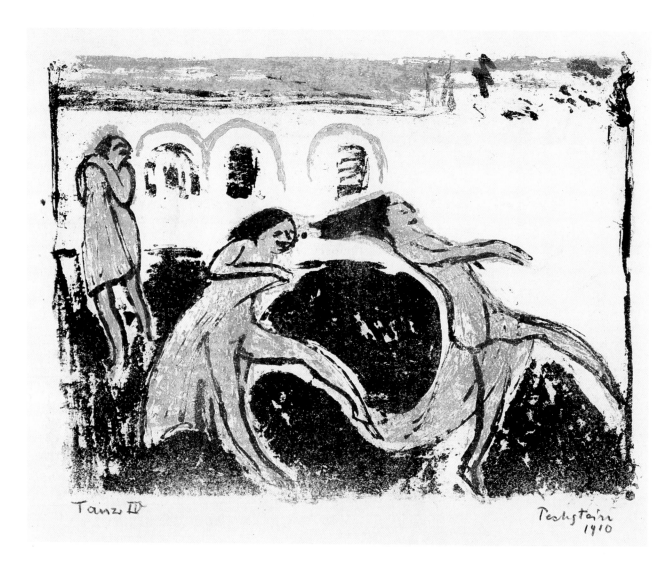

64. *Tanz IV* (Dance IV), 1910

From *Tanz*, a series of 8 color lithographs (Berlin: Fritz Gurlitt, 1910),
plate IV
Color lithograph (monoprint) on thin wove paper
34.5 x 38.5cm
Signed and dated in grease pencil, l.r., Pechstein 1910; titled, l.l.,
Tanz IV
Edition: probably 5-10
Krüger L128
Provenance: The artist
Vivian and Gordon Gilkey Graphic Arts Collection 82.80.254

To fulfill their goal of depicting the human figure "in free
and natural motion," the Brücke artists frequently por-
trayed dancers. Like the French Fauves and their prede-
cessors, Edgar Degas and Henri de Toulouse Lautrec,
they drew heavily on the cabaret and dance hall for their
subject matter. Charged with erotic abandon, Pechstein's
series of eight color lithographs is typical of their direct,
celebratory handling of the theme.

All the works in this series were made with the same
stone and with the same two colors: brown and black.
The brown was applied after the black and was probably
printed off the black key stone like a monoprint.

MP

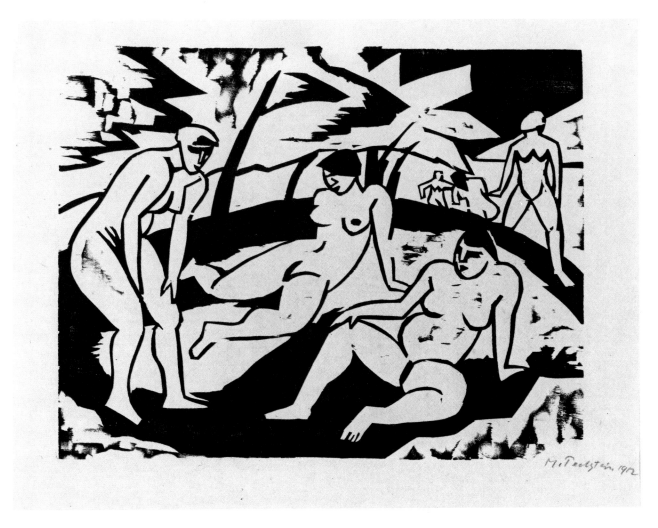

65. *Badende VIII* (Bathers VIII), 1911

From *Badende* (Bathers), a series of 11 woodcuts (Berlin: Fritz Gurlitt, 1912), plate VIII
Woodcut on thin laid paper
31.7 x 40.4 cm
Signed and dated in pencil, l.r., M. Pechstein 1912
Edition: 15 on Japan Paper, 8 handcolored impressions on Bütten
Krüger H103
Provenance: Littmann Collection
Vivian and Gordon Gilkey Graphic Arts Collection 84.25.128

Bathers VIII is one of 11 woodcuts Pechstein created in 1910-1911 on the theme of the bathers. Divided between indoor and outdoor scenes, the images are apparently based on sketches of his young wife, Lotte, made on summer trips to the Kurische sandbar in Nidden, East Prussia.

The composition of *Bathers VIII* is dominated by a triangular arrangement of figures and landscape elements with a central vanishing point. The formality of this structure and the subjugation of the figures to the composition call to mind Cézanne's great bather series. While the technique appears rough and spontaneous, Pechstein has carefully varied the depth of his carving to create textured areas which contrast with the flat planes of black and white.

Bathers VIII is one of four prints from the series to be exhibited in the second and last exhibition of Der Blaue Reiter that was held in Munich in 1912 and devoted exclusively to graphic works.

MP

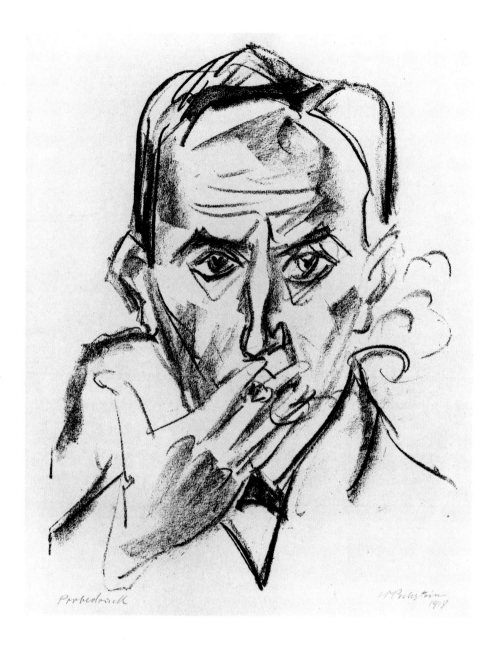

66. *Raucher* (Smoker), 1916

Lithograph on heavy wove paper
39.5 x 29.8cm
Signed and dated in pencil, l.r., HM Pechstein 1918; annotated, l.l,
Probedruck
Edition: unknown
Krüger L173
Provenance: Littmann Collection
Vivian and Gordon Gilkey Graphic Arts Collection 85.14.79

In the fall of 1915 Pechstein was drafted into the German infantry. He was stationed on the Franco-German front and from July 1 to November 13, 1916, participated in the Battle of the Somme. This military debacle of 100 days resulted in a 5-mile gain for Britain and France against entrenched German troops at the cost of 1,070,000 lives. The experience of having witnessed such slaughter, an average of 11,000 men a day, was traumatic for Pechstein and he had a difficult period of adjustment upon returning to civilian life.

Although Pechstein was not discharged until the spring of 1917, he apparently made this self-portrait while on leave during the winter of 1916. Through the anxious expression and tense gesture, Pechstein underscores the psychological impact of his experiences.

MP

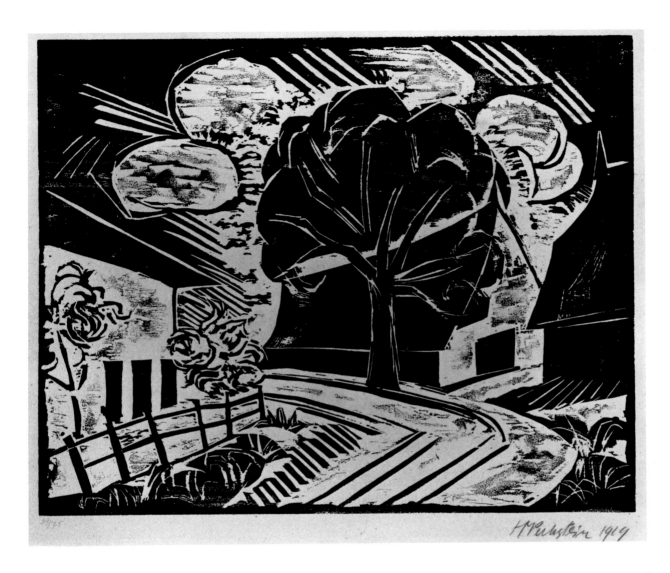

67. *Am Dorfeingang* (At the Entrance to the Village), 1918

From *Ein Dorf* (A Village), a portfolio of 6 woodcuts (Berlin:
I.B.Neumann, 1918), plate VI
Woodcut on laid paper
32.9 x 41 cm
Signed and dated in pencil, l.r., HMPechstein 1919; numbered, l.l.,
39/75
Edition: 75 on Zanders-Bütten
Krüger H199
Provenance: Littmann Collection
Vivian and Gordon Gilkey Graphic Arts Collection 81.81.434

After the war, Pechstein produced a large amount of
work that was eclectic in both style and subject matter. In
1918, for example, he completed four portfolios of prints
on a variety of subjects, from the battle of the Somme
and his journey to Palau to more mundane ones such as
Mother and Child and *A Village*, as well as a great number
of portraits and other single works.

Featuring scenes of a village at three times of day and
from three different views, *A Village* is one of the rare
works by Pechstein that does not center on the figure. In
At the Entrance to the Village, in fact, the very absence of
people, combined with a dramatic use of black and
white, creates an ominous quality that contrasts with the
seemingly benign subject.

MP

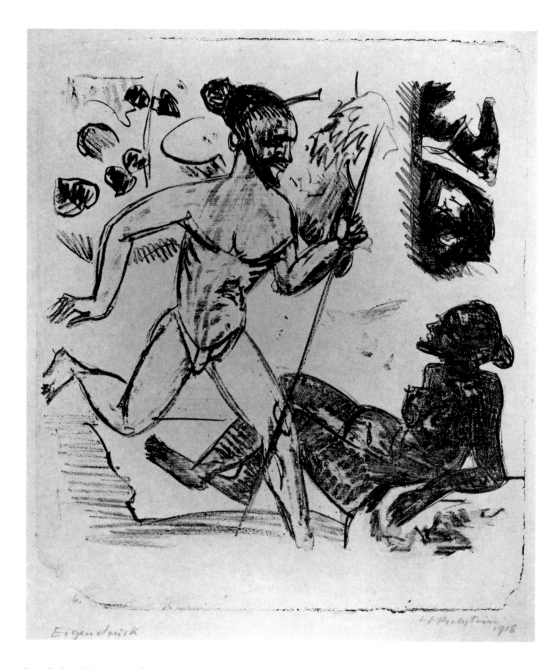

From *Südsee* (Palau), a portfolio of 12 lithographs and a title page

68. *Palau III* (Läufer und Liegender Akt), (Runner and Reclining Nude), 1918, plate III

Lithograph on proof paper
38.4 x 33 cm
Signed and dated in pencil, l.r., HMPechstein 1918; annotated, l.l., 6.
Eigendruck
Edition: at least 7 artist's proofs
Krüger L255, proof before hand-coloring, reproduction reversed
Provenance: The artist
Vivian and Gordon Gilkey Graphic Arts Collection 83.57.173

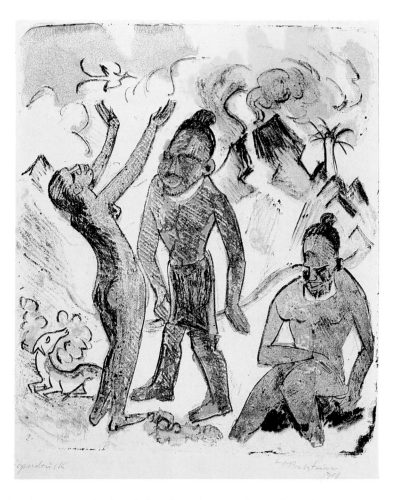

69. *Palau VI (Drei Akte vor Vulkan), (Three Nudes Before the Volcano),* 1918, plate VI

Color lithograph (monoprint) on proof paper
38.5 x 33 cm
Signed and dated in pencil, l. r., HMPechstein 1918; annotated, l. l., 2. Eigendruck
Edition: at least 7 artist's proofs
Krüger L258
Provenance: The artist
Vivian and Gordon Gilkey Graphic Arts Collection 81.81.432

A longing for primitivism encouraged by their readings of Nietzsche and their disdain for modern industrialized society led the Brücke artists to seek out non-European art at every opportunity. Their visits to ethnographic museums in Dresden, Hamburg, and Berlin were an integral part of their working lives and resulted in many stylistic and thematic developments in their work. With the possibilities presented by German colonialism and the precedent of Gauguin, Pechstein, like Nolde, traveled to the South Pacific to experience at firsthand the vitality of a "primitive" culture.

Pechstein had been interested in Palau at least as early as 1906 when a diary entry mentions his having seen the carved and painted beams from Palau in the Dresden Ethnographic Museum. In 1914 he received financing for his trip from Wolfgang Gurlitt in exchange for exclusive exhibition rights to his work. Not long after arriving in Palau, Pechstein decided to stay and bought a small island on which to settle. With the outbreak of World War I, however, the islands were occupied by the Japanese, and he and his wife were captured and shipped to Nagasaki, where they were set free.

After a hazardous journey back to Germany, Pechstein was immediately caught up in the war. It was only after the end of the war in 1918 that he was finally able to review his sketches and memories of his pre-war trip and to create the Palau works. The Südsee series is typical of these nostalgic views of native life.

MP

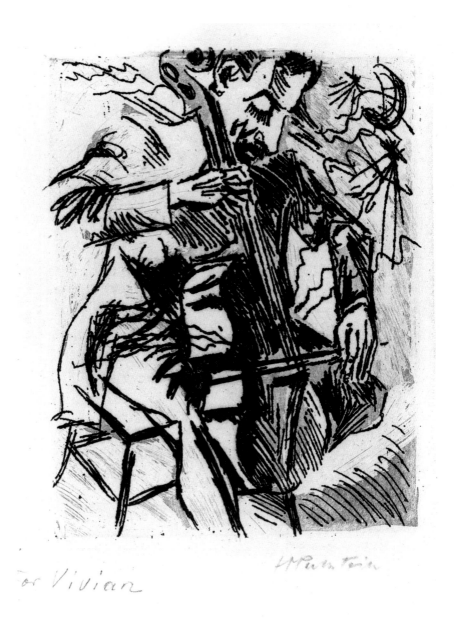

70. *Cellospieler (Dr. Freundlich)* **(Cello Player [Dr. Freundlich]), 1918**

Etching and spitbiting on Japan paper
17.5 x 13.3cm
Signed in pencil, l.r., HMPechstein; inscribed, l.l., For Vivian
Edition: 20 on Japan, 40 on Bütten
Krüger RIII
Provenance: The artist
Vivian and Gordon Gilkey Graphic Arts Collection 81.81.220

In 1918 Pechstein made five portrait prints, three woodcuts and two etchings of the astronomer, Dr. Erwin Finlay-Freundlich. With titles such as *Musician*, *Cellist*, and *Cello Player*, most of them focus on his musicianship and are only secondarily identified as Dr. Freundlich. The *Cello Player* is the only three-quarter length portrait; the others feature the subject's head, sometimes cradled next to the top of his instrument. With a thick crinkly line, Pechstein depicts the rays of music emanating from the strings and connecting with the moon and the stars; in this way he alludes to both Freundlich's scientific and musical interests.

MP

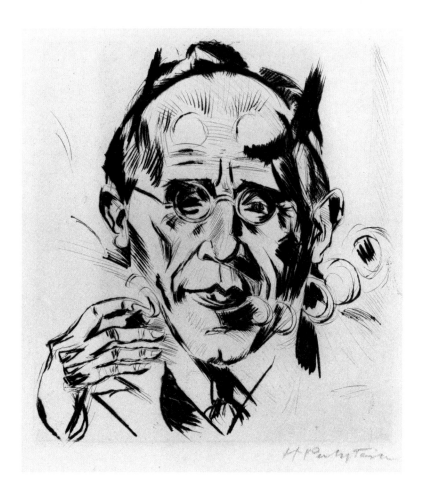

71. *Bildnis Dr. Paul Fechter (Rauchend)* (Portrait of Dr. Paul Fechter [Smoking]), 1919

Drypoint on laid paper
23 x 20.2 cm
Signed in pencil, l.r., HMPechstein
Edition: 20 on Japan; 50 on Bütten
Krüger R113
Provenance: The artist
Vivian and Gordon Gilkey Graphic Arts Collection 84.25.68

Portrait of Dr. Paul Fechter is one of several portraits Pechstein made of this art and literary critic. As a young writer for a Dresden newspaper, Fechter had reported sympathetically on the activities of the Brücke, though giving them mixed reviews. He developed a close friendship with Pechstein after moving to Berlin in 1911, and in 1914 published the first book on Expressionism. Although he is credited as the first writer to explicitly link that term with the Brücke and Der Blaue Reiter, he greatly overstated Pechstein's importance in the movement. In 1921 he published the first catalogue of Pechstein's prints.

Although Pechstein created portraits throughout his career, usually of his male colleagues, the portrait of Dr. Fechter stands out in several respects. It is one of the few portraits, other than self-portraits, that directly engages the viewer and also displays one of the most dramatic uses of drypoint in his oeuvre. The circle motif repeated in the smoke rings, eyeglasses, and forehead alludes to great intellectual powers and creates a visual rhythm that harmonizes the composition.

MP

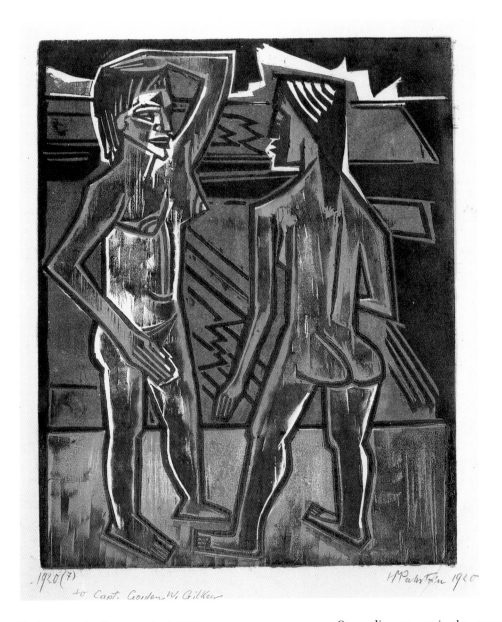

72. *Zwiesprache* (Conversation), 1920

Color woodcut on wove paper
40.2 x 31.7cm
Signed and dated in pencil, l.r., HMPechstein 1920; dedicated, l.l.,
1920(7) to Capt. Gordon W. Gilkey
Edition: unknown
Krüger H228
Provenance: The artist
Vivian and Gordon Gilkey Graphic Arts Collection 82.80.255

Struggling to regain the momentum of his work before the war and to compete with the new second generation of Expressionists, Pechstein returned to a number of old motifs. In 1919 he also returned to Nidden, the fishing village which he first visited with his fellow Brücke members in 1909. *Conversation* is an example of his attempts to create a link with the past and at the same time to succeed in the new competitive print market. Because of its color and more stylized vocabulary, Reinhold Heller suggests that this new style "was less a continuation of Expressionist experimentation than a prefiguration of later devices in form and color identified with Art Deco during the 1920s" (Heller, p.224).

MP

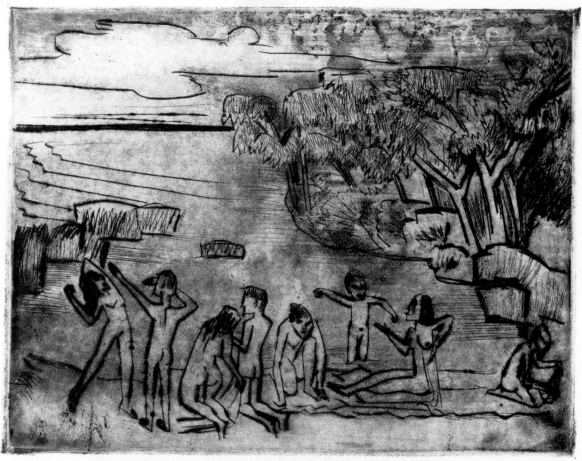

73. *Am Ufer* **(On the Shore), 1920**

From *Die Schaffenden* (The Creators) III, no. 1 (Weimar: Gustav
Kiepenheuer Verlag, 1921)
Drypoint and spitbiting on wove paper
20.3 x 25.8cm
Signed in pencil, l.r., HMPechstein; publishers dry stamp, l.l.
Edition: unnumbered, 25 on Japan, 100 on Bütten
Krüger R116
Provenance: Littmann Collection
Vivian and Gordon Gilkey Graphic Arts Collection 80.122.444

On the Shore, like *Conversation* (plate 72), provides a
nostalgic link with the pre-war Brücke years as well as
catering to the new vogue for Expressionism. It was
Pechstein's fourth print to be published in *Die Schaf-
fenden*, "a periodical in portfolio format" that was created
to supplement *Das Kunstblatt* (The Art Magazine), one of
the most successful of the many art journals that
appeared during the last years of World War I.

On the Shore is a good example of the high quality of
these portfolios. The print is heavily inked and the dry-
point burr provides rich accents amidst the atmospheric
tone. The even tone was probably achieved by using a
chemical wash on the plate, but the mottled effect in the
upper right is the result of using the back of a previously
used etching plate.

MP

74. *Selbstbildnis mit Pfeife (Raucher)* (Self-Portrait with Pipe [Smoker]), **1921**

From *Die Schaffenden* (The Creators) IV, no.1 (Weimar: Gustav
Kiepenheuer Verlag, 1924)
Woodcut on thin wove paper
34.1 x 28.2cm
Signed in pencil, l.r., HMPechstein
Edition: Nr.I-XXV on Japan, 1-100 on Bütten
Krüger H250, no publisher's stamp—outside edition
Provenance: Littmann Collection
Helen Thurston Ayer Fund 52.162

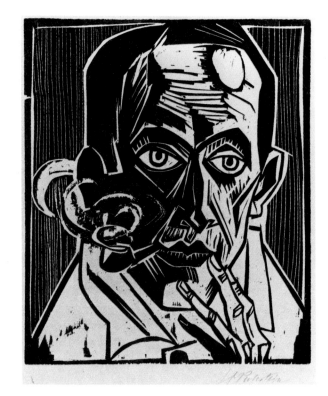

By 1921 Pechstein's reputation within Germany had
become increasingly well-established. Critics regularly
praised him and considered him the leader of the Brücke.
Two monographs on his work were already published,
Fechter's catalogue of his graphics had just appeared, and
a major retrospective was on display in the new museum
of modern art in Berlin. Compared to his self-portrait of
1917, *Self-Portrait with Pipe,* not surprisingly, radiates
confidence.

Typical of Brücke self-portraits, *Self-Portrait with Pipe*
focuses on the head and provides only simple indications
of background. With its broad planes of black and white
dividing the face between deep shadow and bright light,
the portrait takes on a mask-like appearance. Its high
degree of finish and stylization is in contrast to the
process orientation of earlier Brücke work, and in place
of raw energy there is a quiet introspection.

MP

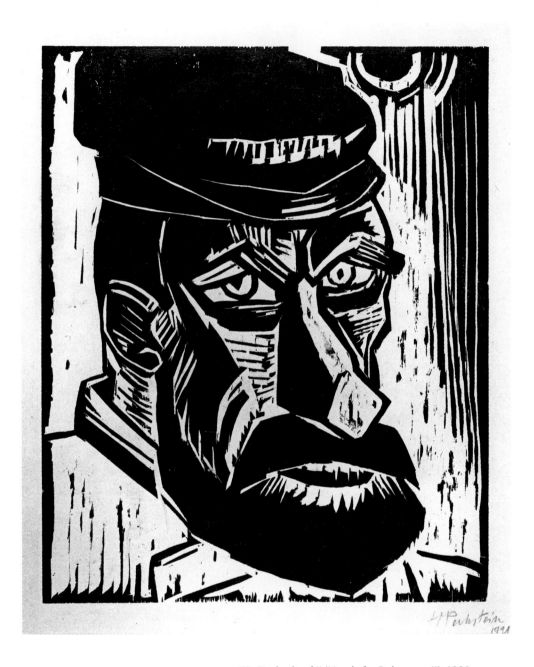

75. *Fischerkopf II* (Head of a Fisherman II), 1921

From *Fischerköpfe* (Heads of Fishermen), a series of 11 woodcuts
Woodcut on heavy wove paper
40 x 32.2cm
Signed and dated in pencil, l.r., HMPechstein 1921
Edition: unknown
Krüger H238
Provenance: Littmann Collection
Vivian and Gordon Gilkey Graphic Arts Collection 82.80.259

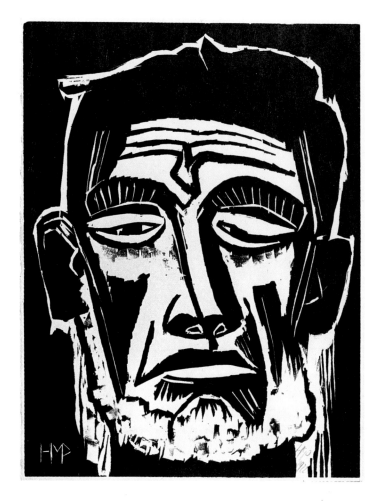

76. *Kopf eines Seemannes* (Head of a Sailor) or *Fischerkopf* (Head of a Fisherman), 1922

From *Arno Holz zum sechzigsten Geburtstage gewidmet von deutschen Künstlern* (Dedicated to Arno Holz on his Sixtieth Birthday by German Artists), a portfolio of 30 original prints by various artists (Berlin: Fritz Gurlitt, 1923)
Woodcut on wove paper
40.2 x 29.8cm
Signed and dated, l.r., HMP 1922; signed in the wood ,l.l., HMP
Edition: 100 numbered portfolios, 30 other
Krüger H269
Provenance: Hanna Bekker vom Rath, Frankfurt am Main
Vivian and Gordon Gilkey Graphic Arts Collection 81.81.429

Pechstein discovered the rugged inhabitants of Nidden during his first trip with Heckel and Kirchner to the Baltic Sea town in 1909. While his colleagues depicted nude bathers, he was drawn to the villagers and the drama of their daily confrontation with the sea. In 1911 he created a series of 11 woodcut portraits of fishermen that can be considered a prototype for these later works.

After the war Pechstein again began spending summers in Nidden and returned to the motif of the fisherman. Unlike the very rough, schematic images of his first series, the fishermen heads from 1921 and 1922 are carved with a greater sense of sculptural form and decorative detail. Many of these later works, such as *Head of a Fisherman II*, resemble African masks with their crude faceting and striated planes; the marks of the shoemaker's knife with which Pechstein carved continue to be plainly visible. With their blunt solidity and weathered features, the fishermen are like archetypes of the honest worker who struggles for survival.

MP

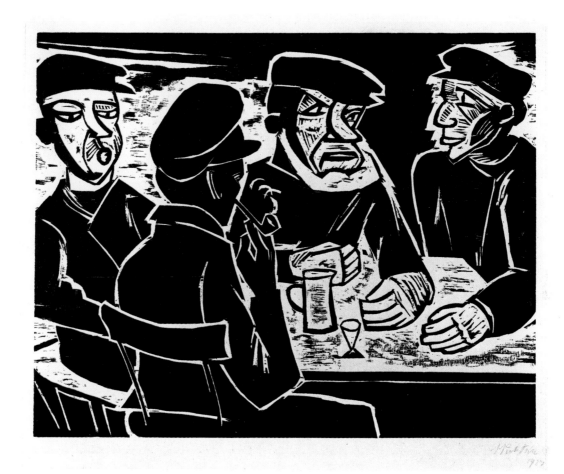

77. *In der Kneipe, Kajüte* (In the Pub, Kajüte) 1922

Woodcut on heavy wove paper
40.1 x 49.7cm
Signed and dated in orange pencil, l.r., HMPechstein 1924
Edition: unknown
Krüger H274
Provenance: The artist
Vivian and Gordon Gilkey Graphic Arts Collection 80.122.52

Pechstein's representation of the men in the pub adds a new dimension to the motif of the fisherman. Seated together around the table, the men are revealed as members of a community such as Pechstein and others had envisioned at the outset of the new Socialist Republic of Weimar. Although there are no specifically religious overtones, the image is reminiscent of the fifth sheet in his Lord's Prayer series (1921), in which four men are seated around a table, hands folded in prayer. Drawing on the iconography of 19th-century Realism, Pechstein uses the North Sea fisherman to represent the embodiment of man's essential goodness.

MP

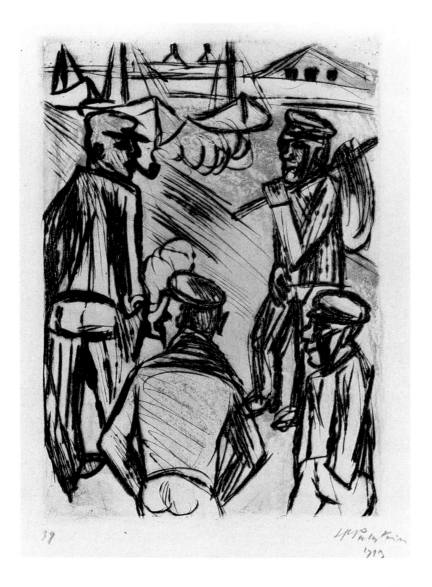

78. *Pommersche Fischer* (Pomeranian Fishermen), 1923

Drypoint and spitbiting on heavy wove paper
24.7 x 17.2cm
Signed and dated in pencil, l.r., HMPechstein 1923; numbered, l.l.,
39
Edition: unknown
Krüger R149
Provenance: unknown
Gift of Frederic Rothchild 76.38.6

After Eastern Prussia, of which Nidden was a part, was placed under temporary French administration as a result of the Versailles Treaty, Pechstein began spending his summers in Leba in Eastern Pomerania. With *Pomeranian Fishermen,* he returns to the motif he first explored in Nidden, but with increased naturalism. Like the lithographic series on the lives of the farmers and fish-ermen of Pomerania he completed the same year, this etching shows the fishermen at work and is less iconic than his earlier series of fishermen heads.

In 1933 Pechstein was dismissed from his teaching post in Berlin. After writing a letter denouncing the labeling of his work as degenerate, he was placed on the Gestapo list of the politically insane. He moved to Leba but even there feared discovery by the Gestapo and withdrew alone to a small hut on Koser Lake where he fished in order to eat and trade with local farmers. He remained in Leba until 1945, returning periodically to his studio in Berlin until it was bombed in 1942, destroying many of his works.

MP

79. *Yali und sein weisses Weib* **(Yali and his White Woman), 1923**

Book with eight etchings with drypoint, roulette and spitbiting, 5/220
Text by Willy Seidel
(Berlin: Fritz Gurlitt Verlag, 1923)
Edition: 220
Krüger R136-143
Provenance: Littmann Collection
Helen Thurston Ayer Fund 59.12 a-h

Yali II (Die Ona and das Weisse Mädchen) (The Ona and the White Maiden)
Drypoint, roulette, and spitbiting on wove paper
24 x 18cm
Signed in pencil, l.r., HMPechstein

Yali IV (Yalis Werbung) (Yali's Wooing)
Drypoint, roulette, and spitbiting on wove paper
23.9 x 18cm
Signed in pencil, l.r., HMPechstein

Willy Seidel's *Yali and his White Woman* relates the story of a shipwrecked child whose life is spared by a tribesman who later claims her for his mate. Reflecting the romantic primitivism of the pre-war Brücke, it is filled with lush descriptions of an unspoiled paradise. "White Bird," as she is called, initially resists Yali's attempt to assert his rights over her. She runs away in search of her mythical dream lover, Oro, but he tragically eludes her; she returns, defeated, to Yali and bears his children.

Pechstein draws heavily on his sketches and memories of Palau for the illustrations to Seidel's poetic text. His use of the roulette to create texture and of drypoint to lend emphasis, particularly to the dark skin of the tribesmen, contributes to the unusually tactile quality of these works.

MP

OTTO MUELLER 1874-1930

Born in Liebau, Silesia (now Poland), Otto Mueller began his training at age sixteen in a four-year apprenticeship to a lithographer in Gorlitz. In 1894 he enrolled at the Academy of Art in Dresden, where he studied for two years. Mueller remained near Dresden until 1908, but did not meet any of the artists affiliated with the Brücke until 1910, two years after his move to Berlin. It was then, after having his work rejected for inclusion in the Berlin Secession exhibition, that he joined Emil Nolde and Max Pechstein in founding the Neue Secession. These artists, along with other members of the Brücke, exhibited their work in an alternative exhibition, "Rejects of the Berlin Secession." Mueller's images of nudes in nature, for which he is best known, caught the attention of the Brücke artists. He was invited to join the group, and he remained affiliated until its dissolution in 1913.

Mueller served in the military for one year during World War I and was hospitalized briefly in 1917. Unlike that of the other Brücke artists, his imagery seems not to have been affected by his wartime experience; his postwar work differs little from that made before the war.

In 1919 Mueller began teaching at the Breslau Academy and continued there until his death. He traveled extensively in Eastern Europe during the 1920s and his art of the period reflects his fascination with the region's gypsy culture. Mueller's interest in printmaking was primarily in lithography. Of his total oeuvre of 149 prints, he made only 6 woodcuts and 1 etching; the rest were lithographs.

VWH

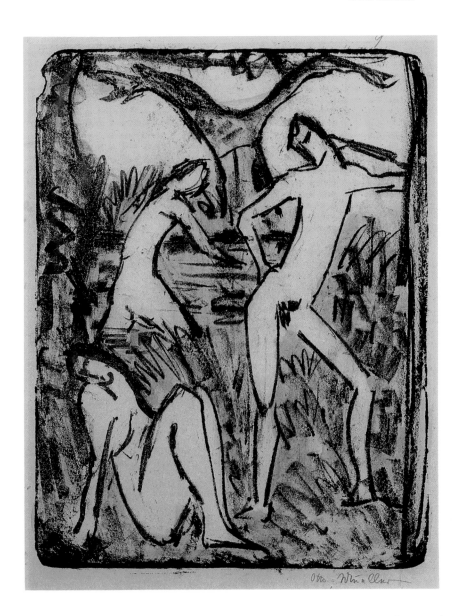

80. _Zwei Mädchen und stehender Jüngling_ (Two Girls and Standing Youth), c. 1910

Hand-colored lithograph on buff wove paper
43.4 x 32.7cm
Signed in pencil, l.r., Otto Mueller
Edition: approximately 3
Karsch 16, I/II
Provenance: Littmann Collection
Vivian and Gordon Gilkey Graphic Arts Collection 85.14.46

When Otto Mueller joined the Brücke in 1910, his artistic style was already developed. Thus, his work shows little change as a result of his new affiliation, save for an increased angularity evident in prints such as _Two Girls and Standing Youth_. Mueller's youthful figures create a classic triangular composition in which there is little sense of comradery. The youths are introspective and their apparent natural kinship with the countryside creates a sense of reverie absent in similar scenes by other Brücke artists.

Again, unlike his Brücke colleagues, whose brilliant colors were expressive in and of themselves, Mueller used subtle tones to complement the serene mood of his compositions. Whether applying his color mechanically during the printing process or by hand after a print was pulled, he tended toward muted shades of blue, green, pink, and ochre. In this print, a single shade of blue bathes the landscape, throwing the figures into relief and underscoring the sense of quiet harmony.

VWH

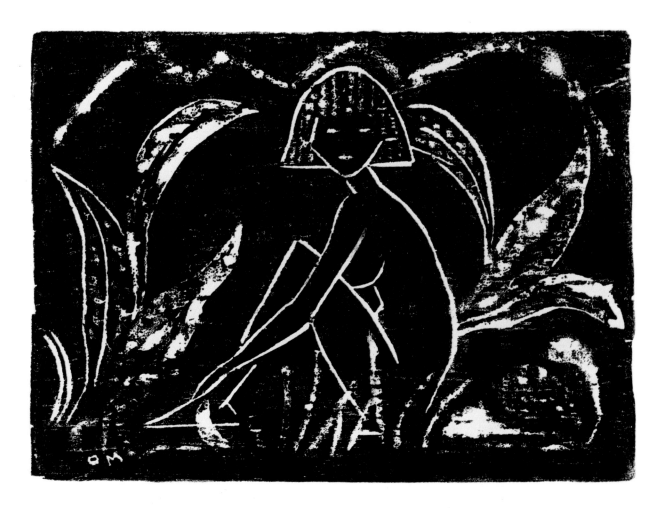

81. *Mädchen zwischen Blattpflanzen* (Girl Between Plants), 1912

Woodcut on heavy wove paper
27.9 x 37.3cm
Signed in block posthumously by Maschka Mueller, l.l., OM
Edition: 500
Karsch 3, IIA/II
Provenance: Carus Gallery, New York
Gift of Ruth Cole and Jacob Kainen 86.102.2

Girl Between Plants is one of only six woodcuts that Mueller made. Undoubtedly encouraged by his association with the Brücke artists to experiment in this medium, his early interest in lithography nevertheless prevailed. Even while carving with a knife, Mueller approached his block as he would a litho stone. In *Girl Between Plants,* for example, instead of carving out around the line; he carved his line directly, so that it appears white rather than black. The soft texture of the leaves and hair is also more characteristic of the lithographic medium than the woodcut.

As in *Three Girls in the Woods* (plate 82), Mueller emphasizes the human affinity to nature by repeating shapes within the composition. The slope of the woman's back is accented by the curving foliage; a distant mountain crowns her head.

Mueller's debt to Egyptian art is revealed in the stylization of the figure. As in Egyptian art she is created from two distinct points of view with her head and body at right angles to one another. The overall flatness of the figure as well as her geometric hairstyle also recall Egyptian models.

Girl Between Plants appears to be a pendant to another woodcut, *Boy Between Plants.* The composition is identical except that the boy faces right, while the girl faces left.

VWH

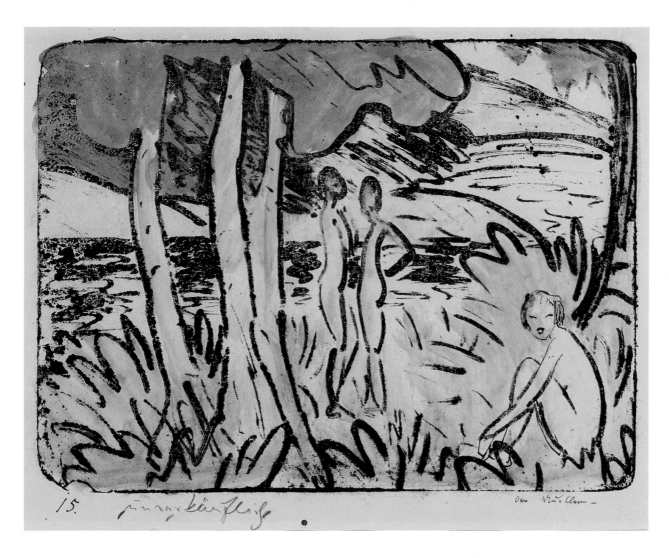

82. *Drei Mädchen im Wald* (Three Girls in the Woods), 1912

Hand-colored lithograph on buff wove paper
32.7 x 43.3cm
Signed in pen, l.r., Otto Mueller; inscribed, l.l., 15. unverkäuflich (not for sale)
Edition: approximately 8
Karsch 26
Provenance: Littmann Collection
Helen Thurston Ayer Fund 52.160

Well over half of Mueller's prints feature Arcadian images of nudes in landscapes. With its lush, timeless setting and softly rounded figures, *Three Girls in the Woods* is one of the finest examples of this genre. Typically, both landscape and figures are treated with equal simplicity, and forms are repeated in both. The smooth curve of the seated figure's back, for example, is continued in the hills beyond the lake, while the trees in the foreground mirror the two standing models. Once again, Mueller applies color to underscore the serene atmosphere of the composition. The darker tones of the trees' foliage provide a protective canopy for the figures below.

The outline of *Three Girls in the Woods* with its notched corner in the lower left is the same as in *Two Girls and Standing Youth* (plate 80), indicating that Mueller used the same chipped stone for both prints. This was, and remains, a common practice for stone lithographers. This particular stone, in fact, was used by Mueller for nearly all of the 50-odd lithographs he made between 1909 and 1914.

VWH

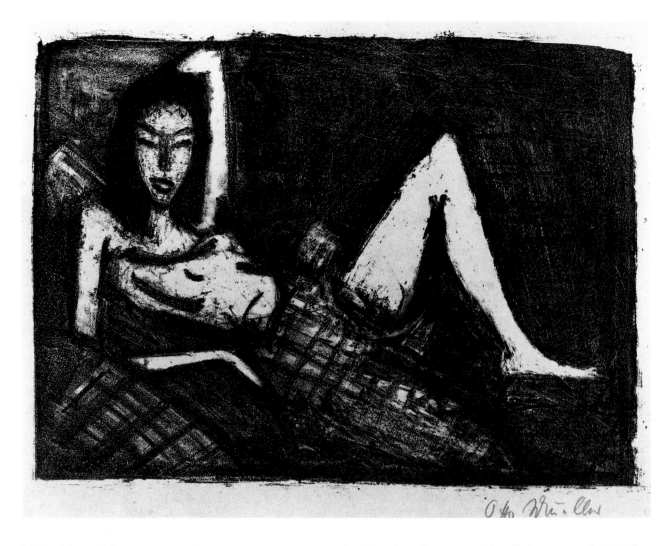

83. *Mädchen auf dem Kanapee (Girl on a sofa)*, 1921-22

Lithograph on heavy wove paper
30 x 39.5cm
Signed in pencil, l.r., Otto Mueller
Edition: 20
Karsch 146, II/II
Provenance: Littmann Collection
Vivian and Gordon Gilkey Graphic Arts Collection G3218

In this print of a young girl reclining on a sofa, Mueller may have been inspired by the manière noire technique, in which the artist blackens the surface of the stone, then scrapes away pigment to shape an image. By building up his blacks on a roughly grained stone and then scratching and scraping through the crayon, Mueller achieved a textural richness and depth that are usually associated with that reductive method. Mueller created a similar surface texture in his paintings, applying color to gesso-treated burlap rather than to a smoother canvas.

Girl on a Sofa is one of several slightly erotic studio nudes Mueller created in 1919 and 1921. Wrapped in darkness, the figure's sensuality is expressed by her seductive pose, exotic features, and the suggestion of discarded clothing.

VWH

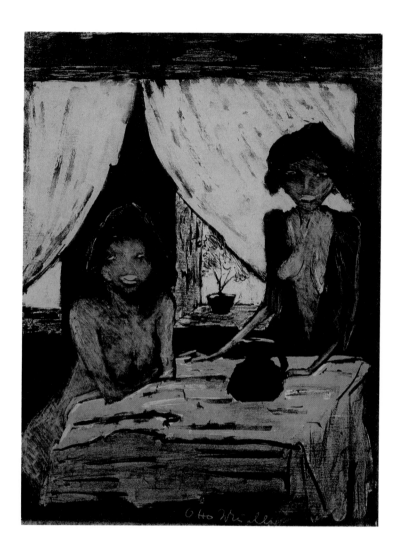

84. *Zwei Zigeunermädchen im Wohnraum* (Two Gypsy Girls in a Room), 1926-27

From *Die Zigeunermappe* (The Gypsy Portfolio), a portfolio of nine color lithographs (Berlin: Neumann-Nierendorf, 1927)
Color lithograph on ochre wove paper
69.9 x 50.2cm
Signed in yellow grease pencil, l.c., Otto Mueller
Edition: 60
Karsch 163, III/III
Provenance: Littmann Collection
Vivian and Gordon Gilkey Graphic Arts Collection 82.80.666

In response to his frequent travels to eastern Europe during the 1920s, Mueller created a portfolio of nine color lithographs portraying the Gypsies of Hungary and Poland. *The Gypsy Portfolio* was printed by a colleague at the Breslau academy where Mueller taught.

Mueller's depictions of the gypsy culture focused on the women and children. As in this print, the women are often bare-breasted, expressing both their sexuality and their roles as nurturing mothers. Mueller was not interested in studies of individuals, but rather in presenting types. As such, figures are interchangeable from one print to the next and the settings appear more as props than indigenous environments.

Unlike the other color lithographs by Mueller in this exhibition, which are hand-colored, the prints of *The Gypsy Portfolio* were created with a number of individually printed stones. For *Two Gypsy Girls in a Room*, Mueller used three stones, printing first with tan ink, then with the red of the skin and tablecloth, and finally with black. His use of a warm, ochre-colored paper adds yet another color and generally enhances the rich tonalities of the image.

VWH

Born into a religious and philosophically oriented family in Munich, Marc's first goal was to become a priest. He received his high school diploma in theology and subsequently spent two years studying philosophy at the University of Munich. After a year of military service, he decided to pursue a career in art and enrolled at the Munich Academy. Trained in academic naturalism, he absorbed a variety of French influences including Impressionism, Post-Impressionism and Art Nouveau during two visits to Paris and Brittany in 1903 and 1907. In 1910 Marc began a friendship with August Macke and Wassily Kandinsky and the next year joined them as a member of the Neue Künstlervereinigung München (New Artists Association of Munich). By the end of the year he, Kandinsky, Alfred Kubin and Gabriele Münter had left in protest and within weeks opened the "1st Exhibition of the Editors of Der Blaue Reiter."

The following year Kandinsky and Marc co-edited the *Almanach Der Blaue Reiter* (Blue Rider Almanac), one of the most important documents of modern art. Marc wrote the lead article, "Spiritual Treasures," in which he lamented the materialism of the age and proposed a new art that would go hand in hand with a new spiritual epoch. Although Marc had made some prints earlier, it was under Kandinsky's impetus that he began making woodcuts. Both artists found the simplification forced by the medium well suited for expressing their spiritual concerns. The second exhibition of Der Blaue Reiter in 1912 was devoted to prints, drawings, and watercolors.

In the fall of 1912, Marc traveled with Macke to Paris where he met Robert Delaunay and also had his first contact with the work of the Futurists. His work became increasingly abstract as he sought to express the unity of animals and nature through the use of purely formal means.

Marc welcomed the outbreak of war in 1914, believing that it would purge the degraded German culture and allow for a return to innocence and purity. He volunteered for service in August 1914 and died at Verdun in 1916. Of the 46 known prints that he made in his short life, a number were first printed in *Der Sturm* and others published only after his death.

MP

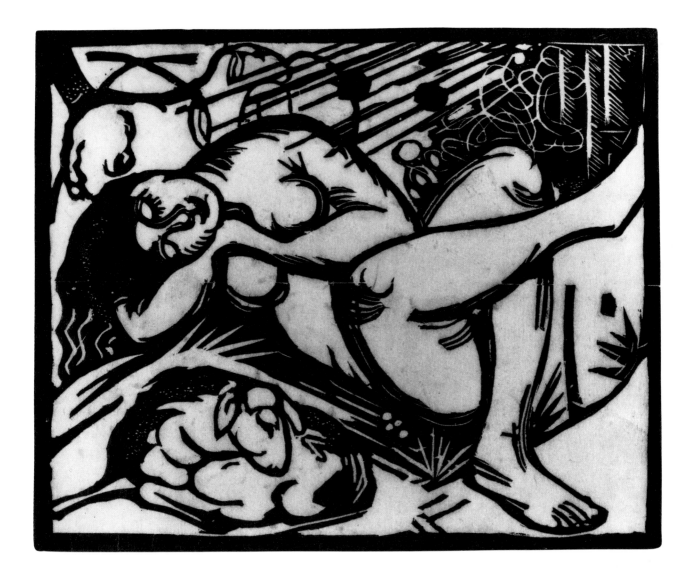

85. *Schlafende Hirtin* (Sleeping Shepherdess), 1912

Woodcut on Japan paper
19.9 x 23.8 cm
Signed in pencil on verso, l.l., Maria Marc; l.c., Schlafende Hirtin; ink
stamp on verso, l.l., Handruck von Originalholzstock bestätigt
Edition: unknown
Lankheit 829, posthumous estate print
Provenance: Maria Marc
Vivian and Gordon Gilkey Graphic Arts Collection 81.81.470

Marc believed that in sleep "the intimate reality of things, our dream life, the true life" is captured and frequently depicted sleeping animals in his work. While he rarely included figures, the sleeping shepherdess symbolizes a state of innocence analogous to that of the animals she herds. The similarity of pose between her and her sheep and the rhythm of curves connecting them suggests that it is in the realm of dream that unity with nature can be achieved for humankind.

While this print was twice published in *Der Sturm* in 1913 and 1916, this particular impression was printed after Marc's death under the supervision of his wife, Maria Marc. The fine white line across the center of the print reflects the gap between two parts of the block that had been glued together.

MP

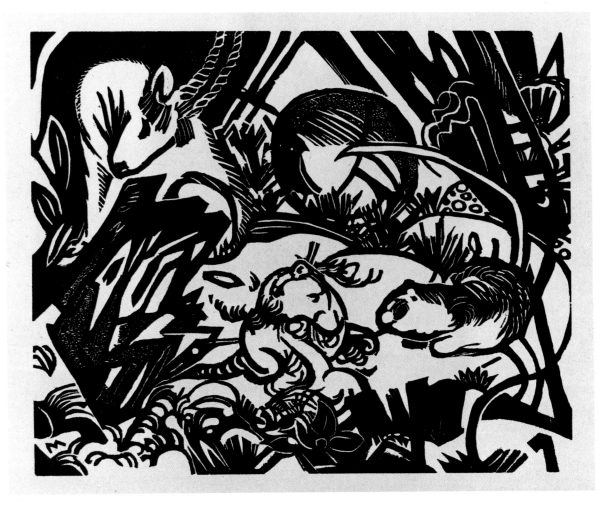

86. *Tierlegende* (Animal Legend), 1912

From *Genius* 1, no.2 (1919)
Woodcut on wove paper
19.7 x 24cm
Printed on verso, l.l., Franz Marc/ Aus der Tierlegende.
Original-Holzschnitt.
Edition: unknown
Lankheit 831.3
Provenance: Estate of Joseph Anthony Horne (purchased by Horne in Germany c.1947-48)
Vivian and Gordon Gilkey Graphic Arts Collection G8547

Like many of his Expressionist colleagues, Marc felt a yearning to escape the world in which he lived and to return to a more innocent state. Influenced by the 19th-century philosophy of Jean-Jacques Rousseau and others, he believed that modern man had alienated himself from nature through an over-emphasis on rationality. Animals were considered purer and instinctually truer than humans and thus became a symbol of that longed-for unity with nature.

In a letter of 1911 Marc wrote, "People with their lack of piety...never touched my true feelings. But animals with their virginal sense of life awakened all that is good in me." For many years he portrayed animals exclusively in his work, using them as a vehicle for his own spiritual expression.

The vigorous composition of *Animal Legend* reflects Marc's recent travels to Paris where he was introduced to the Orphic Cubism of Robert Delaunay and the work of the Futurists. Through his interweaving of representational and abstract forms, of curvilinear and linear lines, and positive and negative space, he conveys the dynamic relationship between nature and animals, the "organic rhythm" that binds everything into a spiritual whole.

Animal Legend was first published in *Der Sturm* 3, no.127/128 in 1912.

MP

Wassily Kandinsky was a central figure in the development of 20th century art. A poet, playwright, painter and printmaker, he was one of the first artists to make the transition from representational to abstract art.

Born in Russia in 1866, Kandinsky forsook a law career and moved to Munich, Germany in 1896 to study painting. He subsequently founded several artists' groups including Phalanx (1901), the Neue Künstlervereinigung München (1909), and, with Franz Marc, Der Blaue Reiter (1911). Through Der Blaue Reiter's invitational exhibitions and the *Almanach Der Blaue Reiter* (Blue Rider Almanac), he and Marc embraced a wide range of artistic forms — from drawings by children and paintings by Cézanne to medieval woodcuts and sculpture from South Borneo—forms which, though diverse, shared in embodying the "inner desire" of the artist. Kandinsky carried this idea to its conclusion in his influential treatise, *Über das Geistige in der Kunst* (On the Spiritual in Art), where he posited the development of an abstract art based on a sensitivity to pure form and color and rooted in "inner necessity."

At the outbreak of World War I, Kandinsky returned to Russia where he was prominent in the formation of a post-revolutionary culture. When the new Soviet government became hostile to avant-garde art, he left his homeland once more and accepted a teaching position at the Bauhaus, first at Weimar and then at Dessau. He stayed in Germany until 1933, when the Nazis closed the school. He spent the last 11 years of his life in Paris.

Printmaking was an integral part of Kandinsky's artistic activities. He made prints throughout his career and maintained that there was no essential difference between the graphic arts and painting. While emphasizing their common roots in inner necessity, Kandinsky also noted the distinctiveness of the respective techniques. In his book, *Punkt und Linie zur Fläche* (Point and Line to Plane), 1926, he describes the specific characteristics of the principal graphic media and explores their relationship to the basic pictorial elements of point, line and plane. Kandinsky's sensitivity to the inherent qualities of the medium is evident in most of his 203 known woodcuts, drypoints, and lithographs.

MP

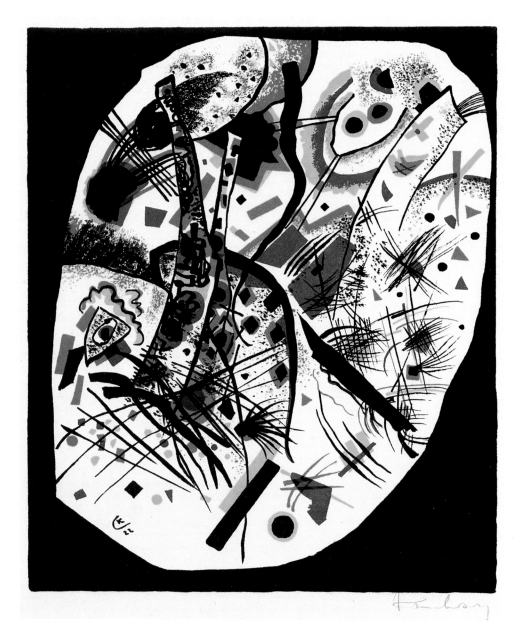

From *Kleine Welten* (Small Worlds), a portfolio of 12 prints (Berlin:
Propylaen Verlag, 1922)
Printed at the Staatliches Bauhaus, Weimar
Edition: 30 on Japan, 200 on Bütten

87. *Kleine Welten III* (Small Worlds III), 1922

Color lithograph on wove paper
27.8 x 23 cm
Signed in pencil, l.r., Kandinsky; signed and dated on the stone, l.l.,
K 22
Roethel 166
Provenance: Gerd Rosen, Berlin
Vivian and Gordon Gilkey Graphic Arts Collection 79.50.89

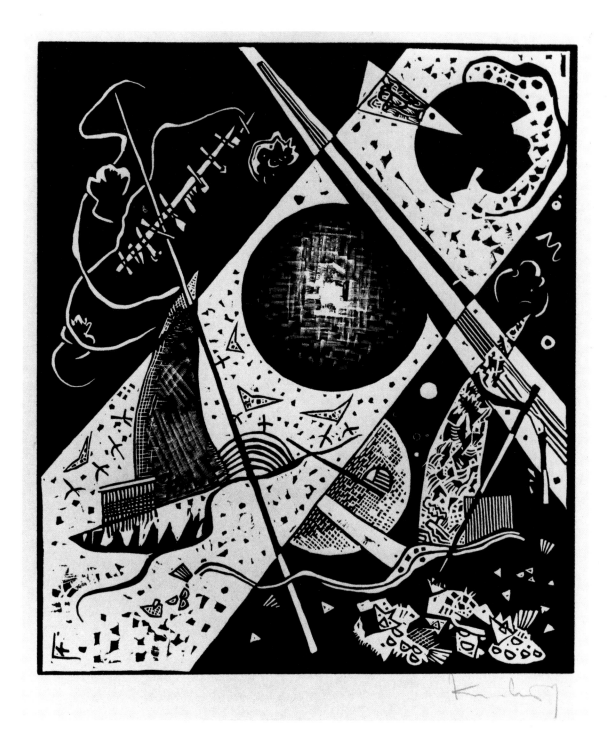

88. *Kleine Welten VI* **(Small Worlds VI), 1922**

Woodcut on wove paper
27.3 x 23.3 cm
Signed in pencil, l.r., Kandinsky; signed in the block, l.l., K
Roethel 169
Provenance: Gerd Rosen, Berlin
Vivian and Gordon Gilkey Graphic Arts Collection 81.81.439

◆ 105 ◆

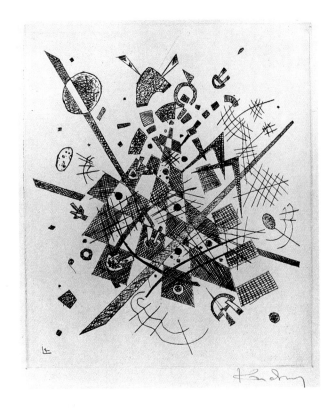

89. *Kleine Welten IX* **(Small Worlds IX), 1922**

Drypoint on heavy wove paper
23.7 x 19.8 cm
Signed in pencil, l.r., Kandinsky; signed in the plate, l.l., K
Roethel 172
Provenance: Gerd Rosen, Berlin
Vivian and Gordon Gilkey Graphic Arts Collection 81.81.430

Small Worlds was Kandinsky's most important statement as a printmaker during the latter half of his career and one of the principal productions of the Bauhaus printing workshop. The portfolio comprises four drypoints, four woodcuts — two in black and white and two in color (which were actually transfer-lithographs created from woodcut impressions) — and four color lithographs. Kandinsky's use of the different media allowed him to demonstrate the unique character of each and to illustrate his belief that all phenomena, including technical resources, arise from inner necessity. As he wrote in the introduction to the portfolio, "In all twelve cases, each of the *Small Worlds* adopted, in line or patch, its own necessary language."

The character of the various languages, or techniques, is explained in *Point and Line to Plane.* Etching is noted for the utmost precision of its line and its appropriateness for black and white. Accordingly, the drypoint etching, *Small World IX,* is a study of lines: ruled and free-hand, cross-hatched and scribbled. The woodcut, *Small World XI,* on the other hand, is characterized by the interplay of foreground and background planes (positive and negative space) and various illusions of texture. In the lithograph, *Small Worlds III,* Kandinsky combines the whole range of points, lines, and planes, and also color to create an image that most closely approximates a painting. Because of its facility of execution and ease of correction Kandinsky considered lithography the most appropriate print medium for his time.

Stylistically, the twelve prints represent a transitional phase in Kandinsky's development between his recognizable abstractions of the earlier decade and the strict geometry of his later years at the Bauhaus. While the use of ruler and compass in *Small World XI* looks forward to Kandinsky's cool Bauhaus style, for example, *Small Worlds III,* with its hieroglyphic references to the physical world, is reminiscent of his earlier *Improvisations.* All of the compositions resemble to some degree cosmological phenomena and call to mind Kandinsky's statement that "the entire 'world' can be regarded as a self-contained, cosmic composition, which itself consists of innumerable, independent hermetic compositions" (*Point and Line to Plane,* p.554).

MP

Paul Klee was born near Bern, Switzerland, the son of two musicians. Talented in both music and fine arts, he decided to pursue the latter and moved to Munich in 1898 to study drawing. Following trips to Italy (1901-02), Paris (1905), and Berlin (1906), Klee settled in Munich with his wife, Lily Stumpf. There he met Kandinsky and became involved with Der Blaue Reiter. After an influential trip to Tunisia in 1914, Klee developed his mature style. No longer drawing his subjects directly from nature, he probed his imagination, his experiences, poetry, music, and the world of science. He became "above all a painter of ideas and visions" (Museum of Modern Art, p.9).

Klee was invited to join the faculty of the Bauhaus in 1921 and remained associated with it until 1931, when pressures within and without the institution led him to resign. These were highly productive years for Klee, who thrived on the stimulation of students and colleagues, especially, Kandinsky. In 1931, Klee left the Bauhaus to teach at the Düsseldorf Academy. Forced to resign this position by the Nazi government, he left Germany for Bern in 1933. His works were included in the Degenerate Art exhibition held in Munich in 1937.

One of the most inventive and prolific of the modern masters (he is credited with 9,000 works), Klee nevertheless made relatively few prints — a total of 109. Although his earliest work was in the graphic arts, he gradually ceased making prints altogether. Called a "reluctant printmaker" by art historian Charles Haxthausen (*In Celebration of Paul Klee 1879-1940*, p.9), Klee seldom improvised in the medium but rather used it largely as a reproductive method. The prints typically were based on at least one model, usually a preparatory drawing, and usually following it by several years. Before World War I he made only one or two proofs of most of his prints; afterwards nearly all were produced in fairly large editions, many for journals of original graphics, deluxe editions, and group portfolios.

MP

90. *Kleinwelt* (Little World), 1914

From *Die Schaffenden* (The Creators) I, no. 1 (Weimar: Gustav
Kiepenheuer Verlag, 1919)
Etching on zinc on heavy wove paper
14 x 9.5cm
Signed in pencil, l.r., Klee; titled, l.l., Kleinwelt; signed and dated in
plate, u.r., 1914 120 Kl
Edition: 100
Kornfeld 61 (work number 120)
Provenance: HOM Gallery, Washington, D.C.
Gift of Ruth Cole and Jacob Kainen 87.33

Influenced by Robert Delaunay's Orphic Cubism and by
Kandinsky's spiritual orientation, Klee's work under-
went a shift from the Impressionism of his preceding
years in Munich towards a visionary, Cubist-inspired
style. *Little World,* though small in scale, reflects a wide
range of influences from Cubism and Expressionism to
the art of children and ethnic cultures championed by
Der Blaue Reiter. From Cubism Klee derived the shallow
pictorial space of *Little World*, its fragmented structure
and lack of a single compositional focus. Through foul-
biting he created a textured field and populated it with
tiny stick figures, puppet faces, and assorted doodles.
The result is an explosive chaos that mirrored the social
context just before the outbreak of World War I.

In 1914, Klee traveled to North Africa where he expe-
rienced a dramatic conversion to color. He began to focus
his efforts on watercolors and his interest in prints
waned. *Little World* is one of only four prints he made in
this year and one of the few he created before the end of
the war in 1918.

MP

91. *Zerstörung und Hoffnung* (Destruction and Hope), 1916

Lithograph with watercolor on laid paper
46.5 x 33.2cm
Signed, dated and titled in pencil, l.c., 1916 55 KLee
Zerstörung und Hoffnung; signed in the plate, l.c., Klee
Edition: 15 on Japan, 45 on Bütten
Kornfeld 68, trial proof (work number 55)
Provenance: Buchholz Gallery, New York
Helen Thurston Ayer Fund 40.42

The summer after Klee was drafted into the German infantry reserves, he was transferred to a flying school near Munich. There he rented a room in a farmhouse where he could play the violin and paint in his free time. His son Felix described how he had taken stacks of the lithograph, *Destruction and Hope* to the room and "touched them up there with watercolor, adding colored triangles, circles, stars, and moons" (Rewald, p.31). Using stencils to apply the color, Klee created four separate watercolor versions in the edition of sixty. The

Portland print, however, is an unnumbered variant and thus can be considered a trial proof.

Destruction and Hope is a succinct statement about the devastation of World War I and the persistence of hope. Klee uses a cubist scaffolding with its fractured space and razor-sharp angles to create a sense of anxiety and a metaphor for war's ruin. Imbedded in the scaffolding are two military figures wearing buttoned coats and the spiked helmets of the German army. While they are associated with the rubble of shapes and lines before them, the sun, moon, and stars, painted in transparent watercolor, float free of the destruction and symbolize hope.

Drawn with tusche ink and a pen, the print was published by the Munich dealer, Hans Goltz. He had sponsored the second Blaue Reiter exhibition, in which a number of Klee's prints were included, and became Klee's dealer in 1919.

MP

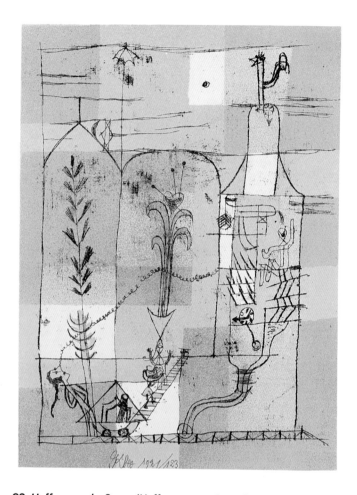

92. *Hoffmanneske Szene (Hoffmanesque Scene)*, 1921

From Bauhaus-Drücke, Neue europäische Graphik (Bauhaus
Impressions, New European Graphics), Portfolio I (Weimar, Bauhaus,
1921)
Color lithograph on heavy wove paper
31.6 x 22.9cm
Signed and dated, l.c., Klee 1921/123
Edition: unnumbered, 10 on Japan, 100 on velin
Kornfeld 82 (worknumber 123)
Provenance: Buchholz Gallery, New York
Helen Thurston Ayer Fund 40.43

Hoffmannesque Scene was one of about twenty prints Klee
made at the Bauhaus in Weimar and one of two that was
included in the 1921 Bauhaus Portfolio with two works
each by other Bauhaus masters. The portfolio was the
first fruit of an ambitious Bauhaus project to document
contemporary modernism with prints from all the major
European countries.

Inspired by the comic opera *Tales of Hoffmann* by
composer Jacques Offenbach, *Hoffmannesque Scene*
exemplifies the light humor and musicality of Klee's
work. Like most of Klee's lithographs of the 1920s, it was
created through an innovative method of oil transfer.
Although transfer paper was a stock item in lithography
shops, Klee elaborated on the technique to create unique
drawings as well as highly original prints. By using an
intermediate sheet covered in oil paint as the carbon
paper, he transferred not only the line of his stylus but
also marks from the pressure of his hand. In this way, he
added both an element of texture and the quality of
controlled accident to his compositions.

With the aid of the trained printers at the Bauhaus,
Klee was able to create color prints without relying on
hand-coloring or stenciling techniques. *Hoffmannesque
Scene*, one of several examples from the 1920s, is notable
for its economical use of color. Using only two color
stones, Klee arranged for the overlappping of yellow and
purple to produce a third color, a tannish-brown. With
the addition of the white rectangles, areas reserved for the
color of the paper, he created a total of four separate layers
that appear to float around and under the drawn line.

MP

93. *Kopf bärtiger Mann* (Head of a Bearded Man), 1925

Lithograph on wove paper
22.1 x 15.2cm
Signed in pencil, l.l., Klee; signed and dated in the plate, l.c., Kl 1925
R4.; publisher's dry stamp, l.l.
Edition: 30 on Japan, 232 on velin
Kornfeld 98 (work number 84, (R.4))
Provenance: O.W. Gauss, Munich
Vivian and Gordon Gilkey Graphic Arts Collection 82.80.258

When the Bauhaus was forced to move to Dessau following its closing by the newly elected Weimar government, the emphasis changed from the fine to the applied arts. The print shop was reorganized as a commercial print shop, and the department concentrated on publication projects to the exclusion of fine prints. Without the facilities and expertise formerly provided him, Klee could not print lithographs and produced only four etchings while he was there between 1925 and 1931.

In 1925 Klee drew a series of 18 satiricial "portraits" characterized by short, quirky marks. *Head of a Bearded Man* was copied from one of these drawings by means of his oil transfer technique, though it was not published until 1930 by O. W. Gauss. Klee's sense of humor emerges in this portrait, said by the publisher to be a self-portrait; the "bearded man" is not just a man with a beard, for *all* of his features are delineated by variants of the same beard-stubble mark. (Interestingly, Klee shaved his beard for the first time in years in April 1925.) The figure is also, however, an image of transience—a loose collection of matter, verging on complete dissolution.

Head of a Bearded Man is one of the last lithographs that Klee made. After a three-year hiatus, he made his last ten prints, all etchings, in the years 1928-1932.

MP

LYONEL FEININGER 1871-1956

Lyonel Feininger was born in New York City in 1871 to musicians of German descent. In 1887 he went to Germany to study music but turned instead to painting. Following several years of art school in Hamburg, Berlin, and Paris, he settled in Berlin where he supported himself as a successful cartoonist from 1893 to 1908. His growing ambition to become an independent artist took root in Paris during a two-year sojourn with the painter, later his wife, Julia Lilienfeld. In 1913 Feininger was invited by Franz Marc to exhibit with Der Blaue Reiter, and in 1917 he had his first one-man exhibition at the Sturm Gallery.

Feininger became the first appointee to the staff of the Bauhaus in 1919 when he was made Master of Form in the graphic workshop. In 1924 he resigned his position to devote more time to his own work, but he continued to be affiliated with the school until it was closed by the Nazis in 1933. That same year Feininger was denounced as "degenerate," and in 1936 he and his family sought refuge in the United States, first settling in California where he taught at Mills College. He moved to New York City in 1937 and lived there until his death in 1956. Although Feininger was acknowledged in Germany as one of the foremost avant-garde artists of the time, he was largely unknown in the United States until a retrospective at the Museum of Modern Art in 1944 established his reputation.

Feininger's prints, created between 1906 and 1955, have been increasingly recognized as a significant part of his oeuvre. Only about one-fifth of his 65 etchings, 324 woodcuts and 20 lithographs were ever editioned, however, contributing to their relative scarcity. As with his paintings, Feininger drew his subject matter largely from architecture, land and sea, and combined the influence of French Cubism with a strong romantic feeling.

MP

94. *Kleinstadt* (Small Town) or Sonnenaufgang (Sunrise), 1911

From *Arno Holz zum sechzigsten Geburtstage gewidmet von deutschen Künstlern* (Dedicated to Arno Holz on his Sixtieth Birthday by German Artists), a portfolio of 30 original prints by various artists (Berlin: Fritz Gurlitt, 1923)
Etching on wove paper
15.3 x 23.5cm
Signed in pencil, l.l., Lyonel Feininger; titled, l.r., Kleinstadt; signed and dated in the plate, l.r., Leinoel Einfinger / 1911
Edition: 100 numbered portfolios, 30 other
Prasse E37
Provenance: Hanna Bekker vom Rath, Frankfurt am Main
Vivian and Gordon Gilkey Graphic Arts Collection 85.14.40

Small Town is representative of Feininger's first successful work as an independent artist. After freeing himself from the "serfdom of the caricaturist's life" a few years earlier, he had begun his new career by working directly from nature. By 1910 he realized that he needed to free himself from nature as well and began creating from his imagination. Works such as *Small Town* from the following year have a quirky animated look that represents a direct link with his earlier caricatures. His sense of humor is evident not only in the image but also in the soundplay of his signature, "Leinoel Einfinger" (Linseed oil One-finger). At the same time, Feininger's manipulation of scale and traditional perspective, and his interest in the effects of movement indicate a sophisticated awareness of the issues central to the avant-garde of the time.

MP

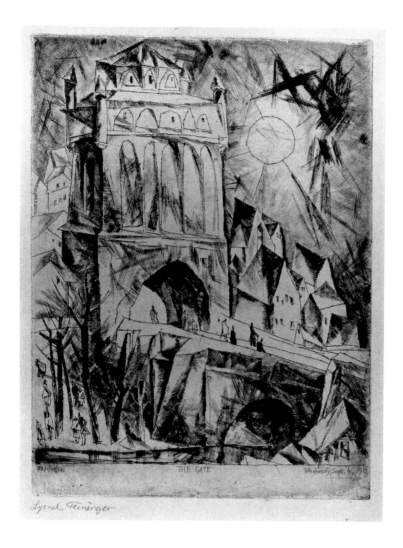

95. *Das Tor* (The Gate), 1912

From *Die Schaffenden* (The Creators) I, no. 1 (Weimar: Gustav
Kiepenheuer Verlag, 1919)
Etching and drypoint on wove paper
27 x 20cm
Signed in plate, l.l., Feininger; l.c., THE GATE; l.r., Wednesd'y,
Sept. 4, 1912
Signed in pencil, l.l., Lyonel Feininger; publisher's dry stamp, l.l
Edition: 25 on vellum, 100 on wove
Prasse E52
Provenance: David Tunick, Inc., New York
Helen Thurston Ayer Fund 81.77

In the spring of 1911, Feininger exhibited six paintings at
the Salon des Independents in Paris and there for the first
time witnessed the new discoveries of the Cubists. He felt
an immediate sense of recognition and excitement,
which was soon reflected in his work. *The Gate* is one of
Feininger's few drypoints and the first of his prints to
exhibit his assimilation of Cubist style and techniques.

Like his Parisian friend Robert Delaunay, Feininger
approached Cubism less as an exploration of volume
than of the effects of light. In *The Gate*, the fragmenta-
tion of the architecture is derived from the visual force of
the blazing sun. The monumental scale of the gate tower,
with its sharp surfaces and mysterious opening, contrib-
ute to the overall mystical quality of the work. Feininger
returned to this subject in several woodcuts, *Town Gate,
Ribnitz* (1918), *The Gate* (1920), and a painting, *Town Gate
(of Ribnitz)* (1943).

MP

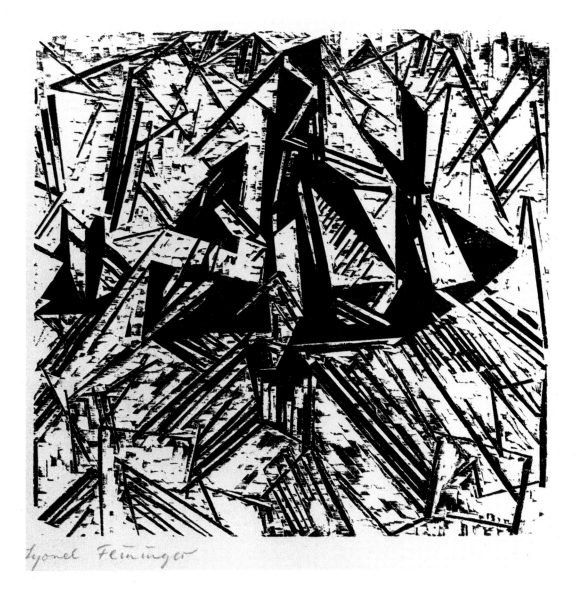

96. *Barke und Brigg auf See* **(Bark and Brig at Sea) or** *Segler*
(Sailboat), 1918

From *Die Fibel* (The Primer) (Darmstadt: Karl Long Verlag, 1919)
Woodcut on laid paper
17.8 x 18.1cm
Signed in pencil, l.l., Lyonel Feininger
Edition: unknown
Prasse W 99, II/II
Provenance: Gerd Rosen, Berlin
Vivian and Gordon Gilkey Graphic Arts Collection 82.80.256

Due in part to the shortage of materials such as oil paint
and copper etching plates near the end of World War I,
Feininger, like many leading artists of the time, turned to
woodcut. The simplest and most direct of the graphic
media, the woodcut required nothing more than a sturdy
pocket knife and an ordinary plank or cigar box cover.
Using the palm of his hand for pressure, Feininger
printed most of the blocks himself and seldom in edi-
tions. In 1918, the year he made his first woodcuts, he
produced 115 individual blocks.

Feininger's work in woodcuts was effective in helping
him to simplify issues of spatial organization. *Bark and
Brig at Sea* is typical in its boldness of design and high
degree of abstraction. Feininger uses the inherent
angularity of the woodcut line to emphasize the
crystalline structure of his forms and the unity of the
picture plane. Sky and ocean, foreground and back-
ground are so well integrated that they are almost indis-
tinguishable from each other.　　MP

ALFRED KUBIN 1877-1959

Alfred Kubin was born in Leitmeritz, a small town in what is now Czechoslovakia, but was then part of the Austro-Hungarian Empire. The son of an Austrian officer turned civil servant, Kubin suffered a very unhappy childhood following the death of his mother, a gifted pianist, when he was 10. After a series of adversities, including a stint in the army and a mental breakdown, he was sent to Munich at age 21 to study art. Visiting art museums for the first time, he admired many artists, among them Hieronymus Bosch, Pieter Brueghel, James Ensor and Odilon Redon, but was especially influenced by the symbolic undertones and narrative structure of the work of Max Klinger.

Kubin experienced a turning point in his life when, in reaction to the grief over his father's death in 1907, he wrote the novel *Die andere Seit* (The Other Side). It brought about the realization that the "highest values reside not only in the bizarre, sublime and comical moments of existence, but that the embarrassing, the indifferent, the commonplace and irrelevant hold the same secrets." At this time he gave up struggling to become a painter and resolved to devote himself entirely to pen drawings.

In the next 50 years Kubin created thousands of pencil sketches, pen and ink drawings, and lithographs. He illustrated approximately 100 books including works by Edgar Allan Poe, E.T.A. Hoffmann, Fyodor Dostoyevsky and August Strindberg. Drawing with a loose scratchy scribble, Kubin created fantastic scenes dramatized by strong light and dark contrasts.

Although Kubin rejected modernism in his work, he exhibited with Der Blaue Reiter and counted among his close friends Edvard Munch, Lyonel Feininger, Paul Klee and Jules Pascin. Representing a nebulous area between the conscious and the unconscious, his works have been hailed as precursors of Surrealism, though there is no direct link between him and that movement.

MP

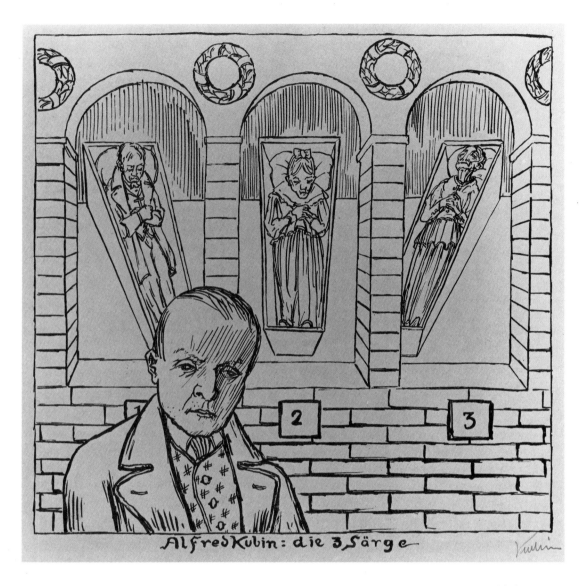

97. *Die 3 Särge* **(The Three Coffins), 1923**

Lithograph on wove paper
29.2 x 29.5 cm
Signed in pencil, l.r., Kubin; signed in the stone, l.c., Alfred Kubin: die 3 Särge
Edition: 100 on Bütten
Raabe 200
Provenance: Littmann Collection
Vivian and Gordon Gilkey Graphic Arts Collection 80.122.434

This self-portrait of Kubin at age 46 shows the formative influence upon the artist of the deaths first of his mother, then his fiancée, and finally, his father. He represents himself as middle-aged and introspective, dominated by a memory that is palpably real. Kubin grants the viewer a sense of clairvoyance through his use of multiple viewpoints and the dispassionate summary of his fate: 1,2,3.

As a result of these personal experiences, death is a frequent presence in Kubin's work. In 1918, a selection of drawings on death titled *Die Blätter mit dem Tod (Ein Totentanz)* (Sheets with Death [A Dance of Death]) was published by Paul Cassirer, Kubin's first dealer. The book included images of death overtaking a draftsman and a painter among others, and concluded with a view of a gravestone engraved with "A.Kubin" above a skull and crossbones. MP

98. *Antlitz des Tigers* **(Countenance of the Tiger), 1923**

Lithograph on wove paper
20.1 x 32.5cm
Signed in pencil, l.r., A Kubin; numbered, l.l., 9/35; signed in the stone, l.l., A Kubin
Edition: 40 on Japan, 35 on Bütten
Raabe 197
Provenance: Littmann Collection
Vivian and Gordon Gilkey Graphic Arts Collection 80.122.433

Like much of Kubin's work, *Countenance of the Tiger* has a distinctly narrative if not illustrative quality to it. In a clear, realistic manner, it depicts the unlikely encounter between a tiger and a well-dressed man with an umbrella. Having frightened off the man, the tiger now confronts the viewer with its mysterious gaze.

Kubin frequently depicted wild animals such as lions, tigers, and panthers in his work. Unlike the animals in the work of Franz Marc, however, which symbolize unity with nature, Kubin's animals represent the untamed, wild, and dangerous aspects of nature and are usually threatening to man. The threat in *Countenance of the Tiger* is typically ambiguous yet weighted with implication. With its dream-like unreality, the image is characteristic of Kubin's blending of the mundane with the metaphysical.

MP

Ludwig Meidner was born in 1884 to a prosperous family in Bernstadt, Silesia (now Poland). His early decision to study art caused a rift in his family, after which he renounced his Jewish faith, joined the Socialist party, and went to Breslau, where he studied at the Royal School of Art for two years. In 1905 he went to Berlin for a brief time, and then to Paris, where he studied at the Cormon and Julian academies. He was greatly impressed by the Impressionist and Post-Impressionist paintings which he encountered in the Parisian art world.

The years from 1907, when he returned to Berlin, until 1920 were those of Meidner's greatest intensity and strength as an artist. After seeing a Futurist exhibition in 1912 he became one of the founders of Die Pathetiker (The Pathetics), whose members painted apocalyptic subjects in the skewed perspectives favored by Futurists. For Meidner personally, it was a period of ecstatic and mystical religious visions that prompted eccentric behavior and eruptions of manic painting activity. He developed a highly emotional and personal style to convey his frenetic interpretations of the city and of contemporary life. As one of Berlin's avant-garde intellectuals, he wrote with a passion similar to that found in his paintings. His writings appear in the journals of Novembergruppe and Arbeitsrat für Kunst, among others, as well as two volumes of prose poems published in 1918 and 1920.

Although conscripted, Meidner did not see action in World War I. Nevertheless, he was able to convey the catastrophic atmosphere of Germany during that period, not only through his cataclysmic city and war scenes, but also through revealing self-portraits and portraits of prominent intelligentsia. In the early 1920s his political fervor waned, and he concentrated on making art.

After the war Meidner's art lost its unique intensity. He became a teacher in a Berlin art school, married, and wrote short stories and essays. In the rising tide of Nazism he proclaimed his Jewishness, and in 1939 was forced to flee with his wife and son to London. He returned to Germany in 1952, and in 1963 had a one-man show, his first since 1918. In his later years he was a productive member of the Berlin Academy of Art. He died in Darmstadt on May 14, 1966.

Unlike the members of Die Brücke, Meidner was not drawn to the use of the woodblock in printmaking. Although a few lithographs are included in his oeuvre, he seems to have made mostly drypoints and etchings, with his greatest productivity occurring in the early 1920s. Very few prints are dated after 1930.

LA

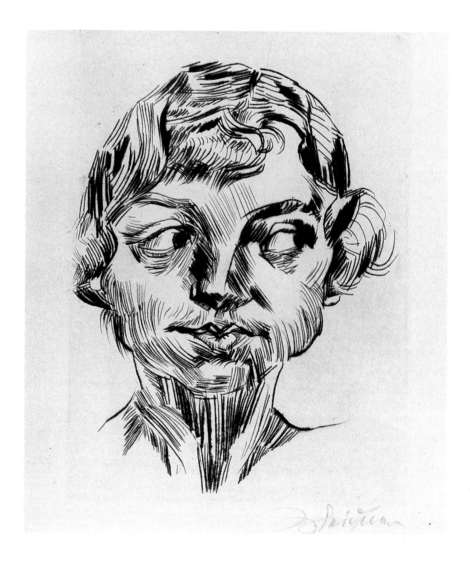

99. *Porträt Florine von Platen* (Portrait of Florine von Platen), 1920

Drypoint on wove paper
17.2 x 12.3cm
Signed in pencil, l.r., Meidner
Edition: unknown
Provenance: R.E. Lewis, San Francisco
Vivian and Gordon Gilkey Graphic Arts Collection G7291
Note: There is currently no catalogue raisonné of Meidner's graphic work.

Meidner, whose writing style was as fervid as his art, wrote in "Vom Zeichnen" (On Drawing) for *Das Kunstblatt* (Artpapers):

> Do not be afraid of the face of a human being. It is the reflection of divine glory although it is more often like a slaughterhouse, bloody rags and all. Press together wrinkled brow, root of nose and eyes. Dig like a mole down into the mysterious deep of the pupils and into the white of the eye and don't let your pen stop until the soul of that one opposite you is wedded to yours in a covenant of pathos.

The portrait of Florine von Platen, who was the former wife of a prominent actor of the time, Eugen Klopfer, is a good example of Meidner's concentration on the psychological aspects of his subjects. The pose is frontal but the eyes do not engage the viewer. Looking off to the far left, the sitter seems aloof and self-contained, absorbed in her own thoughts.

Meidner admired Van Gogh's visionary late work, and the slashing, forceful lines in this drypoint show a similar intensity of style. They push and pull the muscles and features of the face as well as the hair into a pulsing framework for the focal point, the large eyes with their blurred black pupils.

LA

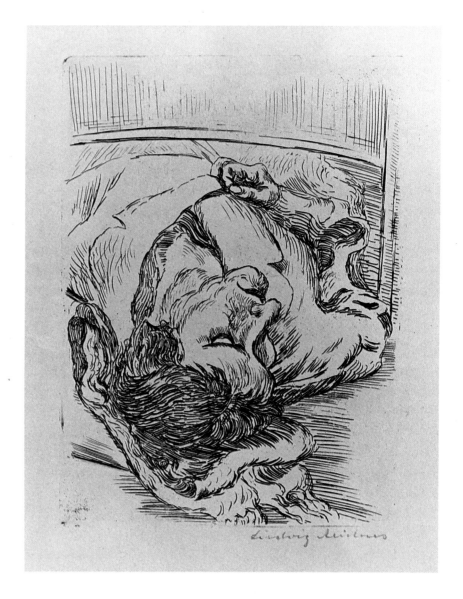

100. *Porträt Tanja liegend* **(Portrait of Tanja reclining), 1923**

Etching on wove paper
17.4 x 12.5cm
Signed in pencil, l.r., Ludwig Meidner
Edition: unknown
Provenance: Littmann Collection
Vivian and Gordon Gilkey Graphic Arts Collection 81.81.226

Although many of Meidner's subjects were prominent intellectuals of the time, some, like Tanja, were personal friends. The pose indicates familiarity as well as psychological tension. Tanja appears to be sleeping but the mood, reflected by the unusual, foreshortened pose and agitated lines, is less serene than anxious.

During the 1920s Meidner may have been better known as a writer than an artist. However, due to the encouragement of the Berlin art dealer, Fritz Gurlitt, he was also productive in graphics, many of which were published by the Verlag für Judische Kunst und Kulture (Publishers for Jewish Art and Culture).

Portrait of Tanja Reclining is an example of Meidner's expressionistic drawing technique, in which he builds his forms and shapes his composition out of choppy, directional lines. The dense markings of the hair form a base for the undulating lines of the facial features that lead up the collar to the clenched hand. A horizontal line in the upper portion of the print cuts off the composition and creates a confining and highly ambiguous space.

LA

MAX BECKMANN 1884-1950

Born in Leipzig, the son of a flour merchant, Beckmann moved with his family to Braunschweig after his father's death in 1894. He attended the Art Academy in Weimar from 1900 to 1903 and after graduating spent five months in Paris before settling in Berlin. He won the Villa Romana prize in 1906 and quickly established a reputation as one of the most promising artists of the Berlin Secession. His experiences as a medical orderly in World War I, however, radically changed the direction of his work. Rejecting the virtuosity of his large Romantic canvases, Beckmann developed an Expressionist style that better reflected his view of the moral chaos of the war and the post-war years. In the early 1920s his work underwent another change taking on some of the more sober, concrete qualities of Neue Sachlichkeit (New Objectivity). Beckmann's late work is a highly original, sometimes impenetrable blend of the real and the visionary.

Like the lives of most of the artists in this exhibition, Beckmann's was dramatically affected by the Nazis' seizure of power in 1933. Dismissed from his teaching appointment at the Municipal Art Institute in Frankfurt in 1933, he emigrated to Holland in 1937, departing the day after hearing Hitler's speech condemning modern art as degenerate. Although he had intended to continue on to America, the German invasion of Holland forced him to spend the war years in Amsterdam. Beckmann arrived in the United States in 1947 where he taught in several art schools, mainly at Washington University in St. Louis and the Brooklyn Museum School in New York.

Although Beckmann produced many prints, his interest in the technical aspects of the media was limited, and his printed oeuvre is made up almost entirely of lithography and drypoint, the two media most similar to drawing on paper. His earliest group of prints dates between 1909 and 1912, but his production increased enormously in the years immediately after World War I; nearly one-third of his entire output of 374 prints was made in 1922-23. Perhaps affected by a collapse in the market for prints and certainly under the spell of painting, Beckmann abandoned printmaking almost completely for the next fourteen years. In 1937 he undertook a commission to illustrate a book and completed two more major portfolios before his death in 1950.

MP

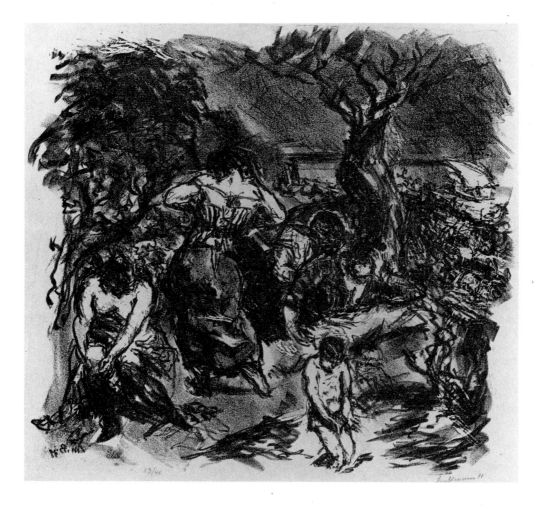

101. *Tegeler Freibad* (Open-air Bath in Tegel), 1911

Lithograph on laid paper
31.6 x 34.4cm
Signed and dated in pencil, l.r., Beckmann 11; numbered, l.l., 13/40;
signed in the stone, l.l., MB
Edition: 40 on Bütten, others on vellum
Gallwitz 16
Provenance: Littmann Collection
Vivian and Gordon Gilkey Graphic Arts Collection 83.57.80

Until 1912, when he turned abruptly to drypoint, Beckmann's earliest prints were almost all transfer lithographs. This print is unusual in that it was not made through the transfer process but rather drawn directly on the stone.

With its feeling of energetic and rapid drawing, *Open-air Bath in Tegel* reflects the influence of Lovis Corinth's romantic realism. The figures are almost indistinguishable from their setting, so similarly are they scribbled and scraped into being. There is, however, less a sense of harmony with nature than an all-encompassing chaos; it is a forbidding scene with its dark sky, tangled bushes and brush and, above all, the Mephistophelian figure crouching in the center of the composition.

The same year that he created *Open-air Bath in Tegel*, Beckmann published a series of prints on New and Old Testament themes. Many of them such as *Hell*, *Samson and Delilah*, and *Serenade of Mephistopheles* suggest a similar preoccupation with the dark and dramatic side of life.

MP

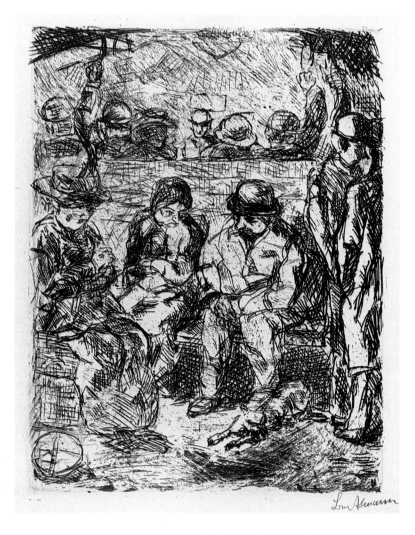

102. *Vierte Klasse II* (Fourth Class II), 1913

Etching on wove paper
19.6 x 14.5cm
Signed in pencil, l.r., Beckmann
Edition: XX on Japan, c.50 unnumbered impressions on Bütten
Gallwitz 40, II/II
Provenance: Littmann Collection
Vivian and Gordon Gilkey Graphic Arts Collection 79.50.623

Beginning in 1911, the theme of the city begins to appear more frequently in Beckmann's prints. Scenes like *Tavern*, *Admiralscafe*, and *Brothel in Hamburg* reflect the German Expressionists' predilection for urban subjects as well as Beckmann's own personal fascination. *Fourth Class II* represents a compassionate observation of an everyday scene among the Frankfurt working class. Framed on three sides by other passengers in a crowded railroad train compartment, a couple with their dog form an intimate group in the center of the composition.

This impression from the second state differs from the first by the addition of foul biting marks and light hatching lines. The foul biting was probably a result of Beckmann's not having cleaned the plate sufficiently before applying the acid-resistant ground the second time. All of the marks contribute to an increased tonal effect and, consequently, a greater sense of atmosphere.

MP

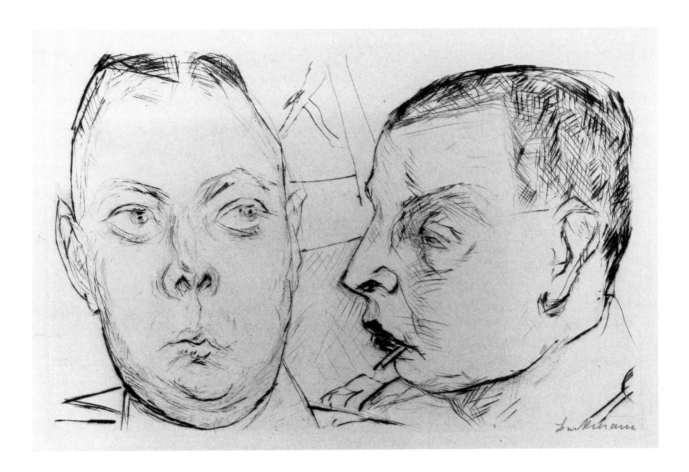

103. *Zwei Autooffiziere* (Two Officers of the Motor Corps), 1915

From *Gesichter* (Faces), a portfolio of 19 drypoints (Munich: Marées-Gesellschaft, 1919-20), plate 15

Drypoint on heavy wove paper

11.9 x 17.9cm

Signed in pencil, l.r., Beckmann; publisher's stamp, l.r.

Edition: unnumbered 40 on Japan, 60 on Bütten

Gallwitz 60

Provenance: Littmann Collection

Vivian and Gordon Gilkey Graphic Arts Collection 83.57.78

In 1914 Beckmann became a hospital orderly and witnessed first-hand the terrible devastation of the war. In July of the following year, he suffered a nervous breakdown from which he spent the next two years recovering.

Because of the unavailability of materials, Beckmann had turned from painting to printmaking at the beginning of the war. He concentrated on drypoint not only for the portability of the plates but also, perhaps, because the sharp scratchy line of the drypoint needle seemed better suited to the harsh realities of wartime than the soft litho crayon.

Two Officers of the Motor Corps is part of a portfolio of 19 drypoints selected by Beckmann and the publisher, Julius Meier-Graefe, from previously unpublished plates made during the five years of the war, 1914–1918. Originally titled *Welttheater* (Theater of the World), the subjects range from landscape to cafe life, from a family portrait to a crucifixion.

The last group of prints in *Gesichter* (Faces) deals with the subject of the military. *Two Officers of the Motor Corps* is the first of these and pictures two intellectuals, one of whom (on the left) is the Berlin publisher, Paul Cassirer. The spare, close-up view of the faces reflects a very different approach from that of the pre-war prints. Meier Graefe's preface to the portfolio helps to describe this change: "The eyes become slits, through which only essentials penetrate. The drama in which he was a supernumerary shrinks the inchoate visions of this lover of frenzy into realities that are hard and sharp like numerals." Beckmann's drawing has become "hard and sharp" and his desire to reveal the truth behind appearances emerges in these dispassionately rendered faces.

MP

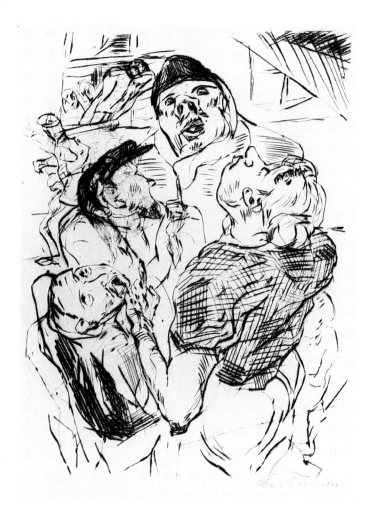

104. *Fliegerbeschiessung* (Aerial Bombardment), 1915

Drypoint on wove paper
20 x 14.8cm
Signed in pencil, l.r., Beckmann
Edition: c.50 impressions
Gallwitz 64
Provenance: Weyhe Gallery Inc., New York
Helen Thurston Ayer Fund 46.38

Beckmann's etchings from 1914 through 1915 mirror increasingly the insecurities of wartime. *Aerial Bombardment* captures the essence of this period with its image of figures, including the horror-struck Beckmann in the lower left, anxiously huddled together. To emphasize the immediacy of their danger, Beckmann has included what appears to be the strut of a low-flying airplane in the upper right corner. Underdrawing, particularly of the figures fleeing in the upper left, underscores the suggestion of movement and heightens the sense of fear and chaos to which Beckmann bore witness.

MP

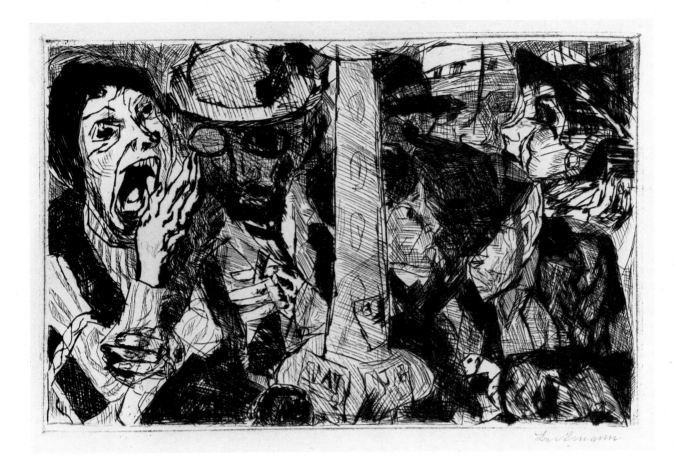

105. *Strasse II* (Street II), 1916

Drypoint on heavy wove paper
19.7 x 29.8cm
Signed in pencil, l.r., Beckmann
Edition: unnumbered, 50 impressions on etching paper
Gallwitz 79, II/II
Provenance: Günther Franke, Munich
Vivian and Gordon Gilkey Graphic Arts Collection 79.50.622

Street II is one of several prints that Beckmann created on the subject of urban life during the war. Bisected by an unidentified monument, the scene is composed of a crowd of jostling figures whose alienation from one another is clearly apparent. With its fierce drawing and emotive distortions, *Street II* is characteristic of Beckmann's new Expressionist style. Beckmann himself appears to be the central figure, partially hidden by the obelisk and dwarfed by the mob around him.

Compared to the first state, Beckmann has filled every inch of the plate with lines and has created an almost continuous matrix of figures. By fusing together these fragments of perception, Beckmann recreates the experience of simultaneity that was central to the Futurists' vision of the urban world and that probably was introduced to him by Ludwig Meidner. Later, he cut the plate and printed the two outer fragments: the figure on the left, described as either yawning or screaming, and the figure on the right, perhaps modeled after Beckmann's friend, Friedl Battenburg.

MP

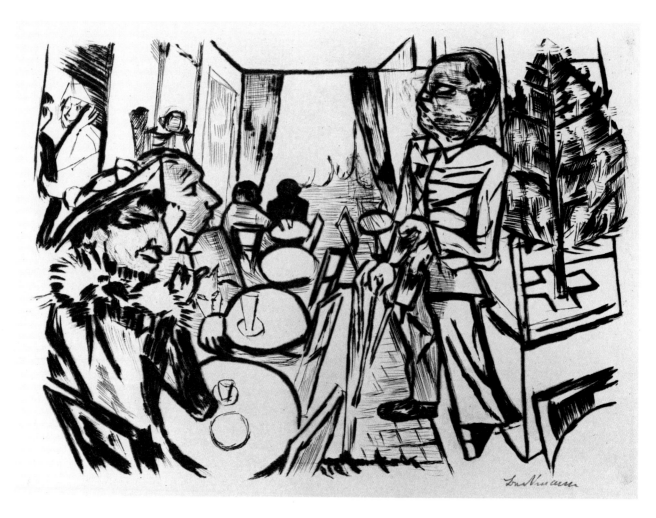

106. *Weihnachten* (Christmas), 1919

Drypoint on wove paper
17.4 x 23.4cm
Signed in pencil, l.r., Beckmann; titled and dated, l.c., Zur Cafe 1919;
signed in the plate in reverse, l.c., Weihnachten 1919; verso: ink
stamp, Bundesdenkmalant 166 23
Edition: unknown
Gallwitz 126
Provenance: Littmann Collection
Vivian and Gordon Gilkey Graphic Arts Collection 82.80.113

Like many of his other post-war prints, *Christmas* was
inspired by the miserable social conditions then current
in cities across Germany, especially Berlin. In it Beck-
mann depicts the confrontation between the maimed
war veteran, an ever-present figure after the war, and the
well-to-do cafe guests. Resentful of this intrusive
reminder of the war they want to forget, the cafe guests
are separated from the veteran by more than a wall of
tables. The title points to the irony of this stand-off
during a time of year that celebrates Christian virtue.
Beckmann believed that people should take responsibil-
ity for one another and the impoverished veteran stands
as a harsh reminder of an alienated society.

Christmas also exemplifies some of the stylistic
changes that occurred in Beckmann's work after the war.
Compared to the more traditionally modeled figures in
his earlier work, these figures resemble flattened car-
icatures. The view of the cafe is likewise distorted; Beck-
mann sharply compresses the space by tilting it up and
thereby making all the principal figures appear larger
than life. He has redrawn the hand and the cane of the
beggar several times to create a sense of movement—an
unsteadiness that accentuates his plight.

MP

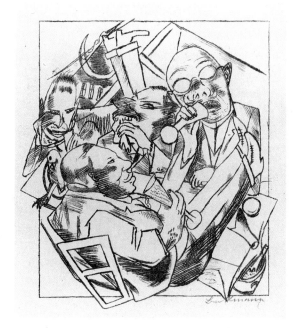

From *Stadtnacht* (City Night), 1920
Book with seven lithographs
Illustrations to poems by Lili von Braunbehrens (Munich: R. Piper & Co., 1921)
Edition: 100 on Japan, 500 on Bütten
Provenance: Littmann Collection
Vivian and Gordon Gilkey Graphic Arts Collection 79.50.628

107. *Titelblatt* (Titlepage)

Transfer lithograph on Japan paper
18.9 x 15cm
Signed in pencil, l.r., Beckmann
Gallwitz 135

108. *Trinklied* (Drinking Song), plate 1

Transfer lithograph on Japan paper
19 x 16.8cm
Signed in pencil, l.r., Beckmann
Gallwitz 136

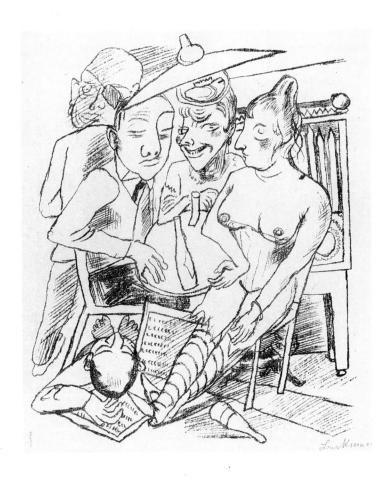

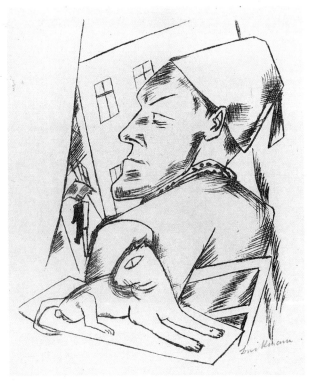

109. *Stadtnacht* (City Night) , plate 2

Transfer lithograph on Japan paper
19.2 x 15.3cm
Signed in pencil, l.r., Beckmann
Gallwitz 137

110. *Verbitterung* (Embitterment) , plate 3

Transfer lithograph on Japan paper
19 x 15cm
Signed in pencil, l.r., Beckmann
Gallwitz 138

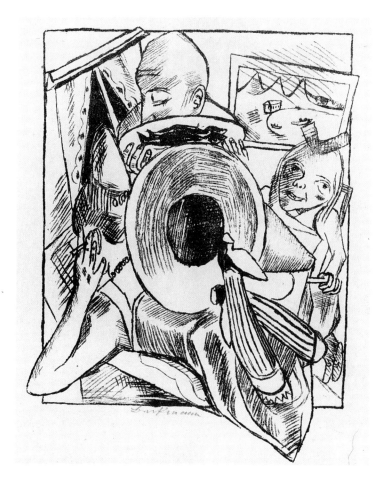

111. *Möbliert* (Furnished Room) , plate 5

Transfer lithograph on Japan paper
21 x 15.9cm
Signed in pencil, l.c., Beckmann
Gallwitz 140

The poems of Lili von Braunbehrens dealing with contemporary lower class life in Frankfurt found a congenial interpreter in Beckmann. His prints follow the text quite closely, with the exception of the title page, which sets the tone for the series. Its expressionistic composition and the nightmarish violence of the scene suggest a city gone mad. The sense of height, of teetering buildings combined with the almost audible scream of the man and the woman, create a general sensation of anxiety and horror.

Characteristic of Beckmann's work of the early 20s, *City Night* demonstrates the shift away from the observed world to a symbolic one. Abandoning traditional perspective, he creates pictorial spaces which are too small and too flat to contain the figures that inhabit them. Figures are distorted in order to fit the squarish format of

the prints and to contribute to the spinning motion of the compositions. Combined with the representations of weakness and debauchery, the close confinement and subordination of the figures symbolize a people without control over their own destiny.

Although *City Night* was created to illustrate a book of poetry, it may be considered within the context of Beckmann's other print cycles, *Faces* (1918), *Hell* (1919) and *The Berlin Trip* (1922), created around the same time. In her essay "Beckmann and the City," Sarah O'Brien-Twohig writes that "Beckmann used the graphic cycle to create a visual stream of consciousness that would convey the tempo of city life. Juxtaposing the different scenes, he could create the sensation of moving through the various strata of urban society observing their reactions to the historical events taking place in their midst" (*Max Beckmann Retrospective*, p. 101). To confirm his role as a participant and witness, Beckmann included a self-portrait with each cycle; in *City Night* he is depicted in a nightcap staring out the window on a rainy night.

MP

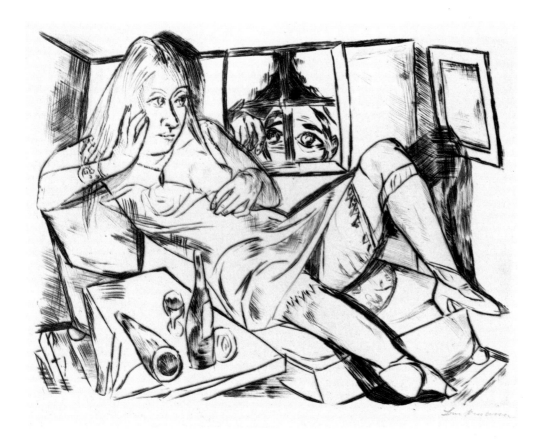

112. *Frau in der Nacht* (Woman in the night), 1920

Drypoint on wove paper
24.7 x 31.8cm
Signed in pencil, l.r., Beckmann; numbered and titled, l.l., 42/50 Frau
auf Sofa
Edition: 40 on Japan, 50 on Bütten
Gallwitz 147
Provenance: Littmann Collection
Vivian and Gordon Gilkey Graphic Arts Collection 82.80.112

The relationship between man and woman is one of the
central themes of Beckmann's work. While this rela-
tionship is understood by him to be essential to life, it is
also a bond that ties man to the earth, restricting his
freedom and impeding his spiritual progress.

Woman in the Night, one of the first of many images
that features a woman with male observer/voyeur, pro-
vides a metaphor for the confining aspect of rela-
tionships; the woman is pent up in a room barely large
enough to contain her, and the man, tapping on the
window, is bound by his attraction. The monumentality
of the seductive woman is repeated in *Seduction,* 1923,
and *Siesta,* 1923, and may be considered symbolic of the
major, adversarial role women played in Beckmann's life.
MP

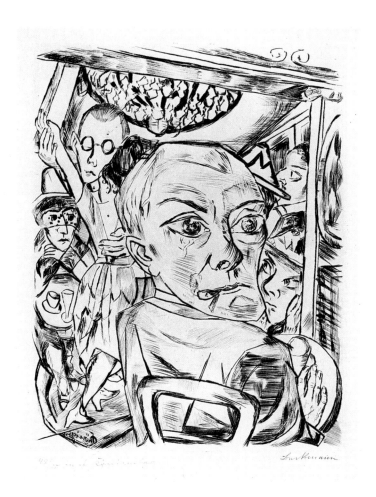

113. *Königinbar* (Selbstbildnis) (Queen's Bar [Self-Portrait]),
1920

Drypoint on wove paper
31.8 x 24.5cm
Signed in pencil, l.r., Beckmann; numbered and titled, l.l., 48/50 In
der Königinbar; signed in the plate in reverse, l.l., Königin
Edition: 40 on Japan, 50 on Bütten
Gallwitz 148
Provenance: Günther Franke, Munich
Vivian and Gordon Gilkey Graphic Arts Collection 80.422.392

Like Kollwitz, Beckmann chronicled his life in a series of
self-portraits that spans the breadth of his career. Num-
bering approximately 80 in all media, they record not
only changes in his personal fortunes and artistic style but
also revelations of his character.

In *Queen's Bar*, the artist portrays himself in one of the
Berlin night clubs he frequented to relax and to observe
people in relative obscurity. Although he uses the same
setting for the drypoint (1923) and the painting (1935) of
the same title, this print is more related to the composi-
tion of *Self-Portrait with Champagne Glass* (1919) in a
private collection. In both images, the artist is seated
inside the night club with his shoulder turned to the
viewer and head turned unnaturally against his body.
Although his glance is directed outside the picture space,
the position of his body aligns him with the activities of
the club. Beckmann thus represents himself as both the
distanced observer and the participant, simultaneously
attracted to and repelled by the scene around him.

MP

◆ 133 ◆

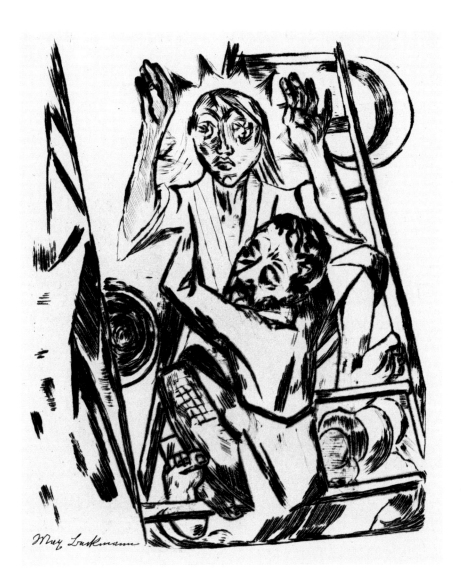

114. *Jacob ringt mit dem Engel* (Jacob Wrestling with the Angel), 1920

Drypoint on laid paper
28.5 x 22.3cm
Signed in ink, l.l., Max Beckmann
Edition: unknown
Gallwitz 151
Provenance: R.E. Lewis, San Francisco
Vivian and Gordon Gilkey Graphic Arts Collection 80.122.391

Jacob Wrestling with the Angel is one of the few works by Beckmann that is based on traditional religious iconography. Although the artist was well-read in religious literature including that of Hinduism, Zoroastrianism and early Christianity, his interest was not that of a follower but of a student seeking a better understanding of the human condition.

His inscription "nach Rembrandt" (after Rembrandt) on a version of this print in the collection of the Städtische Galerie, Frankfurt am Main, invites a comparison with the work of that master whom Beckmann admired above all other artists. Although Beckmann's print does not literally follow the painting by Rembrandt of this subject (Beckmann, for example, includes the ladder from Jacob's dream, the moon and the rising sun that denote the length of time Jacob wrestled), both artists illustrate the same dramatic moment. By presenting the instant in which the angel blesses Jacob instead of the active struggle between them, both artists imply that the struggle was an inward one, that Jacob fought and conquered the evil within himself.

MP

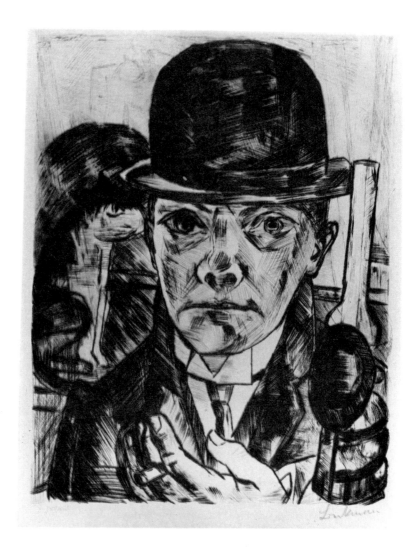

115. *Selbstbildnis mit steiffem Hut* (Self-Portrait in Bowler Hat), 1921

Drypoint on laid paper
32.9 x 24.8cm
Signed in pencil, l.r., Beckmann; annotated, l.l., 2. Zustand
Edition: unknown
Gallwitz 153, II/III
Provenance: unknown
Gift of Mrs. Georgia Heckbert 40.22

In *Self-Portrait in Bowler Hat,* Beckmann employs a personal iconography to construct an image of his inner self. Formally dressed and rigidly fixed in the center of the picture plane, the artist surrounds himself with the symbols of his existence. As in his earlier *Self-Portrait with Cat and Lamp,* 1920, his attributes are the cat, symbol of sin and sexuality; the lamp, symbol of wisdom; and the hand, symbol of the artist. Beckmann portrays himself sandwiched between the physical and the spiritual planes, implying that the role of the artist is to reconcile these two opposing forces.

The changes from the first to the second state of this print show how Beckmann refined his intentions. The original view of the interior with door, window, and electric lamp, as well as the cat in Beckmann's arm, have been burnished out in the second state. The cat and the lamp are redrawn in reverse positions as elements of a new compositional order. The dark oval shapes of the lamp deflector, Beckmann's head and hat, the shadow of his hat and the curve of the cat's back provide a unifying compositional element and the increased drypoint burr results in more dramatic contrasts of black and white. The clarity and power of the resulting image has made it deservedly one of Beckmann's best known prints.

MP

From *Jahrmarkt* (Annual Fair), a portfolio of 10 drypoints (Munich:
Marées Gesellschaft and R. Piper & Company, 1922)
Edition: 75 on Japan and 125 on Bütten

116. *Hinter den Kulissen* (Behind the Scenes), 1921, plate 3

Drypoint on laid paper
21 x 30.5cm
Signed and dated in pencil, l.r., Beckmann 21; annotated, l.l.,
Garderobe I (Handprobedruck)
Gallwitz 165, trial proof
Provenance: Günther Franke, Munich
Vivian and Gordon Gilkey Graphic Arts Collection 80.122.390

117. *Der grosse Mann* (The Tall Man), 1921, plate 5

Drypoint on laid paper
30.8 x 21cm
Signed and dated in pencil, l.r., Beckmann 21; annotated, l.l.,
Karusell I (Handprobedruck)
Gallwitz 167, trial proof
Provenance: Littmann Collection
Vivian and Gordon Gilkey Graphic Arts Collection 78.52.229

118. *Das Karusell* **(The Carousel), 1921, plate 7**

Drypoint on laid paper
28.9 x 25.8cm
Signed and dated in pencil, l.r., Beckmann 21; annotated, l.l.,
Karisell II (Handprobedruck)
Gallwitz 169, trial proof
Provenance: Littmann Collection
Vivian and Gordon Gilkey Graphic Arts Collection 79.50.85

119. *Negertanz* (Negro Dance), 1921, plate 9

Drypoint on laid paper
25.6 x 25.3cm
Signed and dated in pencil, l.r., Beckmann 21; annotated; l.l.,
Negertanz (Handprobedruck)
Gallwitz 171, trial proof
Provenance: Littmann Collection
Vivian and Gordon Gilkey Graphic Arts collection 79.50.625

The theme of the Mardi Gras, the carnival or the masked
ball, becomes central to Beckmann's works of the 1920s
as a "simile for the absurdity, role-playing and ephem-
erality to which the world is condemned" (*Max Beck-
mann Retrospective*, p. 212-213). In the *Jahrmarkt* series, his
most extensive treatment of this theme, Beckmann pre-
sents the great German New Year's Day fair as a complex
personal allegory. He depicts himself in nearly half of the

series — as the circus barker of the first plate, the per-
former in false wig and beard in the third, a spectator at
the tall man show in plate five, and, in plate seven, a rider
on the carousel — making it clear that he is both witness
and participant in the spectacle of life.

In keeping with his concept of the world as theater,
most of the ten compositions that comprise this series call
to mind various stage formats from the half-length pup-
pet theater, to the circular peepshow to the full stage
view. Space is uniformly shallow and frontal. Although
the imagery continues to be bafflingly obscure, Beck-
mann brings a new sense of detachment to his funda-
mentally pessimistic vision of reality.

MP

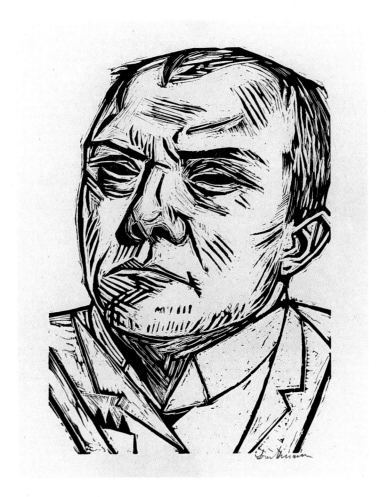

120. *Selbstbildnis* (Self-Portrait), 1922

Woodcut on salmon colored wove paper
22.5 x 15.5cm
Signed in pencil, l.r., Beckmann
Edition: XX on Japan, 60 on Bütten
Gallwitz 195, II/II unnumbered proof
Provenance: Günther Franke, Munich
Vivian and Gordon Gilkey Graphic Arts Collection 79.50.621

Woodcuts are relatively rare in Beckmann's ouevre but those few he made maximize the medium's potential for uncompromising statements. The bold, jagged lines of this self-portrait, the only one he created in woodcut, make it one of the most powerful of Beckmann's self-portraits. The carved lines retain the physical energy of the artist's gouging stroke and give the image a rock-solid, sculptural quality. With its blank eyes and stern expression, the self-portrait is reminiscent of a roman bust but with a raw psychic power that belongs wholly to the 20th century.

MP

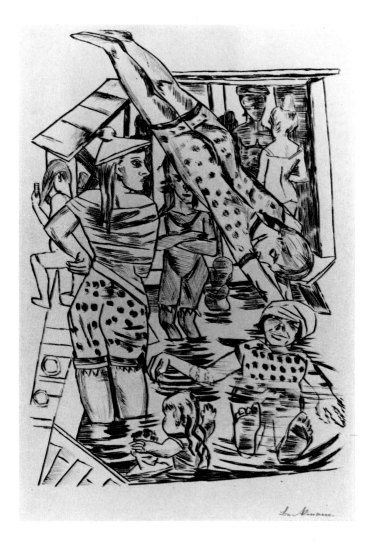

121. *Frauenbad* (Women's Bath), 1922

Drypoint on wove paper
43.7 x 29.3cm
Signed in pencil, l.l., Beckmann
Edition: XX on Japan, unnumbered on Bütten
Gallwitz 204, II/II
Provenance: Günther Franke, Munich
Vivian and Gordon Gilkey Graphic Arts Collection 79.50.630

In *Women's Bath*, Beckmann takes up a subject that he first addressed with a painting by the same title in 1919. Although the printed version is somewhat more realistic, the general approach to the theme remains the same. In both works, there is no exchange among the figures despite the social context, and the space is uncomfortably cramped. In the print, the three principal figures form a rigid triangular shape, underscored by the dotted pattern of their swimsuits. The combination of this surface pattern and the triangular composition seems to freeze the figures in space and to deny them any possibility of movement.

The subject of the women's bath may be considered part of a larger theme in Beckmann's work, that of the women's world. This theme includes images of powerful women with or without subordinate men, and scenes of women with male observers.

MP

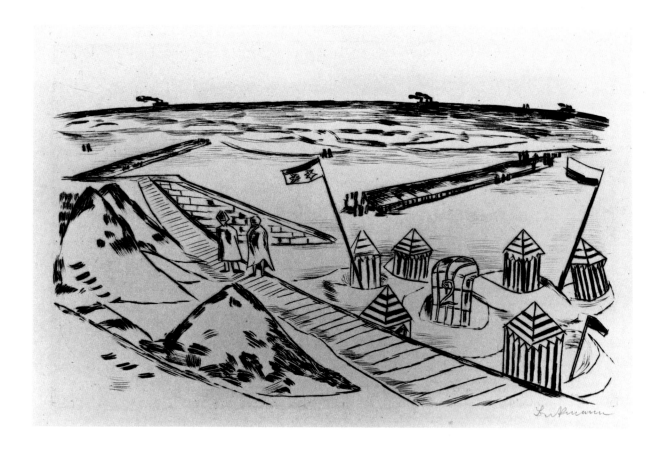

122. *Strand* (Beach), 1922

Drypoint on wove paper
21 x 32.6cm
Signed in pencil, l.r., Beckmann
Edition: XV on Japan, others on Bütten
Gallwitz 209
Provenance: Günther Franke, Munich
Vivian and Gordon Gilkey Graphic Arts Collection 81.81.197

Beach scenes and ocean views figure in Beckmann's work as early as 1902 and continue throughout his career. The artist spoke of his love for the sea in a letter dated March 16, 1915: "And then to the sea, my old romance, it's been too long since I was with you. You swirling infinity with your embroidered dress... If I were the king of the world, I would choose as my highest privilege to spend one month a year alone on the beach." From a bird's-eye view, Beckmann creates an expansive composition that takes in the curvature of the earth and expresses his reverence for the sea. In contrast with the artist's claustrophobic interior views, this openness juxtaposes a feeling of eternity with the limitations of human existence.

MP

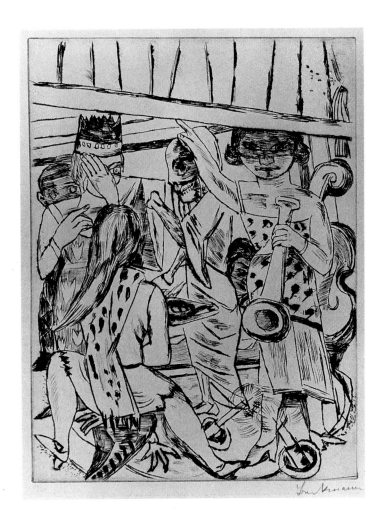

123. *Der Vorhang hebt sich* (The Curtain Rises), 1923

Drypoint on laid paper
29.5 x 21.8cm
Signed in pencil, l.r., Beckmann; numbered, l.l., 14/60
Edition: 60 on Bütten
Gallwitz 240
Provenance: Weyhe Gallery, Inc., New York
Helen Thurston Ayer Fund 46.42

The Curtain Rises exemplifies the type of hermetic allegory that characterizes Beckmann's mature work. Drawing again upon the metaphor of the theater, the artist populates his stage with allegorical figures and symbols representing, among other things, the forces of creativity and sexuality. Many of these images, such as the woman riding the reptile, the figure with crown, the woman with the horn (Naila?), the stand-up bass, and the burning candles appear elsewhere in Beckmann's work, both in paintings and prints.

On one impression of this print in the collection of the St. Louis Art Museum, Beckmann wrote, "Das Mysterium aller Mysteriums von Max" (The Mystery of Mysteries by Max). This inscription suggests that the curtain rising of the title is a metaphor for the unveiling of truth. Although it would seem that women are the initiates and man the observer, the "mystery" remains largely shrouded for the viewer.

MP

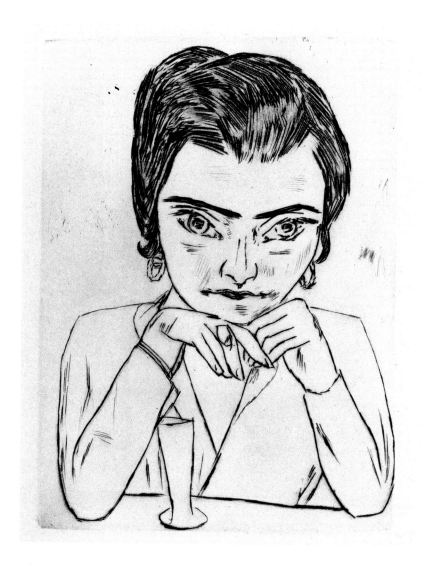

124. *Bildnis Frau H.M. (Naila)* (Portrait of Mrs. H.M. [Naila]), 1923

From *Gegenwart* (Present Time), a portfolio of 42 fascimiles of drawings and watercolors and 6 signed prints by various artists (Munich: Marées-Gesellschaft, n.d.), plate 2
Woodcut on wove paper
34.9 x 32.8cm
Signed in pencil, l.r., Beckmann; publisher's stamp, l.r.
Edition: unknown (probably 100)
Gallwitz 252, II/II
Provenance: unknown
Gift of Frederic Rothchild 76.38.1

Portrait of Mrs. H.M. is part of a group of portraits Beckmann created in the 1920s that emphasized the character of the sitter. Mrs. H.M., or Naila, appears in a number of other prints from 1923 and 1924, sometimes as an allegorical figure. Recognizable by her large slanted eyes, straight dark eyebrows and thin lips, she has an exotic beauty that clearly fascinated Beckmann. Staring hypnotically into space, Mrs. H.M. is portrayed with a directness that is characteristic of Beckmann's Neue Sachlichkeit work.

As the second state of a print that has been radically altered, *Portrait of Mrs. H.M.* offers a valuable insight into the artist's process. In the original version of the print, Beckmann featured the sitter from the waist up seated at a table. In the final state, he focuses on the sitter's face by cutting away the chair back and cropping the composition to bust length. Beckmann uses the woodcut technique to create a more solid, monumentalizing image than drypoint would yield, yet manages at the same time to develop a sympathetic, even gentle, depiction.

MP

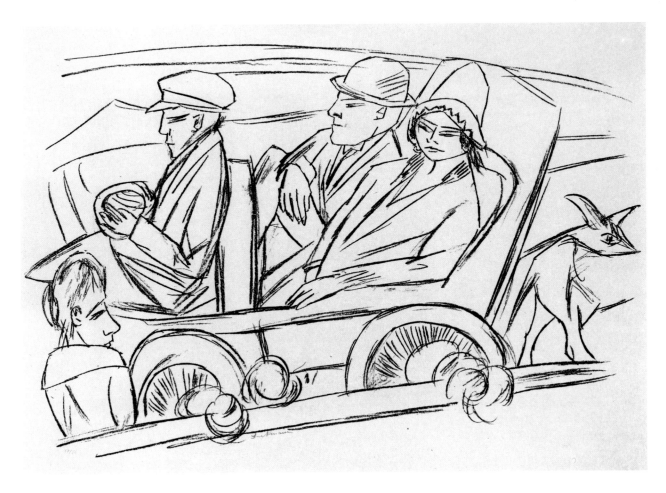

125. *Selbstbildnis im Auto* (Self-Portrait in Auto), c. 1923

Transfer lithograph on wove paper
42 x 63.5cm
Signed in pencil, l.c., Beckmann; numbered, l.l., 17/50
Edition: 50
Gallwitz 268
Provenance: Littmann Collection
Vivian and Gordon Gilkey Graphic Arts Collection 78.52.231

One of the few large-scale prints in Beckmann's oeuvre, *Self-Portrait in Auto* evokes a rare feeling of spaciousness and light. In contrast to his typically frontal, self-scrutinizing images, Beckmann portrays himself here in profile, as a man of calm purpose. The general sense of optimism may be attributed both to Beckmann's personal successes and to the fact that Germany was enjoying a brief period of stability and prosperity. It provides a sharp contrast with *In the Tramway* of the preceding year, in which the artist depicts himself peering suspiciously above a slipped blindfold as he sits between two other passengers on the streetcar.

MP

126. *Der Traum I (Totenklage)* (The Dream I [Death Lament]), 1924

Drypoint on wove paper
45.5 x 20.5cm
Signed in pencil, l.r., Beckmann; annotated, l.l., Traum (Probedruck)
Edition: X on Japan, 25 on Bütten
Gallwitz 270, trial proof
Provenance: Günther Franke, Munich
Vivian and Gordon Gilkey Graphic Arts Collection 80.122.394

Like *The Curtain Rises* (plate 123), *The Dream I* explores the mysteries of sexuality and death. Again, amid the symbols of musical instruments and flickering candles, the female figure is the key, the link between procreation and dissolution. The instruments of the two grotesques, whose music is both celebration and lament, lend them an erotic association; the donkey man, reminiscent of Bottom in Shakespeare's *A Midsummer's Night Dream*, has precedents in the artist's donkey-masked figures, but here has fully merged with his disguise. Beckmann used the vertical zigzag composition in a number of paintings in the '20s, including the 1921 work, similarly titled *The Dream* at the Saint Louis Art Museum.

This is one of the last prints Beckmann created before he stopped making prints from 1925—1937.

MP

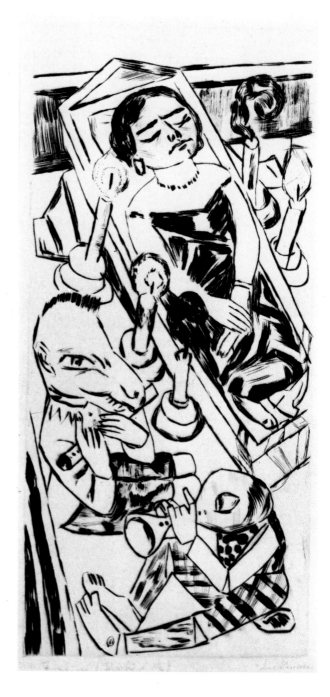

GEORGE GROSZ 1893-1959

No more damning portrayal of German politics and bourgeois society is to be found in the art associated with Expressionism than that of George Grosz. The subjects of his prints were the self-indulgent generals, bureaucrats, industrialists, priests, and sycophants who represented, in Grosz's bitterly cynical view, the greed for money and power that causes war, poverty, and oppression.

Born Georg Ehrenfried Grosz in Berlin in 1893, Grosz demonstrated his antipathy toward authority when he was expelled from grammar school for retaliating when struck by a teacher. By the time he was an art student at the Royal Academy of Art in Dresden in 1911-1912, he was channeling his anger into the production of caricatures and cartoons. After being introduced to drawing from rapid observation during a visit to Paris in 1913, he perfected the technique that marked his style in later satirical drawings.

After serving briefly in the military in 1915, Grosz met the Herzfelde brothers, Weiland and his brother Helmut, later known as John Heartfield, with whom he formed an important and long-lasting relationship. In 1917 they published the *Erste George Grosz-Mappe* (First George Grosz Portfolio), the first of several works by Grosz they would publish over the next decade. Early that year Grosz was readmitted to the army for another brief period that ended with his hospitalization in a mental institution. The experience of his incarceration strongly affected the content of his work.

In 1918 Grosz joined the Communist Party and in the following year became a participant in the Berlin Dada movement. He began to experiment with collage and photomontage while continuing to paint and draw. His style showed the influence of Cubism and Futurism and his subject matter was deliberately provocative. In 1925, Grosz was one of the main painters in the Neue Sachlichkeit exhibition in Mannheim.

In January, 1933 Grosz and his family emigrated to the United States. Later that year his German citizenship was revoked and his work began to be included in Nazi exhibitions of "degenerate" art. Although he taught at the Art Students League in New York and exhibited widely, he was unable to adjust artistically or personally to American culture. He drank to excess and fell into melancholia. He began to revisit Germany in 1954, and in 1959 moved his residence to West Berlin, where he died as the result of an accident a few weeks later.

Grosz was not particularly interested in printmaking techniques but was concerned with reaching as large an audience as possible. Except for a few etchings, his many prints were produced from photolithographic facsimiles of drawings. About 120 single sheets are known, plus 7 portfolios and 6 illustrated books.

LA

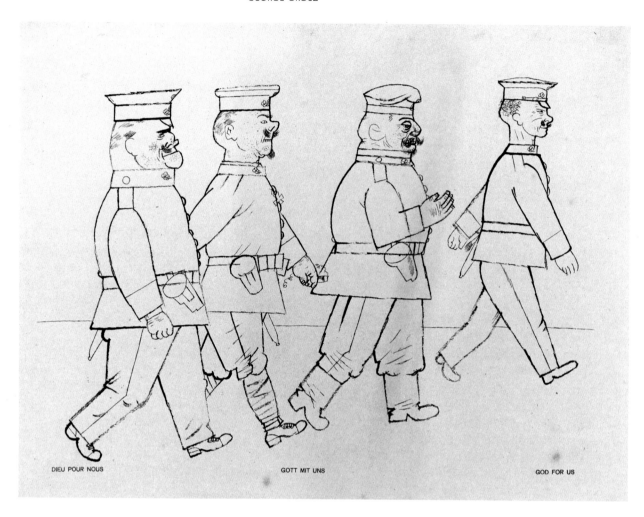

DIEU POUR NOUS GOTT MIT UNS GOD FOR US

From *Gott mit uns* (God with us), a portfolio of nine photolithographs
(Berlin: Malik Verlag, 1920)
Edition: 1-20 on Japan, 21-60 on heavy laid, 61-125 on laid paper

127. *Gott mit uns* (God with us), 1919, plate 1

Photolithograph on laid paper
30 x 42.9cm
Unsigned, titled in the stone: Dieu Pour Nous/Gott mit uns/God for us
Dückers M III, 1
Provenance: unknown
Gift of Mr. Robert Galaher 59.25.1

LE TRIOMPHE DES SCIENCES EXACTES DIE GESUNDBETER GERMAN DOCTORS FIGHTING THE BLOCKADE

128. *Die Gesundbeter* (The Faith Healers), 1918, plate 5

Photolithograph on laid paper
31.9 x 29.6cm
Signed in the stone, l.r., George Grosz; titled, Le Triomphe des
Science Exacte/Die Gesundbeter/German Doctors Fighting the
Blockade
Dückers M III, 5
Provenance: unknown
Gift of Mr. Robert Galaher 59.25.2

God with Us, a series of nine photolithographs, is a scathing commentary on the military forces of the Weimar Republic. Because of its offensive content, Grosz and Weiland Herzfelde, the publisher, were brought twice to trial. After appeals and widespread publicity, both were acquitted, but on condition they destroy all of the nine plates.

The motto, "Gott mit uns," was inscribed on soldiers' regulation belt buckles. Grosz satirizes the motto, giving it sinister implications in applying it to the four brutish noncommissioned officers depicted in *God with Us.*

The Faithhealers was taken from a drawing executed in 1916 or 1917, and is quite probably based on Grosz's own experience in the army when he was confined to a sanatorium in 1916 after suffering a nervous breakdown. Upon being pronounced healthy by the doctors, he was ordered to get out of bed. He attacked the attendant who gave the order and was then himself attacked by other patients. He was discharged from the army in 1917 as unfit for service. Resentment over the treatment he received fed his ire and inspired many caustic drawings.

The strength of Grosz's aggressive political drawings such as this comes not only from his spare, precise line but also from the combination of narrative and formal elements, particularly the spatial contraction. In the foreground two supercilious officers, shown in profile, enjoy smoking and chatting, oblivious to the drama being played out before them. The macabre setting—the long table, receding on a diagonal into a background compressed by the walls of the room, the seated military evaluators, and the standing attendants—becomes a cage imprisoning the skeleton "patient" who is pronounced "KV" (short for "kreigsverwendungsfähig" [fit for service]) by an obviously incompetent doctor.

LA

129. *Kein Hahn kräht nach ihnen* **(Nobody Gives a Damn, also known as The Prisoner), 1920**

From *Die Schaffenden* (The Creators) II, no. 4 (Weimar: Gustav Kiepenheuer Verlag, 1920)
Transfer lithograph on wove paper
27.5 x 21.8cm
Signed in pencil, l.r., Grosz; publisher's dry stamp, l.l.
Edition: 125
Dückers E 63
Provenance: Günther Franke, Munich
Vivian and Gordon Gilkey Graphic Arts Collection 82.80.278

Although it was not included in the series, *God with Us,* that caused Grosz's arrest in 1920 for slandering the army, *The Prisoner* is equally anti-military. Like all Grosz's drawings, it does not refer to a specific event or persons, but is, nevertheless, a biting political statement. While the circumstances that brought the shackled, emaciated prisoner to the scaffold are not stated, it is clear that he and his weeping wife are helpless victims of the doctors and officers who have decided that he is too sick to be executed — he must recover first.

Grosz's political radicalism endured through the 1920s. Like many of his peers, he belonged to the Arbeitsrat für Kunst, a leftist group dedicated to bringing art to the people. In 1924, he became a leader in an organization of revolutionary artists, the Rote Gruppe (Red Group). During the 1930s, however, his audience diminished as the political climate moved to the right. He was harassed by the Nazis, who denigrated his art as "degenerate." Twenty of his works were included in the Degenerate Art exhibition staged in Munich in 1937 by the National Socialists to exemplify the kind of art that was un-German and unacceptable to the Third Reich.

LA

130. *Aus dem Zyklus Parasiten* **(From the Parasites Cycle), c.1920-21**

Probably photolithograph on wove paper
38.5 x 29cm
Signed in pencil, l.r., Grosz, numbered, l.l., 9
Edition: unknown
Dückers E 55
Provenance: William LaGrill, San Francisco
Gift of Mr. and Mrs. Robert O. Lee 67.26

The drawing for this print was found among Grosz's works after his death. With other drawings, it was in an envelope marked "parasites," and was not dated. Because of its similarity to a drawing in the series *Ecce Homo,* it is sometimes mistakenly identified as part of that series. Dückers deduces from its style, however, that it pre-dates the 1921 *Ecce Homo* drawing. The multiplication of the legs reflects the short-lived influence of Italian Futurism on Grosz's work, in evidence for only a few years after his exposure to modernism during a trip to Paris in 1913.

The subject matter relates directly to *Ecce Homo* ("Behold the Man," John xix.5, a representation of Christ wearing a crown of thorns), in which Grosz exposed the hypocrisy, venality, and degradation of the bourgeoisie. He saw himself as a social revolutionary and made many drawings depicting the collapse of Germany's capitalistic society and its values. In this print the figures, both male and female, are stereotypical depictions of the capitalist ruling class as sex-driven, fat, oafish creatures.

Ecce Homo caused Grosz's arrest, trial, and fine in 1923 for obscenity and offending the moral sense of the German people. In his defense he said that the drawings were his expression of the depravity of contemporary society. The sentence was later reversed.

LA

Otto Dix was born in Untermhaus, Thuringia in 1891, the son of a foundry worker. In 1909, following a six-year apprenticeship to a decorative house painter, Dix moved to Dresden in 1909 to study at the School of Applied Arts. His five years in Dresden, a city rich in cultural heritage yet open to innovation, exposed him to the work of both northern Renaissance painters and modern artists including Van Gogh and the members of the Brücke. These influences are reflected in the style of his pre-war work, which moves from German academic realism to a more personal, expressive form.

Like many German artists and intellectuals, Dix saw in the outbreak of World War I the potential for cleansing Germany of corruption and paving the way for a utopian society. In a desire to observe battle firsthand, he volunteered for the army in 1914. The following year he arrived at the Russian front and spent the remainder of the war serving as an artilleryman and an aerial observer. Horrifying experiences in the trenches led him to reevaluate his earlier beliefs and to assume an anti-war posture. Over 600 drawings made at the front form the basis for much of his post-war art, which is characterized by its stinging commentary on the brutality of war and the subsequent failures of the Weimar Republic.

Following the war, Dix was active in several revolutionary artists' groups, including the Sezession-Gruppe 1919 (Secession Group 1919), the Dresden affiliate of the Novembergruppe. Through this movement and others, Dix and his peers hoped to bring about improvements for the working class. He continued to experiment stylistically, searching for a means to convey his disillusionment with contemporary Germany, and in the early 1920s developed a style of socially critical realism called Neue Sachlichkeit (New Objectivity). In 1922, as his interest in printmaking intensified, he moved to Düsseldorf to study intaglio techniques with Wilhelm Heberholz, a master of the medium. The following few years were his most productive as a printmaker, and included several of his most significant portfolios.

Dix returned to Dresden in 1927 to teach at the Academy, and remained in this position until dismissed by the Nazi government in 1933. Labeled "degenerate," much of his work was confiscated and destroyed. In spite of the repressive regime, Dix continued to paint and make prints during World War II. He made the last of his 336 prints in 1969, the year of his death.

VWH

From *Tod und Auferstehung* (Death and Resurrection), a portfolio of six
etchings with drypoint (Dresden: Otto Dix, 1922)
Edition: 50

131. *Der Selbstmörder* (Erhängter) (The Suicide [Hanged Man]), 1922, plate 1

Drypoint and roulette on heavy wove paper
35 x 28.2cm
Signed and dated in pencil, l.r., Dix—22; numbered, l.r., 7/50;
titled, l.c., No. I; signed in plate, l.l., Dix
Karsch 43
Provenance: Littmann Collection
Vivian and Gordon Gilkey Graphic Arts Collection 81.81.473

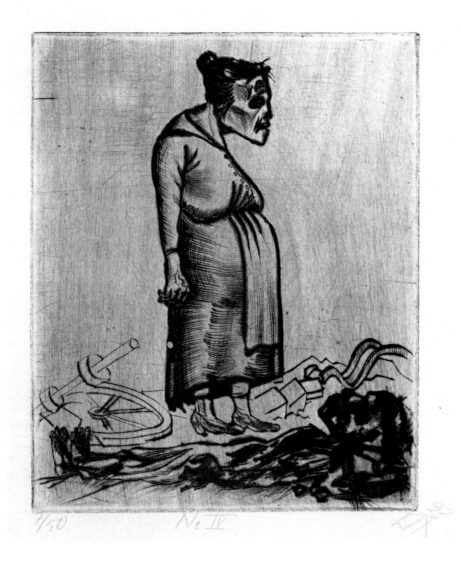

132. *Schwangerschaft* (Pregnancy), 1922, plate 4

Drypoint and roulette on heavy wove paper
34.7 x 28cm
Signed and dated in pencil, l.r., Dix—22; numbered, l.l., 7/50;
titled, l.c., No. IV
Karsch 46
Provenance: Littmann Collection
Vivian and Gordon Gilkey Graphic Arts Collection 83.57.168

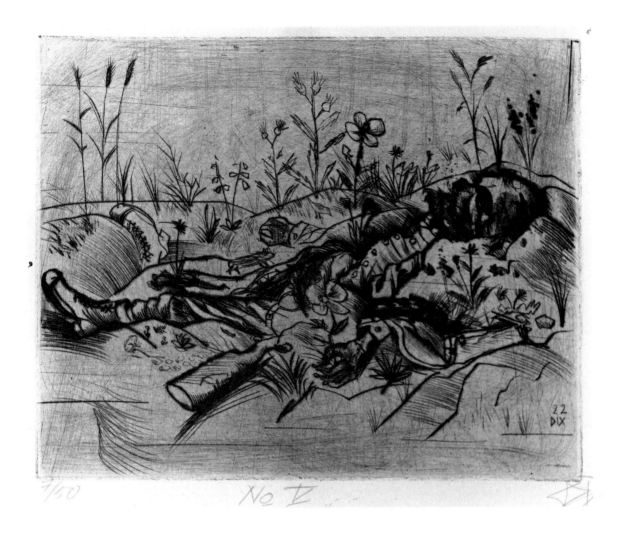

133. *Toter Soldat* (Dead Soldier), 1922, plate 5

Drypoint and roulette on heavy wove paper
28 x 34.5cm
Signed and dated in pencil, l.r., Dix—22; numbered, l.l., 7/50;
titled, l.c., No.V; signed in plate, l.r., 22 Dix
Karsch 47
Provenance: Littmann Collection
Vivian and Gordon Gilkey Graphic Arts Collection 83.57.176

Prior to World War I, Dix, like many young people of his day, passionately read the writings of Nietzsche. The philosopher's assertion that death was necessary to the continuation of life affirmed war as a positive force. Although Dix's own experiences at the front subsequently led him to view Nietzsche's theories with some cynicism, he maintained his belief in the regenerative nature of the cycle of life and death. In *Death and Resurrection,* he explored this concept in the context of the war and post-war years.

In both *Dead Soldier* and *Pregnancy,* death is seen to be literally the source of life; in the former, the body of the decomposing soldier provides direct nourishment for the plant life around him; in the latter, the expectant mother, appearing close to death herself, nevertheless contains the seed of a new life within her.

The Suicide, in which the hanged man's spirit sits dolefully on the chair beside him, likewise promotes the idea of death, not as a finite state, but as part of a never-ending cycle. Significantly, death here is an intentional act born of an inability to cope with the chaotic, corrupt reality of post-war Germany. The spirit has left the figure of the suicide, leaving the corpse as lifeless as the hat and coat hung on the wall opposite it. Death, however, does not offer an escape from the problems of contemporary society and the spirit remains earthbound.

VWH

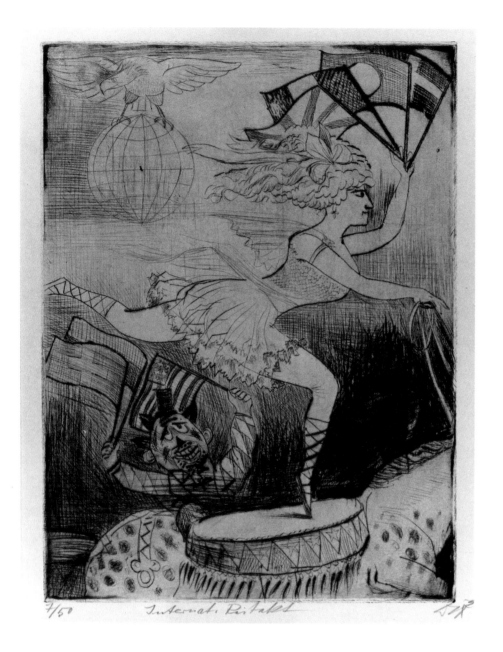

From *Zirkus* (Circus), a portfolio of ten etchings with drypoint (Dresden: Otto Dix, 1922)
Edition: 50

134. *Internationaler Reitakt* (International Riding Act), 1922, plate 6

Drypoint and roulette on heavy wove paper
39.8 x 29.6cm
Signed and dated in pencil, l.r., Dix-22; numbered, l.l., 7/50;, titled, l.c., Internat. Reitakt
Karsch 37
Provenance: Littmann Collection
Vivian and Gordon Gilkey Graphic Arts Collection 84.25.138

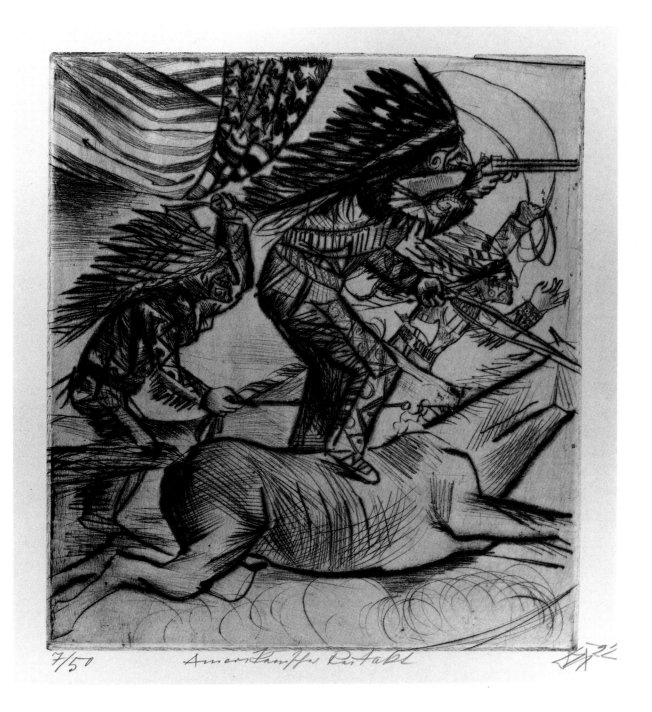

135. *Amerikanischer Reitakt* (American Riding Act), 1922,
plate 7

Drypoint on heavy wove paper
34.6 x 31cm
Signed and dated in pencil, l.r., Dix—22; numbered, l.l., 7/50;
titled, l.c., Amerikanischer Reitakt
Karsch 38
Provenance: Littmann Collection
Vivian and Gordon Gilkey Graphic Arts Collection 83.57.135

136. *Lili, die Königin der Luft* (Lili, Queen of the Air), 1922, plate 9

Drypoint on heavy wove paper
29.9 x 19.8cm
Signed and dated in pencil, l.r., Dix-22; numbered, l.l., 7/50; titled, l.c., Lili
Karsch 40
Provenance: Littmann Collection
Vivian and Gordon Gilkey Graphic Arts Collection 84.25.643

Themes of the circus and the carnival were popular in the late 19th and early 20th centuries and were featured in work by Pablo Picasso, Georges Rouault, Max Beckmann, and E.L. Kirchner, among others. The circus subculture and its assorted characters became a metaphor for human nature and modern society. For Dix, whose work on the theme included one painting, five drawings, and thirteen woodcuts in addition to his *Circus* series, the circus was also a vehicle for commentary on contemporary politics.

International Riding Act and *American Riding Act,* for example, serve as metaphors for post-war international relationships. In the former, the delicate diplomatic stability that existed after the war is implied by the figure of a stunt rider. Though seemingly in control of her mount and the flags she holds high, her perch is precarious, and at any moment she may tumble, spilling the flags chaotically into the ring.

The Wild West is brought to life in *American Riding Act.* Adorned in war paint and headdresses, three Indians on horseback race fearlessly through the picture's frame, whooping and brandishing weapons. Dix and his contemporaries were fascinated by the bravado of the Wild West and, hoping for the success of President Woodrow Wilson's peace plan, were reassured by the sense of confidence implicit in the myth.

Lili, Queen of the Air demonstrates Dix's fascination with circus performers whose acts led them to challenge death. In a simple composition enlivened by a variety of cross-hatchings, he presents what at first appears to be a girlish figure coyly primping her hair. With her tight, tooth-filled smile and large dark-rimmed eyes, however, Lili has an element of menacing sexuality that is typical of Dix's representations of women. The net surrounding her, which reminds one of the dangers of her act, also suggests a spider web in which this would-be seductress catches her prey.

VWH

From *Der Krieg* (War), a portfolio of 50 etchings with aquatint (Berlin: Karl Nierendorf, 1924)
Edition: 70

137. *Unterstand* (Foxhole), 1924, plate 45

Etching and aquatint on laid paper
19.2 x 28.38cm
Signed in pencil, l.r., Dix; numbered, l.l., 48/70; l.c., V
Karsch 114
Provenance: E. Weyhe Gallery, New York
Helen Thurston Ayer Fund 46.51

138. *Appell der Zurückgekehrten* (Roll Call of the Returning Troops), 1924, plate 49

Etching and aquatint on laid paper
19.2 x 28.2cm
Signed in pencil, l.r., Dix; numbered, l.l., 48/70; l.c., IX
Karsch 118
Provenance: E. Weyhe Gallery, New York
Helen Thurston Ayer Fund 46.52

Dix's series of 50 etchings on the war stands as the artist's greatest achievement as a printmaker. As part of the tradition of anti-war series by Francisco Goya, Georges Rouault, and Käthe Kollwitz, *War* combines technique with content to create intense, horrific visions. Although critics associated the series with Dix's need to purge himself of the nightmare he experienced, the artist denied this, saying about the war that "I saw it. I remember it. I paint it." He strove to maintain a sense of objective reportage in this series, while at the same time using techniques, such as a low vantage point and explicit detail, to intensify the drama. As did *Death and Resurrection,* this series reveals the far-reaching impact of the war. In addition to graphic images of life and death at the front, *War* includes scenes of resulting societal ills, such as

prostitution and drunkenness, as well as depictions of civilian suffering.

Foxhole examines the atrocious living conditions at the front. Three soldiers lie motionless in their beds, their bunks suggesting coffins and their sleep, death. In the foreground a malnourished soldier, his mental state uncertain, searches his clothes for lice. Behind him two grimacing soldiers play cards with an animal-like ferocity that underscores the dehumanization of the combat experience.

In *Roll Call of the Returning Troops,* Dix juxtaposes the figure of the officer, resplendent in his crisp uniform, with the rag-tag troops that will return to the front. Using patchy aquatint, he creates the rotting uniforms that hang loosely on the shoulders of the physically and mentally exhausted soldiers. They are ill-prepared for another tour of duty. Ironically, the administrative officer, who will likely never see battle, is in full uniform, down to the spurs on his spit-polished boots. Dix's cynical view of re-enlistment underlines his feelings that the war was a hopeless effort.

VWH

Glossary

aquatint A method of etching in which the plate is dusted with an acid-resistant powder such as resin and heated to the melting point. The plate is then bathed in acid which bites around the surface of the resin particles. The length of time different areas of the plate are immersed in the acid produces different tonal qualities.

Bauhaus A German school of architecture and applied arts founded in 1919 in Weimar by Walter Gropius. The staff of the Bauhaus, which included Wassily Kandinsky, Paul Klee and Lyonel Feininger, among others, was committed to creating a new way of life based on the unification of art and technology. The school relocated to Dessau in 1925 and was closed by the Nazis in 1933.

Berlin Secession A group of successful German artists, including Lovis Corinth and Max Beckmann, who banded together in 1899 as proponents of Impressionism.

Der Blaue Reiter (The Blue Rider) A loosely organized group of artists formed in Germany in 1911 by Wassily Kandinsky and Franz Marc. Named for a color and motif in the founders' work that symbolized their spiritual aspirations, the group organized two important avant-garde exhibitions and produced *The Blaue Reiter Almanac*. Notable for its blend of high art and folk art, children's art and ethnography, the significance of the almanac is in its introduction of abstraction as the style best suited for expressing truth in the coming spiritual age.

Die Brücke (The Bridge) The first Expressionist artists' group formed in 1905 by Ernst Ludwig Kirchner, Fritz Bleyl, Erich Heckel and Karl Schmidt-Rottluff. Their name was derived from the writings of Friederich Nietzsche and his theory that man was a bridge leading to an elevated state of humanity. They are known primarily for their graphics, especially the woodcut, a medium not widely used in Germany since its flowering in the 15th century. The group dissolved in 1913.

Degenerate Term used by the National Socialist Party (Nazis) to describe modern art. An exhibition of Entar-

tete Kunst (Degenerate Art) opened in Munich on July 19, 1937 for the purpose of clarifying to the German public what type of art was unacceptable to the Reich, and thus "un-German."

drypoint A printmaking technique in which the design is scratched into a copper plate with a sharply pointed tool. The incised lines produce a rough, raised edge (burr) which catches the ink and produces a soft, velvety line when printed.

etching A printmaking technique in which the image is bitten into a copper or zinc plate with acid. The image is first drawn on a plate covered in acid-resistant ground and then submerged in acid. The acid erodes the exposed metal and creates grooves and textures that hold the ink for printing.

foul-biting In etching, the accidental pitting of the metal plate by acid.

Genius A magazine published by Kurt Wolff Verlag in Leipzig from 1919 to 1921, dedicated to exploring contemporary issues in art and literature.

Jugendstil The German manifestation of Art Nouveau.

lithograph A method of surface printing in which the image is drawn with greasy crayon or ink on the flat surface of limestone, zinc or aluminum plates. The surface is chemically treated, dampened and then rolled with an oil base ink, which adheres only to the greasy areas and is repelled by the water on the nongreasy areas. Paper is applied to the stone or plate which is run through a flat bed press.

monotype A unique print created by drawing or painting an image on metal or glass and pressing a sheet of paper on it; when the paper is peeled off the ink or paint adheres to it in the reverse of the original design.

Neue Kunstlervereinigung München (New Artists Association of Munich) An artists' group founded by Wassily

Kandinsky and Alexis Jawlensky in 1909 in response to the growing conservativism of the Munich Secession. The group held three exhibitions including the first international exposition of 20th century art before dissolving in 1911.

Neue Sachlichkeit (New Objectivity) A German art movement of the mid-1920s associated with artists such as George Grosz and Otto Dix. Begun as a reaction to the emotional excesses of Expressionism, it represented a new disillusionment and the need to take a clear look at the world, to represent it precisely and unsentimentally.

Neue Secession (New Secession) An artists' group founded in 1910 by artists who had been rejected by the conservative members of the Berlin Secession. Led by Max Pechstein, the group included members of Die Brücke and the future Blaue Reiter. It dissolved in 1912 after their fourth exhibition.

Novembergruppe (November Group) An artists' group formed in Berlin in November 1918 under the leadership of Max Pechstein and César Klein in order to promote an alliance between expressionist artists and the socialist state. The group established Worker's Councils for Art and concerned itself with the place of the artist in the new society.

Salon des Independents (Salon of the Independents) An exhibition organized in 1884 in Paris in response to continual rejection of avant-garde artists by the official Salon.

Die Schaffenden A magazine for modern graphics founded and edited by Paul Westheim and published in Weimar between 1919 and 1922. The publication brought together prints by important contemporary German and French masters.

soft-ground An etching technique which utilizes a soft ground, usually beeswax and tallow, as opposed to the hard ground of conventional etching. The image is drawn on paper laid on the soft ground, and when the paper is removed, the soft ground sticks to the underside of the sheet where the lines were drawn, thus exposing the metal surface of the plate. Materials can also be pressed into the soft ground to create a variety of textural effects.

spitbiting An aquatint technique for achieving tonal effects by applying acid to the plate with a brush or eye-dropper in areas dampened with saliva or water.

state Proof impressions made during the development of a graphic image. Roman numerals are used to indicate state, for example II/V, indicates the second of five states known to exist of a print.

Der Sturm (The Storm) A magazine and art gallery in Berlin run by Herwarth Walden that championed Futurism and Expressionism in the 1910s and 1920s.

trial proof Proof pulled from a plate, stone or block to check the appearance of the image. A working proof, it usually indicates the direct involvement of the artist.

transfer lithograph A lithograph made by drawing with a greasy crayon on a special clay-coated transfer paper. When the paper is dampened, placed image side down on a clean stone or plate, and run through the press, the image is released onto the printing surface.

woodcut A relief print made from a plank of wood from which areas meant to remain uninked are cut away with a gouge or sharp knife.

BARLACH

Carls, Carl Dietrich. *Ernst Barlach.* New York: Frederick A. Praeger, Inc., 1969.

Reed, Orrell P., Jr. *German Expressionist Art: The Robert Gore Rifkind Collection.* Los Angeles: Frederick S. Wight Art Gallery, 1977.

Schult, Friedrich. *Ernst Barlach: Das graphische Werk.* Hamburg: Hanwedell & Co., 1957.

Werner, Alfred. *Ernst Barlach.* New York: McGraw Hill Book Company, 1966.

BECKMANN

Gallwitz, Klaus. *Max Beckmann, Die Drückgraphik.* Karlsruhe: Badischer Kunstverein, 1962.

Max Beckmann Graphics. Essay by Stephen E. Lackner. Tucson, AZ: Tucson Art Center, 1972.

Schulz-Hoffmann, Carla and Weiss, Judith C., eds. *Max Beckmann Retrospective.* Munich: The Saint Louis Art Museum and Prestel Verlag, 1984.

Selz, Peter. *Max Beckmann.* New York: The Museum of Modern Art, 1964.

DIE BRÜCKE

Brandt, Frederick and Hight, Eleanor M. *German Expressionist Art: The Ludwig and Rosy Fischer Collection.* Richmond: Virginia Museum of Fine Arts, 1987.

Heller, Reinhold. *Brücke: German Expressionist Prints from the Granvil and Marcia Specks Collection.* Evanston, IL: Northwestern University, 1988.

Herbert, Barry. *German Expressionism: Die Brücke and Der Blaue Reiter.* London: Jupiter Books, Ltd., 1983.

Kessler, Charles S. "Sun Worship and Anxiety," *Magazine of Art,* Nov. 1952, pp.304–312.

Reed, Orrel P. Jr. *German Expressionist Art: The Robert Gore Rifkind Collection.* Los Angeles: Frederick S. Wight Art Gallery, 1977.

Robison, Andrew, "Prints of the Brücke Artists," *German Expressionist Prints from the Collection of Ruth and Jacob Kainen.* Washington D.C.: National Gallery of Art, 1985, pp. 51–69.

CORINTH

Carey, Frances and Griffiths, Anthony. *The Print in Germany 1880-1933: The Age of Expressionism.* New York: Harper and Row, Publishers, 1984.

Lovis Corinth: A Retrospective Exhibition in the Gallery of Modern Art. Essays by Hilton Kramer and Alfred Werner. New York: The Foundation for Modern Art, Inc., 1964.

Müller, Heinrich. *Die späte Graphik von Lovis Corinth.* Hamburg: Lichtwarkstiftung, 1960.

Sackerlotzky, Rotraud. "Two Self-Portraits by Lovis Corinth," *The Bulletin of The Cleveland Museum of Art.* December, 1983, pp.418–431.

Schwarz, Karl. *The Graphic Work of Lovis Corinth.* Third Edition. San Francisco: Alan Wofsy Fine Arts, 1985.

DIX

Carey, Francis and Griffiths, Antony. *The Print in Germany, 1880-1933: The Age of Expressionism.* New York: Harper and Row, 1984.

McGreevy, Linda F. *The Life and Works of Otto Dix: German Critical Realist.* Ann Arbor: UMI Research Press, 1981.

Reed, Orrel P. Jr. *German Expressionist Art: The Robert Gore Rifkind Collection.* Los Angeles: Frederick S. Wight Art Gallery, 1977.

EXPRESSIONISM

Carey, Francis and Griffiths, Antony. *The Print in Germany, 1880-1933: The Age of Expressionism.* New York: Harper and Row, 1984.

German Expressionist Prints and Drawings. 2 Vols. Essays by Stephanie Barron et. al. Los Angeles: Los Angeles County Museum of Art, 1989.

Myers, Bernard, S. *The German Expressionists: A Generation in Revolt.* New York: Frederick A. Praeger, Publishers, 1966.

Reed, Orrel P. Jr. *German Expressionist Art: The Robert Gore Rifkind Collection.* Los Angeles: Frederick S. Wight Art Gallery, 1977.

Selz, Peter. *German Expressionist Painting.* Berkeley and Los Angeles: University of California Press, 1957.

FEININGER

Feininger/Hartley. Essays by Alfred H. Barr, Jr. and Alois J. Schardt. New York: The Museum of Modern Art, 1944.

Hesse, Hans. *Lyonel Feininger.* New York: Harry N. Abrams, Inc., 1959.

Ness, June L., ed. *Lyonel Feininger.* New York: Praeger Publishers, Inc., 1974.

Prasse, Leona E. *Lyonel Feininger: A Definitive Catalogue of His Graphic Work, Etchings, Lithographs, Woodcuts.* Cleveland: The Cleveland Art Museum, 1972.

GROSZ

Dückers, Alexander. *George Grosz: Das druckgraphische Werk.* Berlin: Propylaen Verlag, n.d.

Eberle, Matthias. *World War I and the Weimar Artists: Dix, Grosz, Beckmann, Schlemmer.* New Haven and London: Yale University Press, 1985.

Grosz/Heartfield: The Artist as Social Critic. Essays by Sidney Simon and Beth Irwin Lewis. Minneapolis: University Gallery, University of Minnesota, 1980.

Hess, Hans. *George Grosz.* New Haven and London: Yale University Press, 1985.

The Twenties in Berlin: Johannes Baader, George Grosz, Raoul Hausmann, Hannah Höch. Essay by Keith Whelden. London: Annely Juda Fine Art, 1978.

HECKEL

Carey, Francis and Griffiths, Antony. *The Print in Germany, 1880-1933: The Age of Expressionism.* New York: Harper and Row, 1984.

Heller, Reinhold. *Brücke: German Expressionist Prints from the Granvil and Marcia Specks Collection.* Evanston, IL: Northwestern University, 1988.

Meyers, Bernard S. *Expressionism, A Generation in Revolt.* London: Thames and Hudson, 1963.

Robison, Andrew, "Prints of the Brücke Artists," *German Expressionist Prints from the Collection of Ruth and Jacob Kainen.* Washington D.C.: National Gallery of Art, 1985. pp.51-69.

HOFER

Rathenau, Ernest. *Karl Hofer: Das graphische Werk.* New York: Ernest Rathenau, 1969.

Rigby, Ida Katherine. *Karl Hofer.* New York: Garland Publishing, Inc., 1976.

KANDINSKY

Carey, Frances and Griffiths, Antony. *The Print in Germany 1880-1933: The Age of Expressionism.* New York: Harper and Row, Publishers, 1984.

Grohmann, Will. *Wassily Kandinsky: Life and Work.* New York: Harry N. Abrams, Inc., 1958.

Lindsay, Kenneth C. and Vergo, Peter, eds. *Kandinsky: Complete Writings on Art.* 2 vols. Boston: G. K. Hall & Co., 1982.

Roethel, Hans Konrad. *The Graphic Work of Kandinsky.* New York: International Exhibitions Foundation, 1973.

Roethel, Hans Konrad. *Kandinsky, Das graphische Werk.* 2 vols. Cologne: Verlag M. DuMont Schauberg, 1970.

KIRCHNER

Carey, Francis and Griffiths, Antony. *The Print in Germany, 1880-1933: The Age of Expressionism.* New York: Harper & Row, Publishers, 1984.

Dube-Heynig, Annemarie. *Kirchner: His Graphic Art.* Greenwich, CT: New York Graphic Society, 1961.

Gordon, Donald E. *Ernst Ludwig Kirchner.* Cambridge: Harvard University Press, 1968.

Heller, Reinhold. *Brücke: German Expressionist Prints from the Granvil and Marcia Specks Collection.* Evanston, IL: Northwestern University, 1988.

Kainen, Jacob. "E. L. Kirchner as Printmaker," *German Expressionist Prints from the Collection of Ruth and Jacob Kainen.* Washington D. C.: National Gallery of Art, 1985, pp.31-49.

KLEE

The Graphic Legacy of Paul Klee. Essays by Christian Geelhaar et. al. Annandale-on-Hudson, NY: Bard College, 1983.

In Celebration of Paul Klee (1879-1940): Fifty Prints. Essay by Charles W. Haxthausen. Stanford, CA: Stanford University, 1979.

Kornfeld, Eberhard W. *Verzeichnis des graphischen Werkes von Paul Klee.* Bern: Verlag Kornfeld und Klipstein, 1963.

Paintings, Drawings and Prints by Paul Klee. Essay by James Thrall Soby. New York: The Museum of Modern Art, 1949.

Paul Klee: Figurative Graphics from the Djerassi Collection. Essay by Donna Graves. San Francisco: San Francisco Museum of Modern Art, 1986.

Rewald, Sabine. *Paul Klee: The Berggruen Klee Collection in the Metropolitan Museum of Art.* New York: The Metropolitan Museum of Art, 1988.

KOKOSCHKA

Carey, Frances and Griffiths, Anthony. *The Print in Germany 1880-1933: The Age of Expressionism.* New York: Harper and Row, Publishers, 1984.

Oskar Kokoschka 1886-1980. Essays by Werner Hofmann et. al. London: Tate Gallery, 1986.

Wingler, Hans M. and Welz, Friedrich. *Oskar Kokoschka: Das druckgraphische Werk.* Salzburg: Verlag Galerie Welz, 1975.

KOLLWITZ

Hinz, Renate, ed. *Käthe Kollwitz: Graphics, Posters, Drawings.* New York: Pantheon Books, 1981.

Kearns, Martha. *Käthe Kollwitz: Woman and Artist.* Old Westbury, NY: The Feminist Press, 1976.

Klipstein, Dr. August. *The Graphic Work of Käthe Kollwitz.* New York: Galerie St. Etienne, 1955.

Kollwitz, Hans, ed. *The Diary and Letters of Kaethe Kollwitz.* Evanston, IL: Northwestern University Press, 1988.

KUBIN

Alfred Kubin: 1877-1959. Introduction by Alfred Werner. New York: Serge Sabarsky Gallery, 1970.

Alfred Kubin: 1877/1977. Munich: Ellermann Verlag, 1977.

Alfred Kubin: Visions from the Other Side. Essay by Jane Kallir. New York: Galerie St. Etienne, 1983.

Kubin's Dance of Death and Other Drawings. Introduction by Gregor Sebba. New York: Dover Publications, Inc., 1973.

Raabe, Paul. *Alfred Kubin: Leben, Werk, Wirkung.* Hamburg: Kubin Archive, 1957.

MARC

Lankheit, Klaus. *Franz Marc: Katalog der Werk.* Köln: Verlag M. Dumont Schauberg, 1970.

Levine, Frederick S. *The Apocalyptic Vision: The Art of Franz Marc as German Expressionism.* New York: Harper and Row, Publishers, 1979.

Rosenthal, Mark, et al. *Franz Marc: 1880-1916.* Berkeley: University Art Museum, 1980.

Schardt, Alois. *Franz Marc.* Berlin: Rembrandt Verlag, 1936.

MEIDNER

Ludwig Meidner: An Expressionist Master. Essay by Victor H. Miesel. Ann Arbor, MI: The University of Michigan Museum of Art, 1978.

Rigby, Ida Katherine. *An alle Künstler! War — Revolution — Weimar: German Expressionist Prints, Drawings, Posters and Periodicals from the Robert Gore Rifkind Foundation.* San Diego: San Diego State University Press, 1983.

MUELLER

Brandt, Frederick R. and Hight, Eleanor M. *German Expressionist Art: The Ludwig and Rosy Fischer Collection.* Richmond: Virginia Museum of Fine Arts, 1987.

Heller, Reinhold. *Brücke: German Expressionist Prints from the Granvil and Marcia Specks Collection.* Evanston, IL: Northwestern University, 1988.

Otto Mueller zum Hundertsten Geburtstag: Das graphische Gesamtwerk. Berlin: Galerie Nierendorf, 1974.

Reed, Orrel P., Jr. *German Expressionist Art: The Robert Gore Rifkind Collection.* Los Angeles: Frederick S. Wight Art Gallery, 1977.

Robison, Andrew. "Prints of the Brücke Artists," *German Expressionist Prints from the Collection of Ruth and Jacob Kainen.* Washington: National Gallery of Art, 1985, pp.51-69.

NOLDE

Brandt, Frederick and Hight, Eleanor M. *German Expressionist Art: The Ludwig and Rosy Fischer Collection.* Richmond: Virginia Museum of Fine Arts, 1987.

Heller, Reinhold. *Brücke: German Expressionist Prints from the Granvil and Marcia Specks Collection.* Evanston, IL: Northwestern University, 1988.

Sabarsky, Serge. *Graphics of the German Expressionists.* Mt. Kisco, NY: Moyer Bell, Ltd., 1984.

Schiefler, Gustav. *Emil Nolde: Das grapische Werk.* Cologne: Verlag M. DuMont Schauberg, 1967.

PECHSTEIN

Heller, Reinhold. *Brücke: German Expressionist Prints from the Granvil and Marcia Specks Collection.* Evanston, IL: Northwestern University, 1988.

Krüger, Günter. *Das Drückgraphische Werk Max Pechsteins.* Hamburg: Max Pechstein-Archiv, 1988.

Lloyd, Jill. *German Expressionism: Primitivism and Modernity.* New Haven: Yale University Press, 1991.

SCHMIDT-ROTTLUFF

Heller, Reinhold. *Brücke: German Expressionist Prints from the Granvil and Marcia Specks Collection.* Evanston, IL: Northwestern University, 1988.

Meyers, Bernard S. *Expressionism, A Generation in Revolt.* London: Thames and Hudson, 1963.

Moser, Charlotte. "Burning Bridges," *Art in America,* November 1989, pp.64-68.

Rigby, Ida Katherine. "The Revival of Printmaking in Germany," *German Expressionist Prints and Drawings.* Los Angeles: Los Angeles County Museum of Art, 1989, pp.39-65.